LOUIS VUITTON

YAYOI KUSAMA

A MESSAGE FROM
YAYOI KUSAMA

FOREWORD BY
DELPHINE ARNAULT

CONTRIBUTIONS BY
JEFFREY DEITCH
FIONA ALISON DUNCAN
JO-ANN FURNISS
MARC JACOBS
PHILIP LARRATT-SMITH
HANS ULRICH OBRIST
AKIRA TATEHATA
MIKA YOSHITAKE

ARTISTS' WORDS BY
ARCA
KATHERINE BRADFORD
ANNE IMHOFF
RYAN MCNAMARA
RAÚL DE NIEVES
PRECIOUS OKOYOMON
RYAN TRECARTIN
NORA TURATO
JACOLBY SATTERWHITE

EDITED BY
FERDINANDO VERDERI
ISABEL VENERO

Creating infinity

LOUIS VUITTON YAYOI KUSAMA

New York · Paris · London · Milan

MY HEART'S GREATEST DESIRE
IS TO CONVEY, IN EVERY
TRANS-COSMIC VISION,
MY ASPIRATION
FOR ETERNAL BEAUTY.
WHAT IS BEAUTY?
THE ARCHETYPE OF LOVE.
THE MORNING LIGHT
WILL ILLUMINATE YOU,
AND ARCHETYPES
OF LOVE-FILLED HUMAN BEINGS
WILL SURROUND YOU.
THE TIME IS NOW, BRIMMING
WITH THE BRILLIANCE OF LIFE.
AS THIS LOVE OF MINE
IS INEXHAUSTIBLE,
I WOULD EMBRACE THE LOVE
OF ALL PEOPLE.
LOVE IS FOREVER.
HUMAN LIFE IS BEAUTIFUL.
A MESSAGE OF LOVE
FOR YOU WHO RECEIVE IT.

YAYOI KUSAMA

Tokyo, 2023

A Message of Love

Yayoi Kusama

FOREWORD
DELPHINE ARNAULT

Yayoi Kusama

It was the middle of 2021, in Paris. As always, we wanted to work with one of *the* most important living artists of our time—this really is the Louis Vuitton way—and yet, we were in the midst of a global pandemic, in one of the most difficult of times. We wanted someone who could speak to our moment and about who they are in their work. But above all, we asked ourselves: Which artist creates work that would bring the most joy to people?

There was only one answer from the beginning: Yayoi Kusama.

Thinking about a trunk she had worked on in 2012, as a gift she offered to Yves Carcelle: it was an amazingly joyful object, with Kusama having personally repainted the Monogram in a touching and profound way. The Monogram is such a part of our universe here—it is very recognizable—yet she had transformed it and made us look at it differently. There were two worlds: hers and ours, our Monogram and her dots.

In a way, it was like two "logos" had found each other and complemented the other's obsessions. It is this obsessive relationship—both together and apart, and embodied in the trunk—that became a touchstone for the wide-ranging project documented in this book.

Later, when we worked together with Kusama and her studio on how we would recreate the dots on the trunk—their color, their thickness, and their hand-painted weight—we had to create an entirely new printing technique to achieve this. We wanted to give the impression that the Monogram had just been painted and wasn't yet dry—like the magic of Kusama's process was taking shape before our eyes ... We went back and forth with her studio in Japan. Because it was at the height of the pandemic, international borders were closed, so we conducted business virtually through Zoom and via the many courier services that were still working.

Artists push the boundaries of possibility. At Louis Vuitton, working with artists pushes our research and enables our ateliers to go so much further. We have amazing teams of artisans who are always looking for new techniques to work with on, for example, our canvas and our leather. But even for them, working under such circumstances was extreme and achieving the technical results they were able to was quite remarkable.

Yet, it was not always certain that we would get to this point.

We reached out to the people we had worked with in 2012 for the first collaboration with Kusama and asked whether she would consider doing another. The initial response was not very encouraging. But they said, "because it's for Louis Vuitton, we will ask her."

Two or three weeks later, they came back with an answer: "She would love to do it. And she wants it to be even bigger than the first time."

Needless to say, we were delighted—and somewhat daunted.

This is when we had the idea to do the collaboration across the entire Vuitton universe—incorporating both the women's and the men's spheres. It is the first time any collaboration has been done in the luxury world to this extent—360 degrees. It appears across all categories of Louis Vuitton: on the windows, in all the advertising, in the digital realm and, of course, in all the products. And every facet of this expansive project is unique.

Walking along the Champs-Élysées, you can see how the dots

have taken over and how the giant, inflatable Kusama figure is painting them at the top of the Vuitton building. At Place Vendôme, there was an animatronic version of the artist painting in a storefront window. On Avenue Montaigne, metallic spheres protruded from the building's facade. We wanted the viewer experience in each location to be completely different, to touch upon the different aspects of each site, and to offer various ways of seeing and experiencing the project. The collaboration is not just about buying the extraordinary items it produced, it's also about taking part in it, getting a sense of what it means—it is both the translation and transformation of a vision. And this ambitious project has been presented in almost every major city in the world.

The collaboration has required a huge amount of work from all the teams: from the supply chain to the visual merchandising to the advertising and the marketing, from the ateliers to the packaging ... Everyone at Louis Vuitton has been involved.

We're all very proud of this beautiful, joyful project. And one of the very best reactions came from Yayoi Kusama herself when she visited the stores in Tokyo—she was so moved.

This project has indeed been very moving—for Kusama and her studio, for the Louis Vuitton teams, and especially for me. We often do not realize the massive emotional investment that fashion necessitates and the sheer amount of hard work that is involved—particularly under these difficult circumstances.

Here, sincerity was always as important as strategy. In our collaboration with Kusama, the most successful living female artist of our time, as in all of our art projects, the idea has always been to push boundaries, both technically and culturally.

It is fascinating to work with people who do not see the world in the same way as everyone else. When you speak to Nicolas Ghesquière, Jeff Koons, Frank Gehry, or Karl Lagerfeld—just a few of the great artists we have had the pleasure of working with at Louis Vuitton—they could look at a picture, and point out a detail that you have never seen before—and once you have seen that detail it changes your whole perception of the work or, sometimes, the whole world.

Working with such icons is a unique opportunity—one that I am eternally grateful for. To have worked with Yayoi Kusama is truly something special, and it has been an honor for all of us to translate her vision for the world.

Finding fantastic contemporary artists who work with us to have their art translated into clothing, to have those works in our windows, expands the artists' audience beyond gallery- and museum-goers. It connects these artists to the wider culture, and gives viewers a chance to see the world in a different way—something I hope we have accomplished with this project.

IN SEARCH OF INFINITY

"My desire was to predict and measure the infinity of the unbounded universe, from my own position in it, with dots—an accumulation of particles forming the negative spaces in the net. How deep was the mystery? Did infinite infinities exist beyond our universe?"—Yayoi Kusama

The negative space of the net is the polka dot, as Kusama has pointed out. The shapes complement and fulfill each other. Emerging from the artist's hand like waves cascading or cells multiplying, dots and nets reach toward infinity, covering the surfaces of everything from canvas and clothing to buildings and trees. Kusama's first New York solo show in 1959 introduced her *Infinity Nets*, then referred to as *Interminable Nets*, to the world. Inspired by the rippling Pacific Ocean as seen from her airplane window on her journey from Japan to the United States, Kusama had painted, as critic, artist, and close friend Donald Judd wrote, "innumerable small arcs superimposed on a black ground overlain with a wash of white" that produced an effect that is "both complex and simple" on canvases as long as thirty feet. Based on transhistorical patterns found in nature, from the microbiological to the cosmic, infinity nets and dots recur throughout Kusama's oeuvre, shifting in their associations depending on their placement and execution. A net may look like lattice, lace, the veins of leaves, rhizomes, root systems, or fish scales, while dots might call to mind atoms, cells, pores, pollen, seeds, and stars. In Kusama's beloved mirror rooms, the celestial association of her dots comes through powerfully. Enclosed in a room of mirrors, little lights reflect endlessly, giving the viewer a sense of being in outer space or, as the artist suggests, a "mysterious and amazing" sense "of the infinite existence of electronic polka-dots." *Fiona Alison Duncan*

2023

Silk

Louis Vuitton, Infinity Dots square (detail)

Creating Infinity

Yayoi Kusama

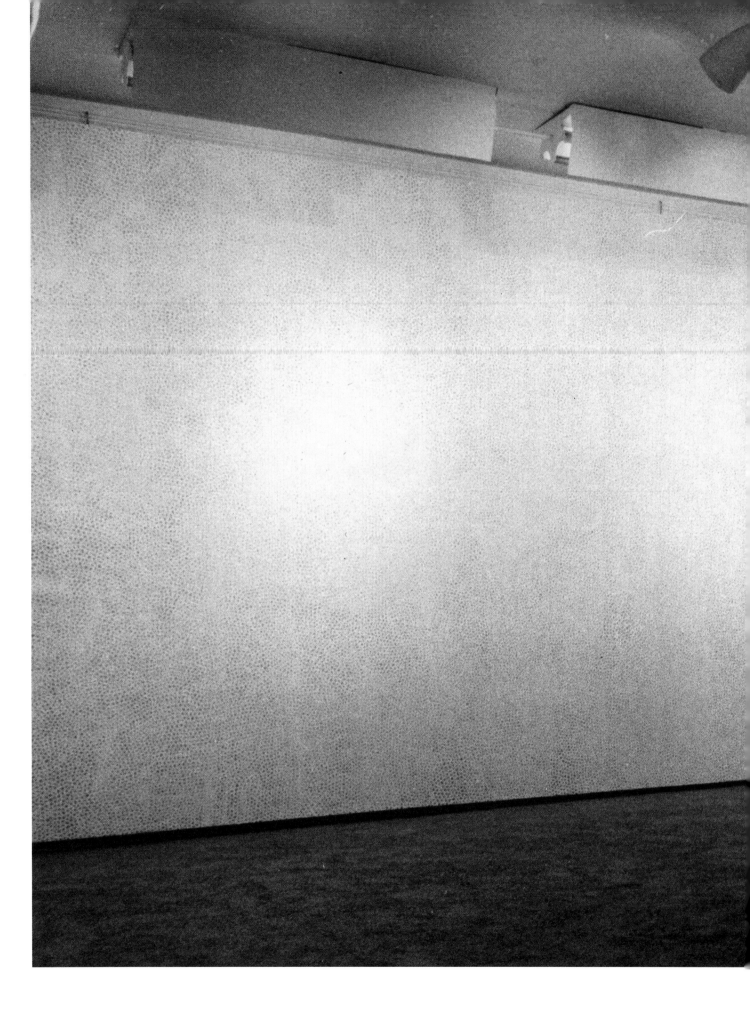

Stephen Radich Gallery, New York, 1961

33-foot-long *Infinity Net* painting

Yayoi Kusama

2023

Louis Vuitton, Infinity Dots Vivienne

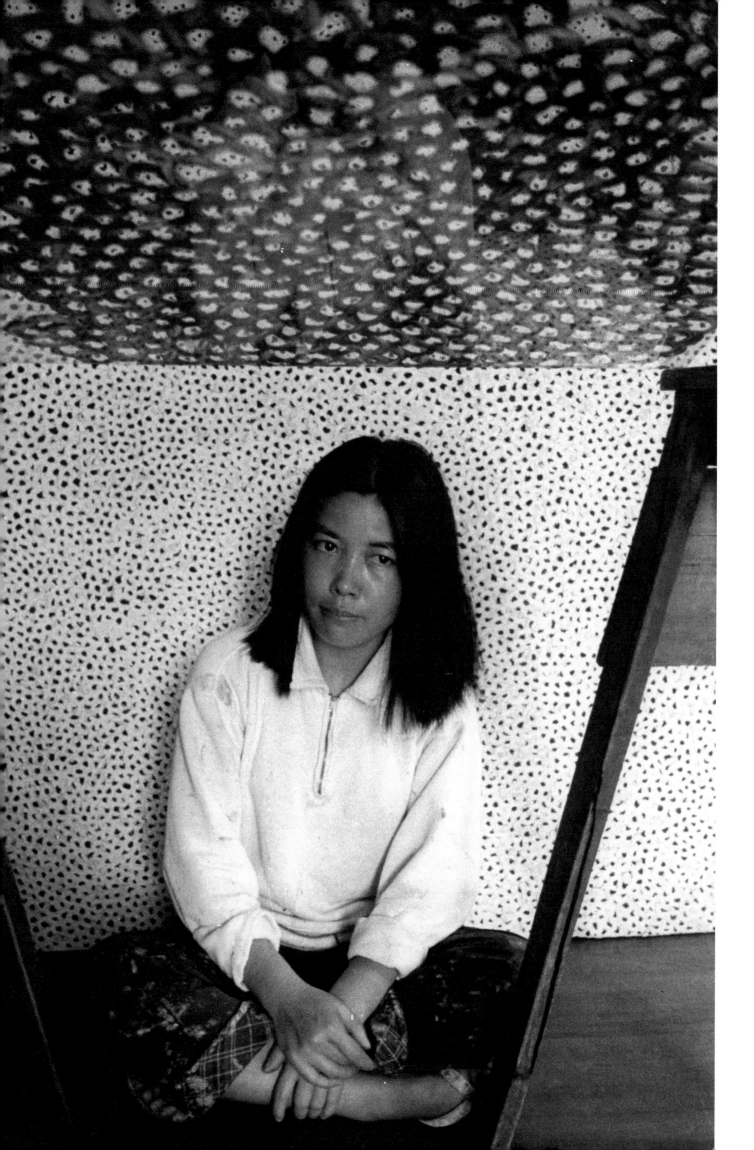

New York, c. 1959

The artist in her studio

Yayoi Kusama

2023

Photograph by Steven Meisel

Hoyeon Jung for Louis Vuitton

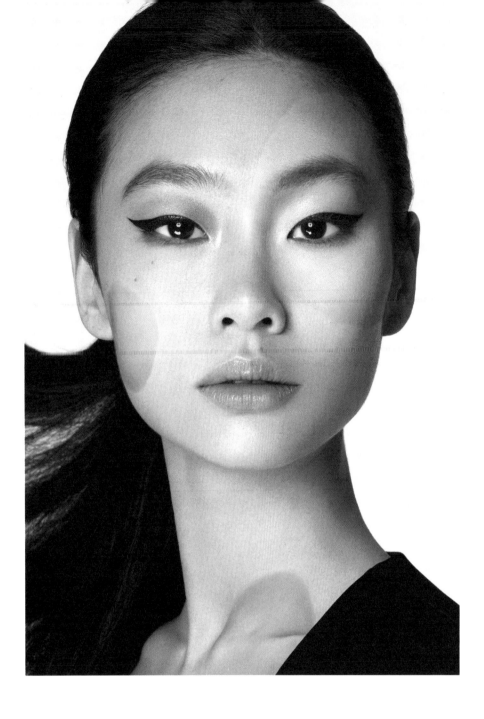

YAYOI KUSAMA TAUGHT ME HOW TO ACHIEVE AUTONOMY AND AUTHENTICITY THROUGH THE MERE IDEA OF WORKING FROM A PLACE OF NECESSITY, CATHARSIS, AND MEDICINAL AND SPIRITUAL FULFILLMENT. SHE GAVE ARTISTS THE CODE TO ACHIEVING A PSYCHIC SENSIBILITY FOR CRAFTING AN IMMERSIVE CONCEPTUAL PRACTICE.

JACOLBY SATTERWHITE

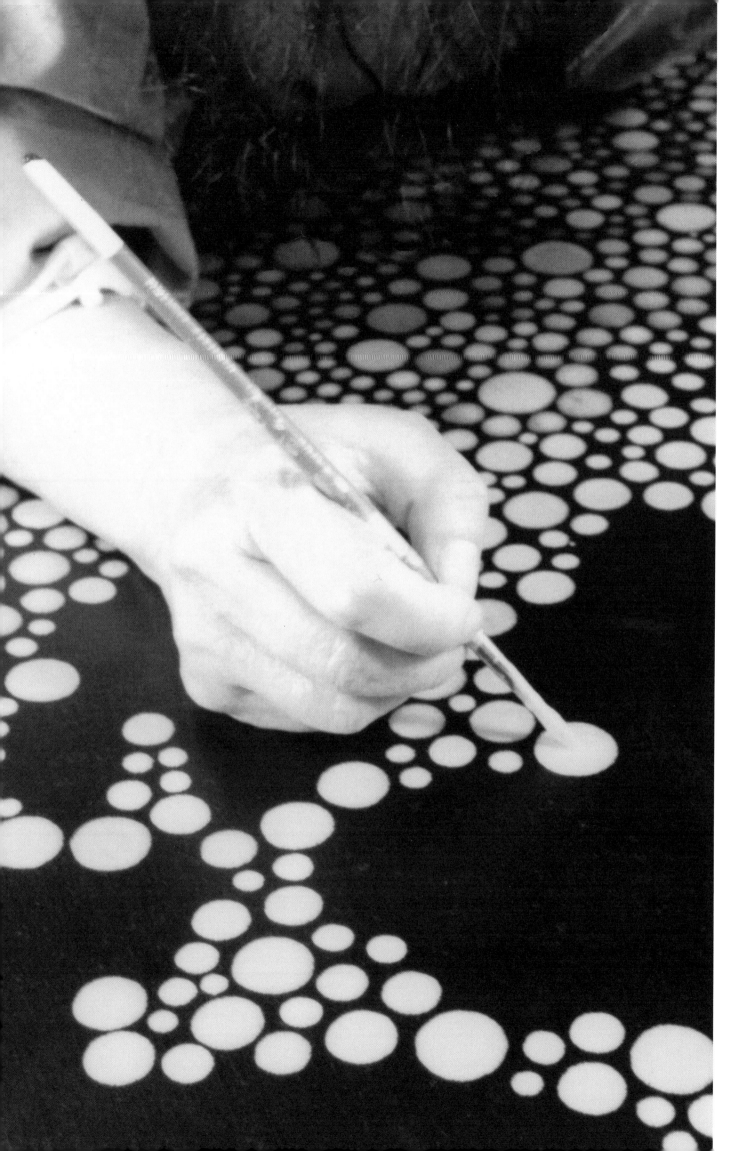

Tokyo, 1997

The artist painting dots in her studio

Yayoi Kusama

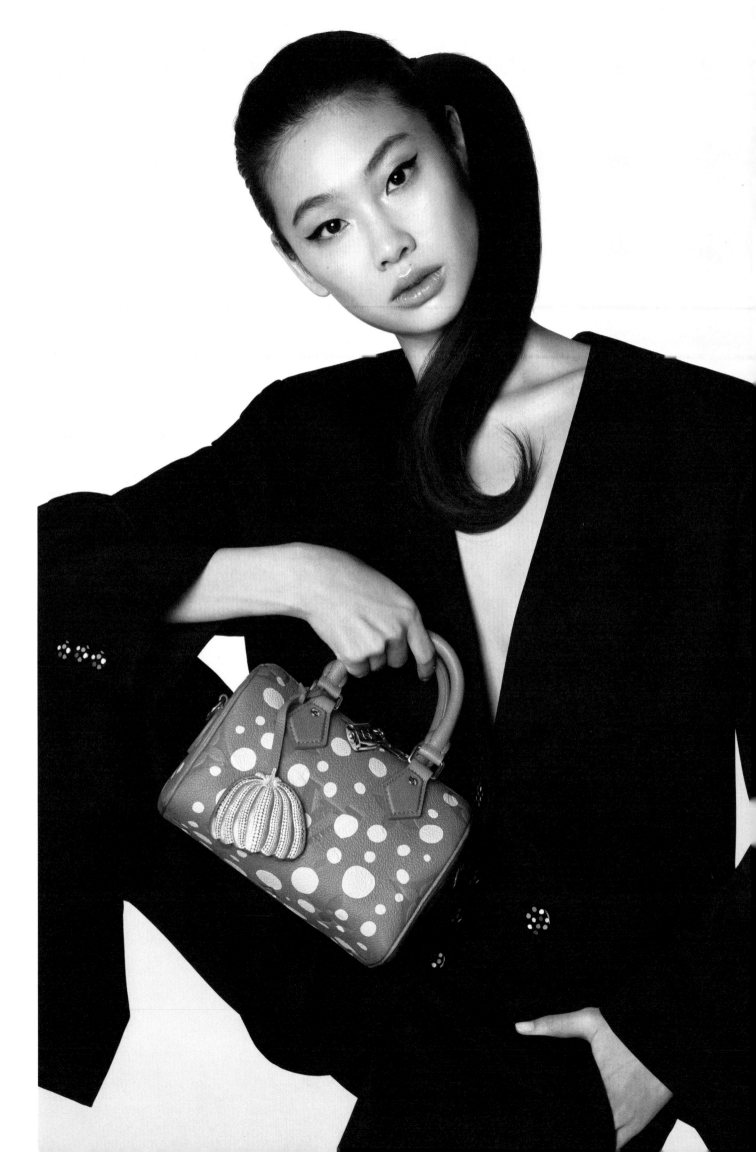

2023

Photograph by Steven Meisel

Hoyeon Jung for Louis Vuitton

New York, c. 1967

The artist in her studio

Yayoi Kusama

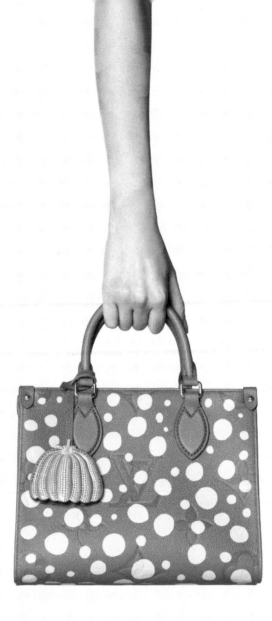

2023

Photograph by Steven Meisel

Louis Vuitton, Infinity Dots OnTheGo bag

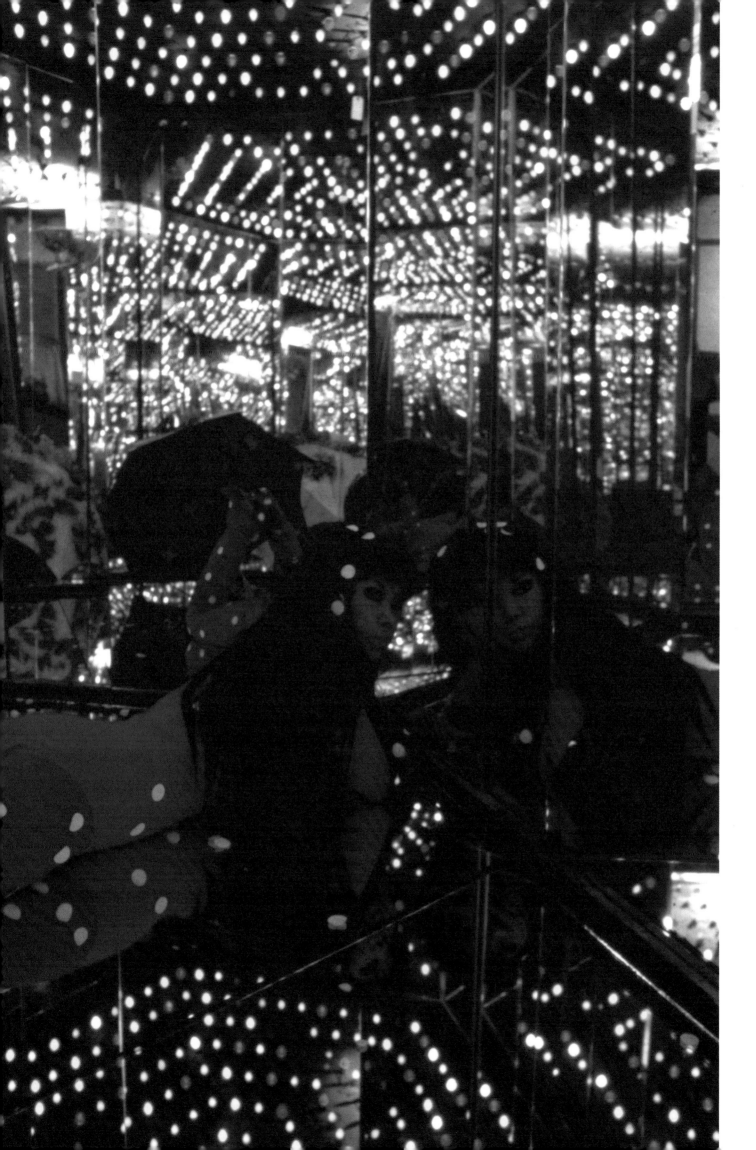

Richard Castellane Gallery, New York, c. 1966

The artist at her exhibition *Kusama's Peep Show* or *Endless Love Show*

Yayoi Kusama

AS A DEVOUT MEMBER OF THE CHURCH OF SELF-OBLITERATION, I THANK KUSAMA AND HER 1960S PERFORMANCES FOR HIGHLIGHTING THE SYMBIOTIC RELATIONSHIP BETWEEN SEXUAL LIBERATION AND ANTI-CAPITALISM. HER 1968 "HOMOSEXUAL WEDDING," COMPLETE WITH A TWO-PERSON "ORGY WEDDING GOWN," SHOULD BE THE TEMPLATE FOR ALL QUEER NUPTIALS.

RYAN MCNAMARA

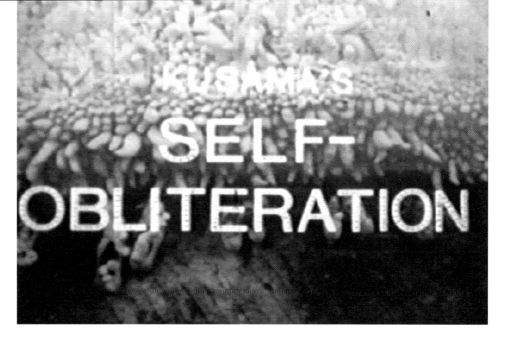

1967

16mm film

Kusama's Self-Obliteration

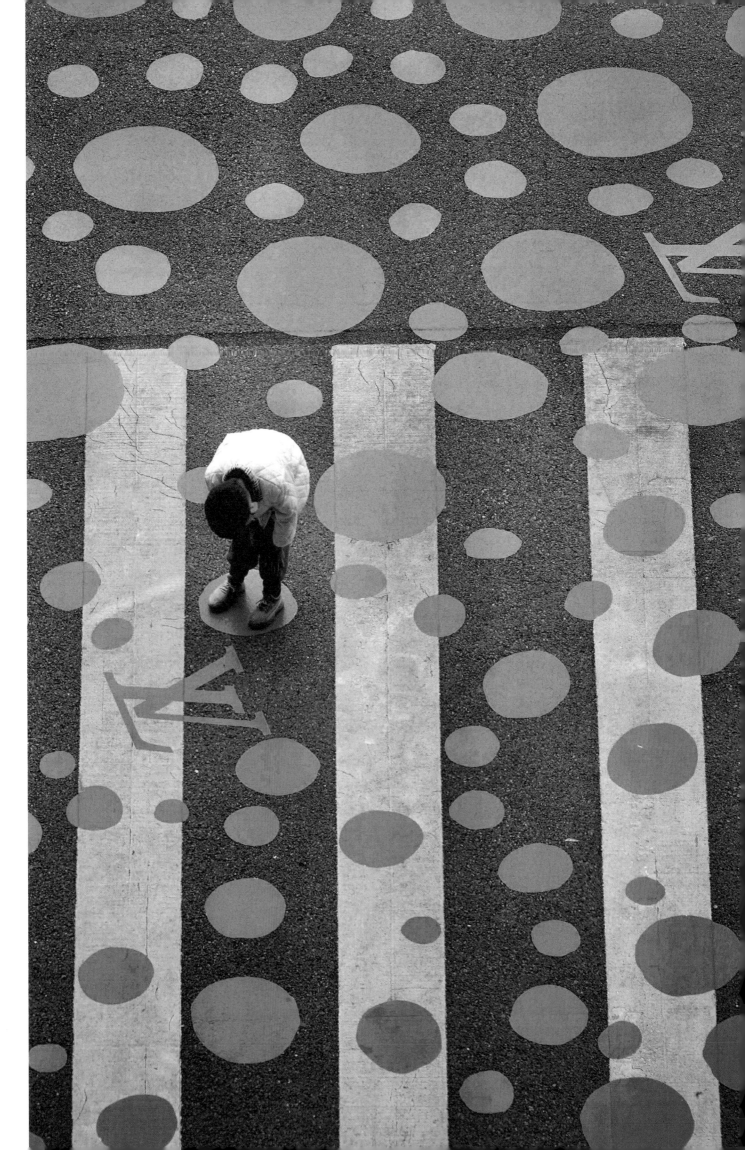

Shenzen, 2023

Photograph by Cai Zichang

Louis Vuitton, Infinity Dots street installation

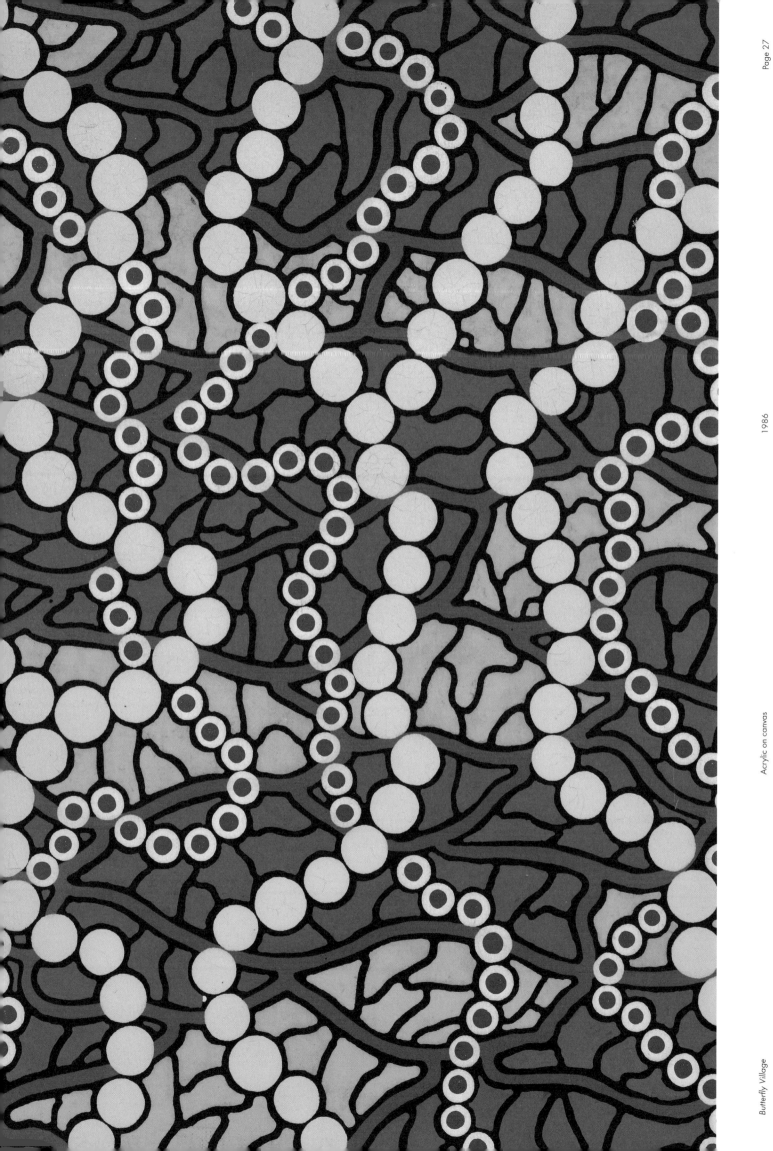

1986

Acrylic on canvas

2023

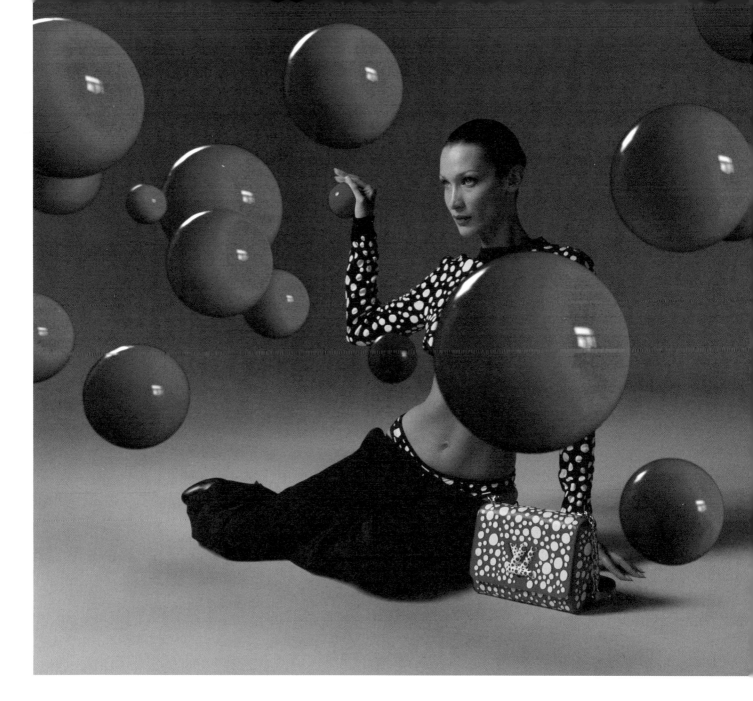

Video directed by Ferdinando Verderi

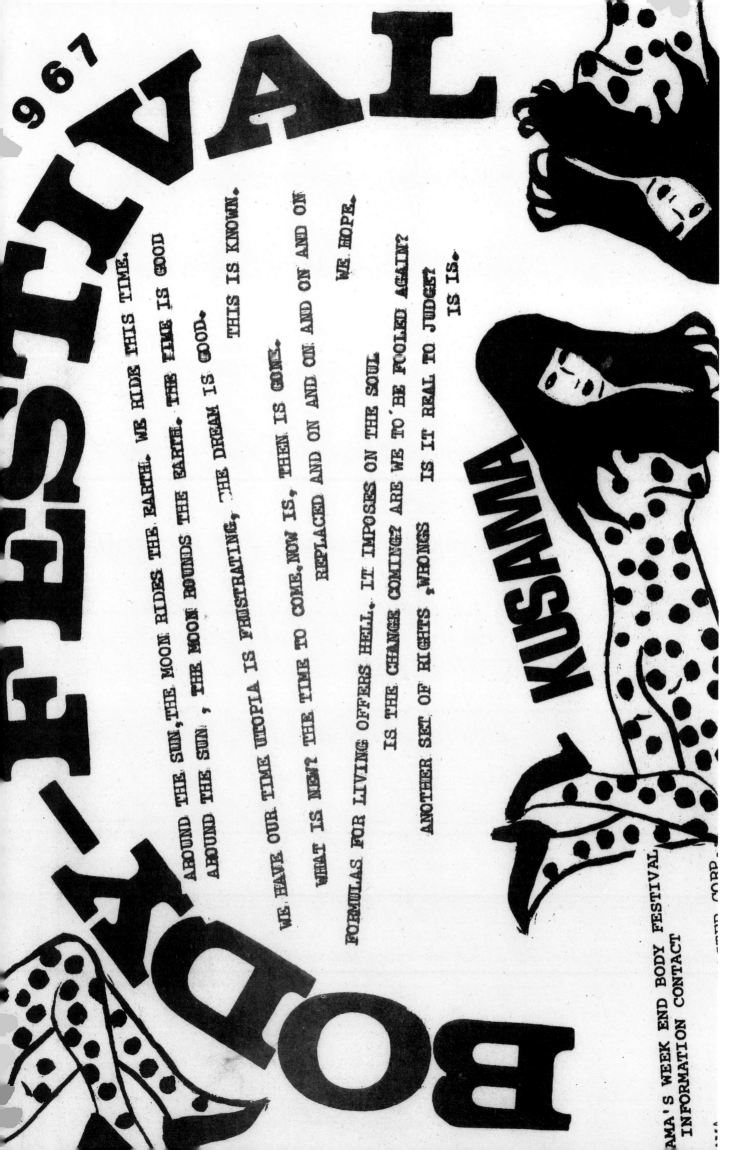

FESTIVAL
967
BODY

KUSAMA

AROUND THE SUN, THE MOON RIDES THE EARTH, WE RIDE THIS TIME.

AROUND THE SUN, THE MOON ROUNDS THE EARTH, THE TIME IS GOOD

THE DREAM IS GOOD.

THIS IS KNOWN.

WE HAVE OUR TIME UTOPIA IS FRUSTRATING.

WHAT IS NEW? THE TIME TO COME, NOW IS, THEN IS GONE.

REPLACED AND ON AND ON AND ON AND ON

WE HOPE.

FORMULAS FOR LIVING OFFERS HELL, IT IMPOSES ON THE SOUL

IS THE CHANGE COMING? ARE WE TO BE FOOLED AGAIN?

ANOTHER SET OF RIGHTS ,WRONGS IS IT REAL TO JUDGE?

IS IS.

AMA'S WEEK END BODY FESTIVAL
INFORMATION CONTACT

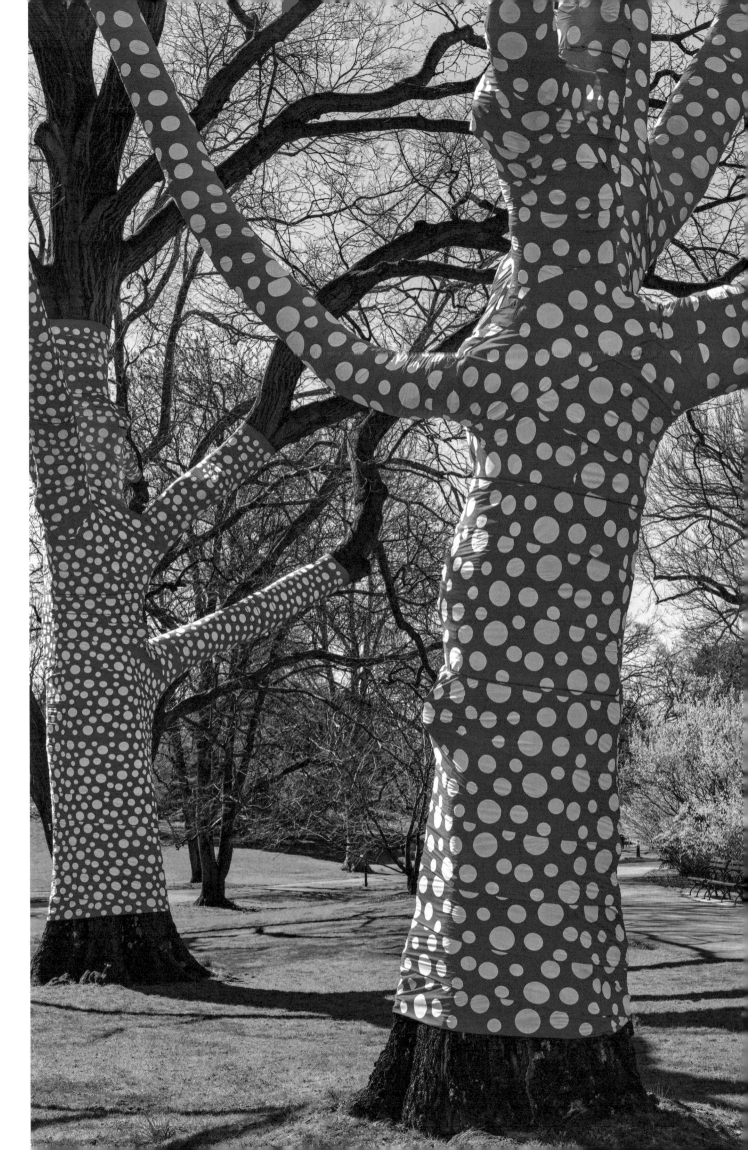

Site-specific installation

Ascension of Polka Dots on the Trees, 2002/2021

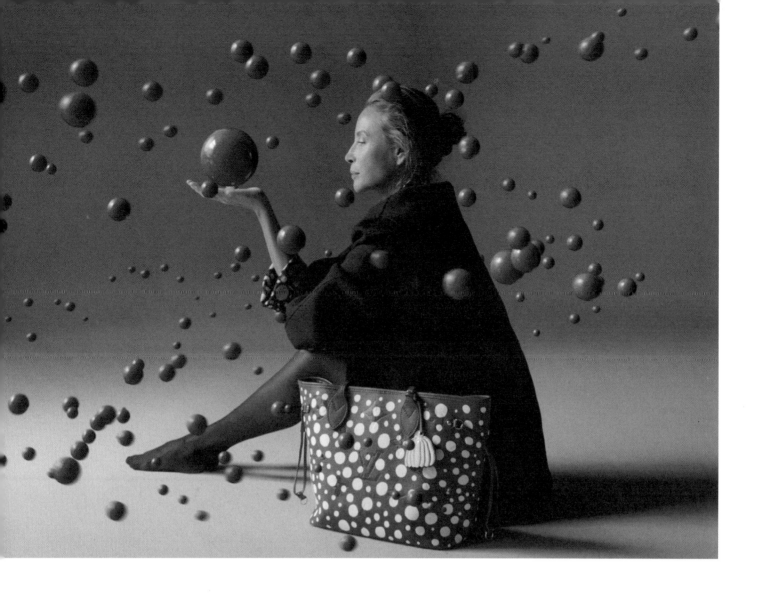

2023

Video directed by Ferdinando Verderi

Christy Turlington for Louis Vuitton

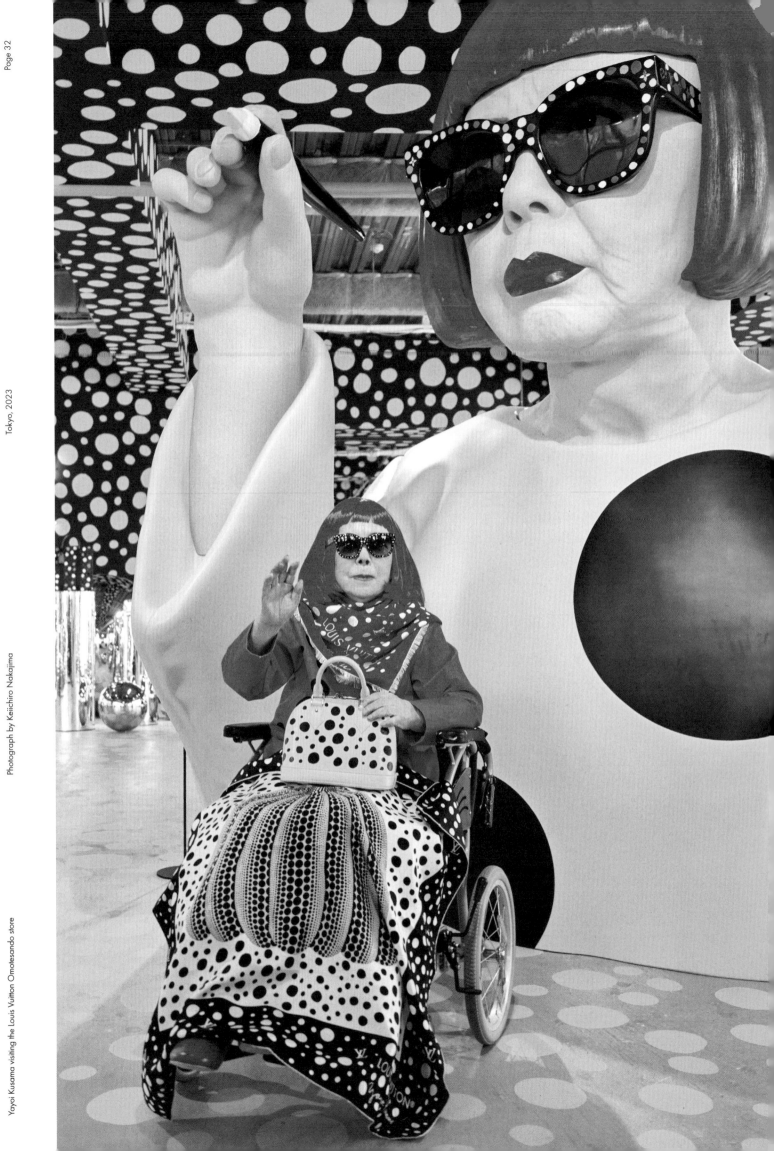

Tokyo, 2023

Photograph by Keiichiro Nakajima

Yayoi Kusama visiting the Louis Vuitton Omotesando store

INFINITY-NETS (ZUXDZ) (detail) Acrylic on canvas 2018

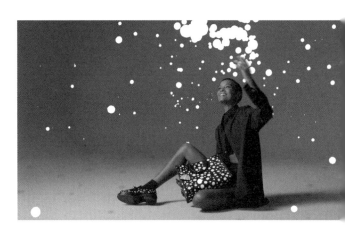
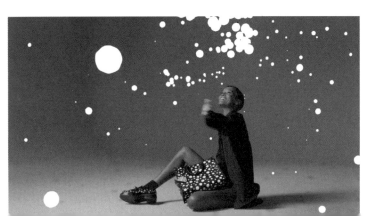
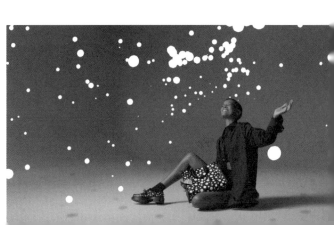

2023

Video directed by Ferdinando Verderi

Liya Kebede for Louis Vuitton

2015

Acrylic on canvas

DOTS-OBSESSION (RKM) (detail)

2021

Acrylic on canvas

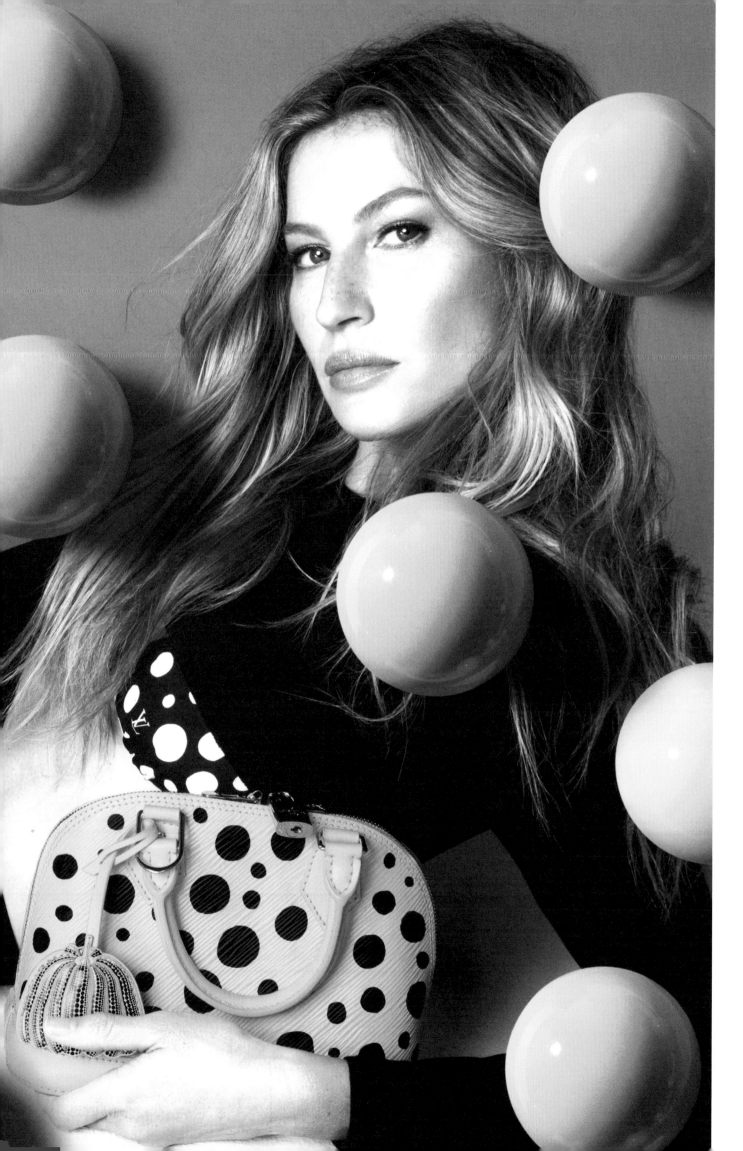

2023

Photograph by Steven Meisel

Gisele Bündchen for Louis Vuitton

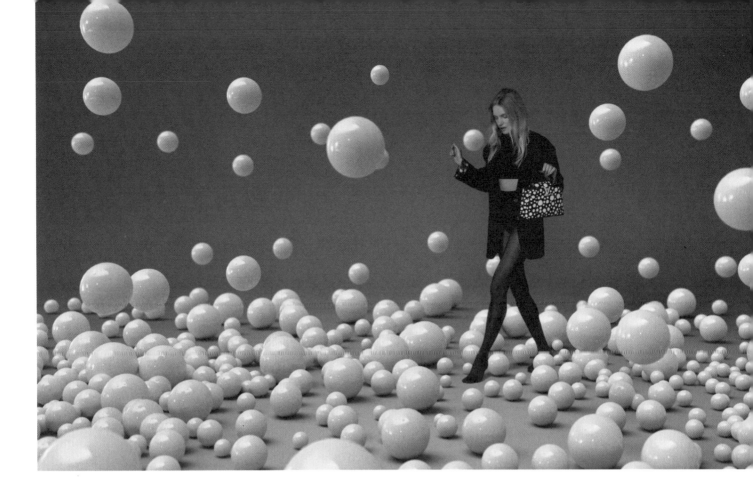

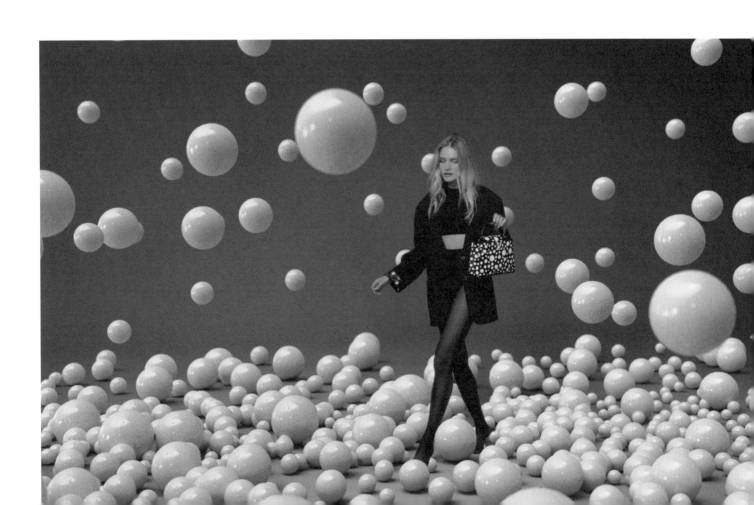

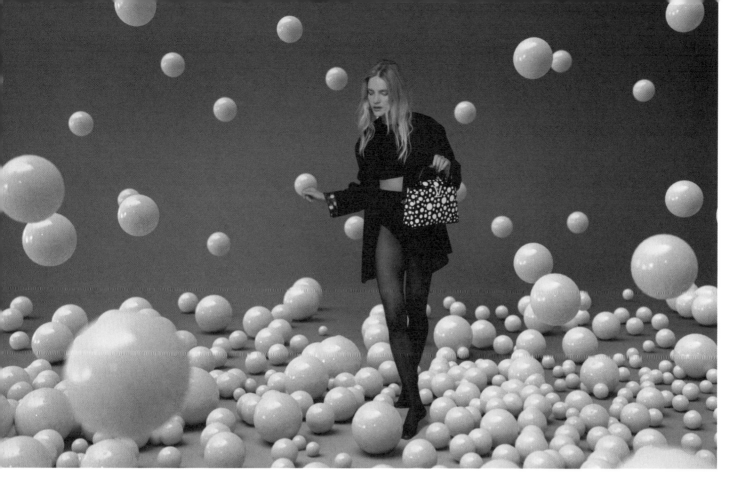

2023

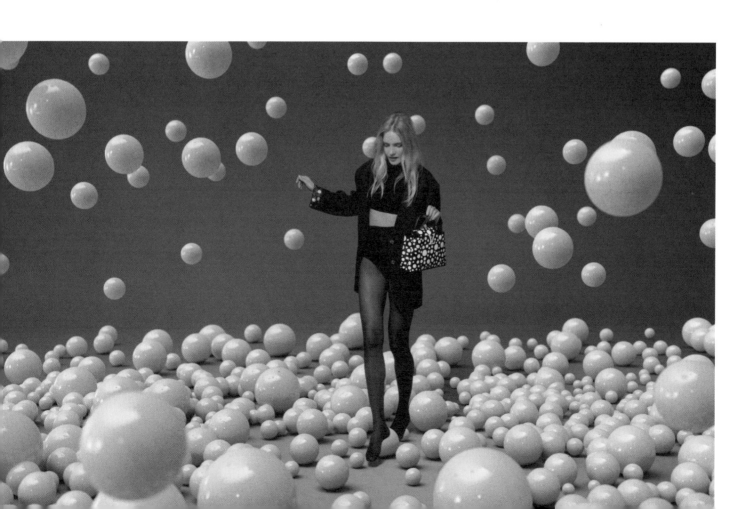

Video directed by Ferdinando Verderi

Natalia Vodianova for Louis Vuitton

2023

Video directed by Ferdinando Verderi

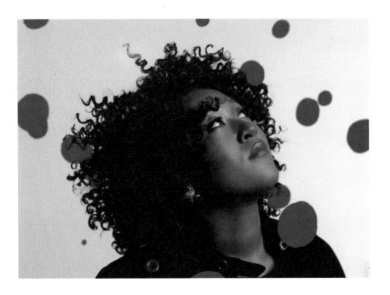

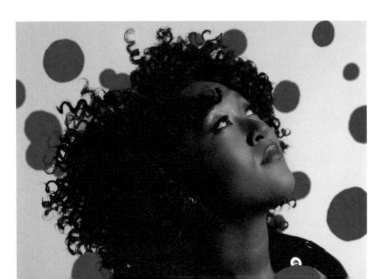

Acrylic on canvas

1993

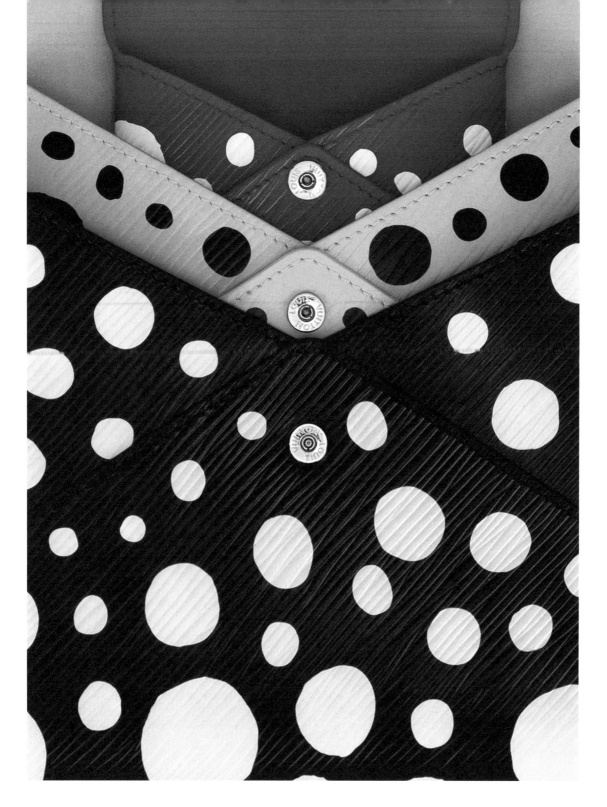

Épi-grained cowhide leather

Louis Vuitton, Infinity Dots Kirigami pochette (detail)

2007

Acrylic on canvas

Dots Infinity (ABCOT) (detail)

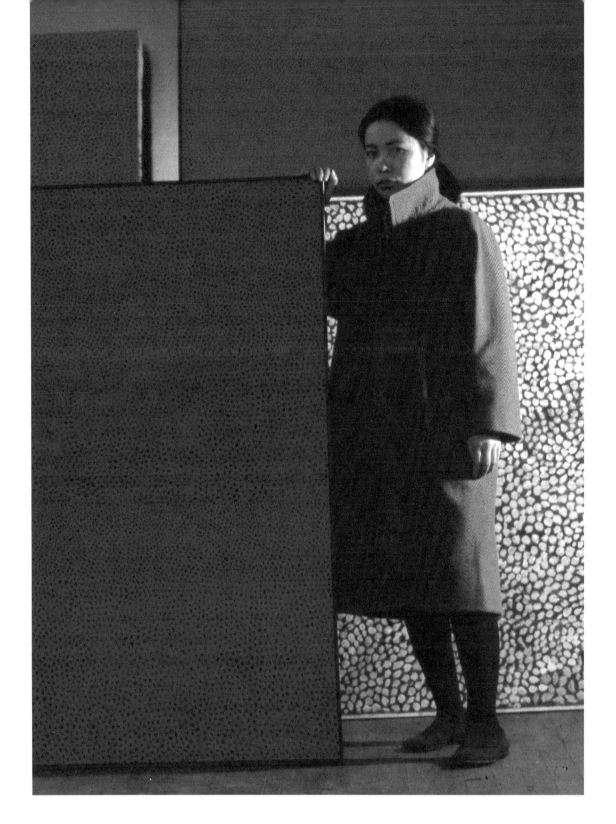

The artist in her studio with *Infinity Net* paintings

Yayoi Kusama

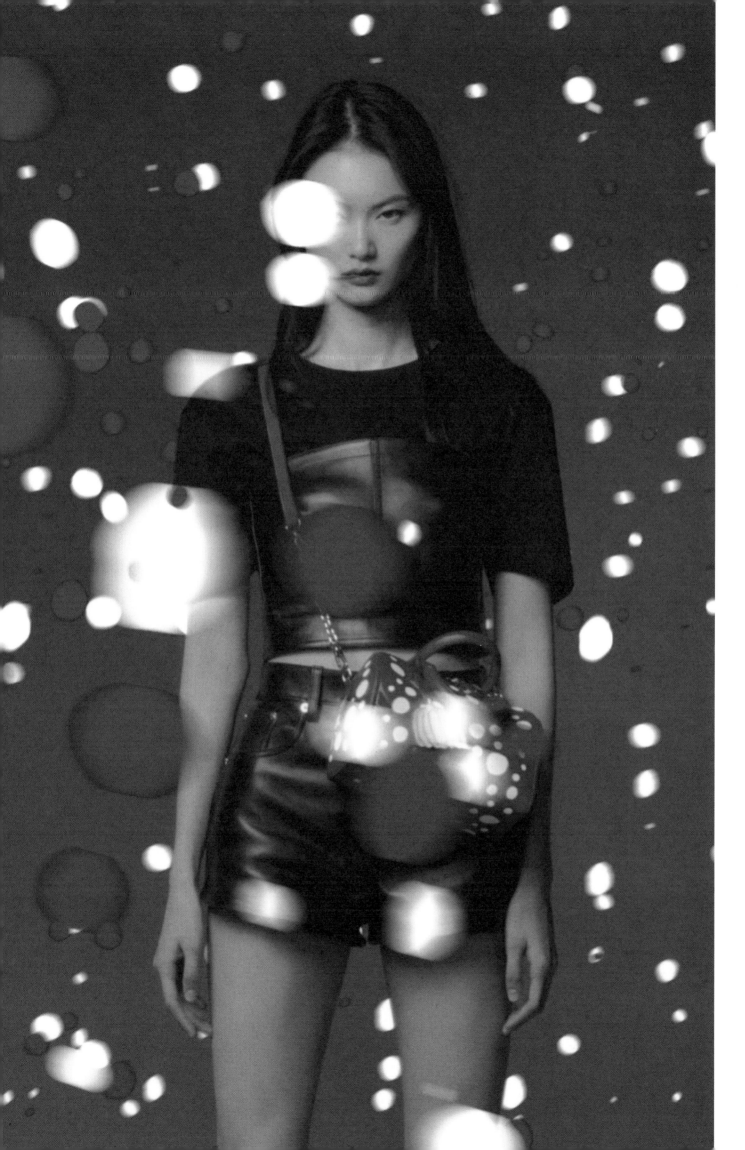

2023

Video directed by Ferdinando Verderi

He Cong for Louis Vuitton

MIRROR MIRROR

In 1966, Yayoi Kusama crashed the 33rd Venice Biennale with her performance installation *Narcissus Garden*. Dressed in a gold kimono, the uninvited artist stood among 1,500 mirrored orbs, each roughly the size of her own head, with which she had covered the grass outside the Italian Pavilion. As Kusama later explained, the orbs were available for two dollars or 1,200 lire, "as if I were selling hot dogs or ice cream cones." A comment on the commodification of art and the self-interestedness of collectors (a painted sign read "Your Narcissism for Sale"), the reflective spheres also summoned Kusama's interest in the celestial: as she wrote in her press release, "The silver ball is also a representative of the moon, of sunshine, of peace." Kusama was eventually removed by Biennale officials for "peddling," but not before many photographs were taken. Circulating in the international press and, later, in history books, these images furthered Kusama's own stardom.

Since its first performance, *Narcissus Garden* has been reprised more than forty times around the world. Without Kusama's presence as saleswoman in these later iterations, the spheres alone animate their surroundings, which have varied from an abandoned train garage to waterways, gardens, and museums. Like Kusama's polka dots, the orbs suit every site where they pop up. Reflecting and absorbing the environment on its convex mirrored surface, each globe becomes a world of its own that you could hold, although the closer viewers get, the more they themselves become the orb's subject, gazing at their own distorted reflections like the tragic, mythic Narcissus.
Fiona Alison Duncan

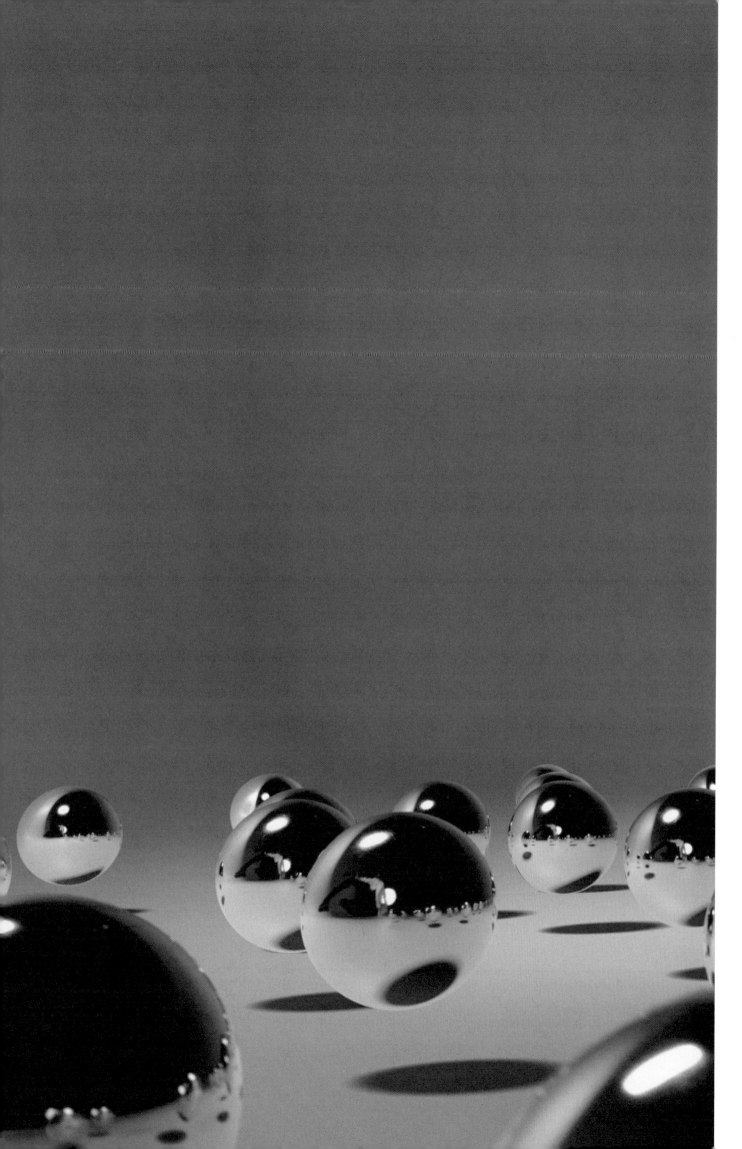

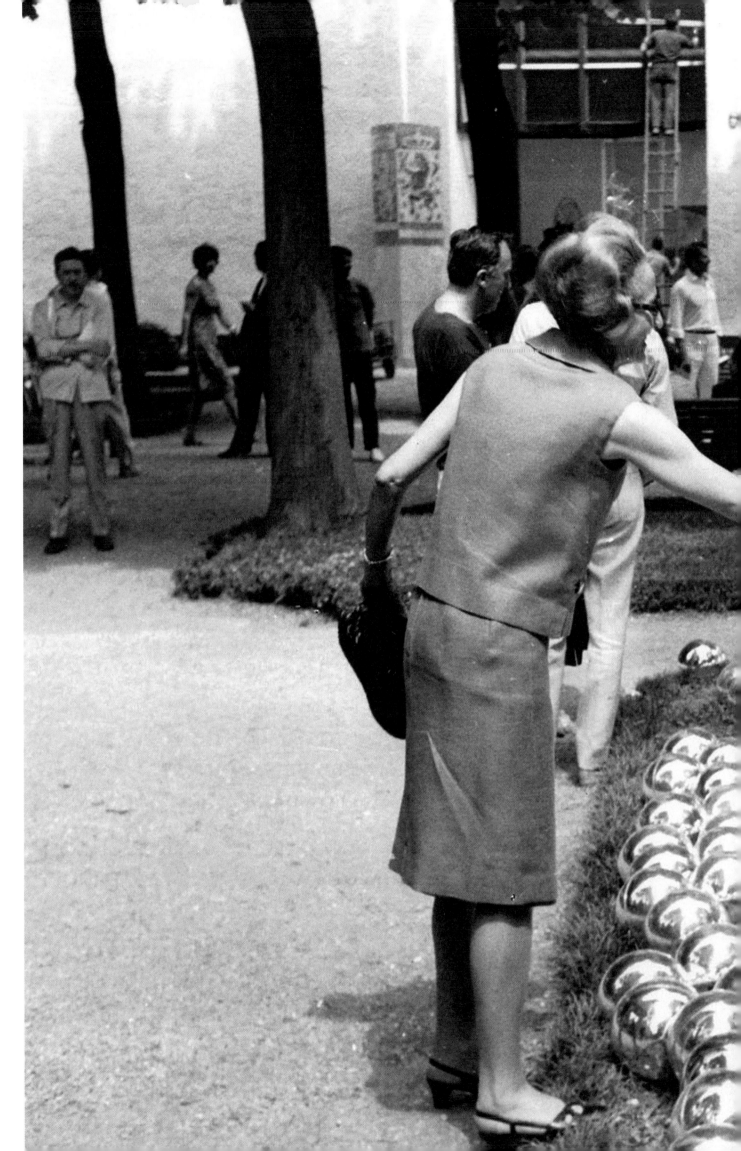

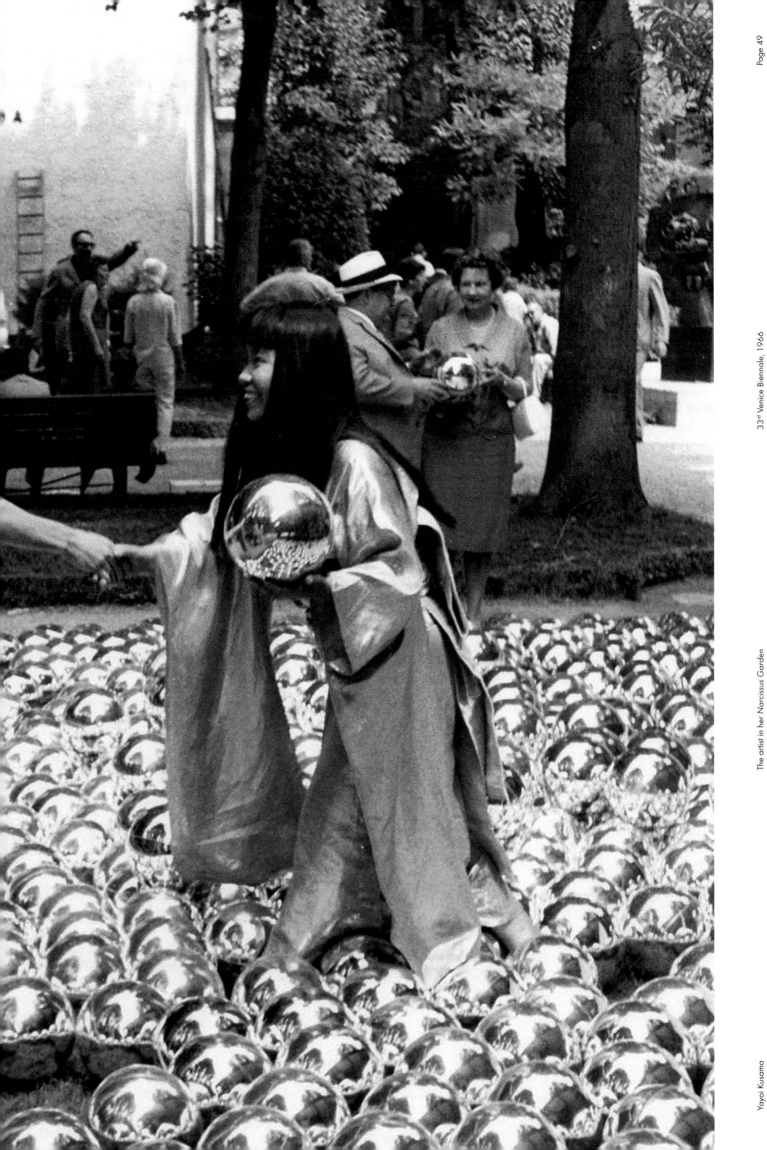

33ʳᵈ Venice Biennale, 1966

The artist in her *Narcissus Garden*

Yayoi Kusama

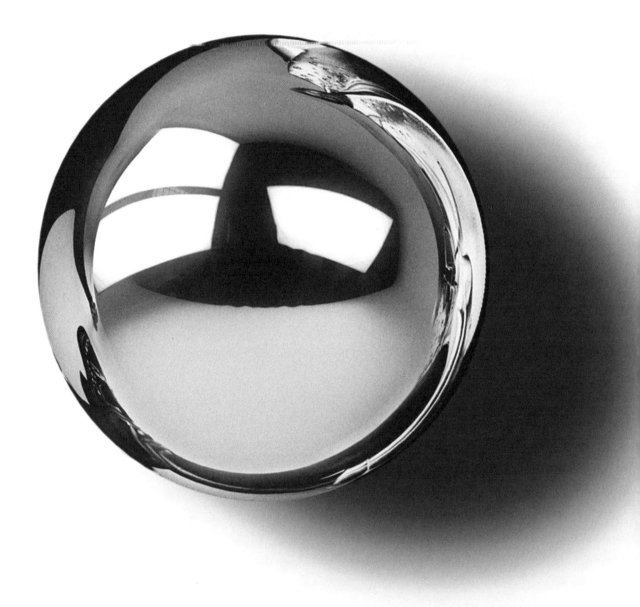

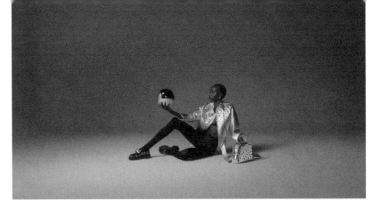
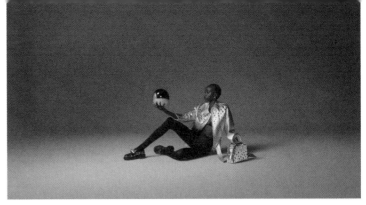

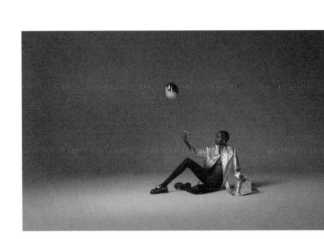

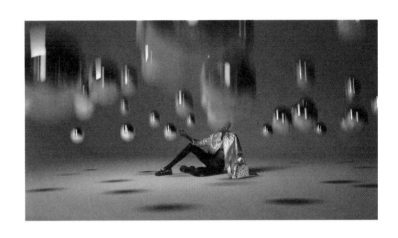

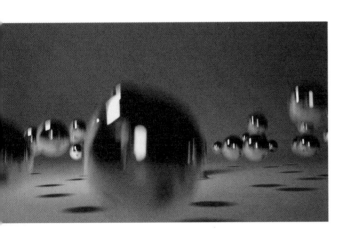
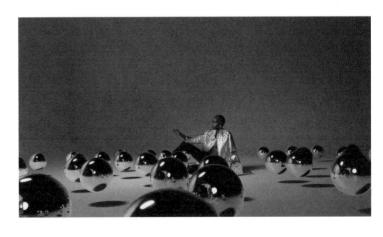

Video directed by Ferdinando Verderi

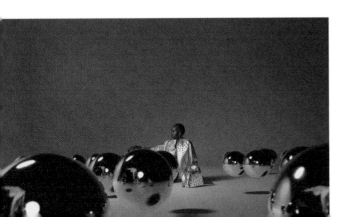
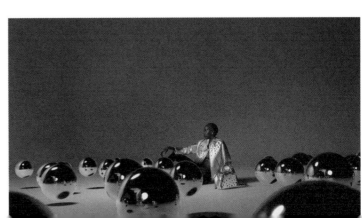

Anok Yai for Louis Vuitton

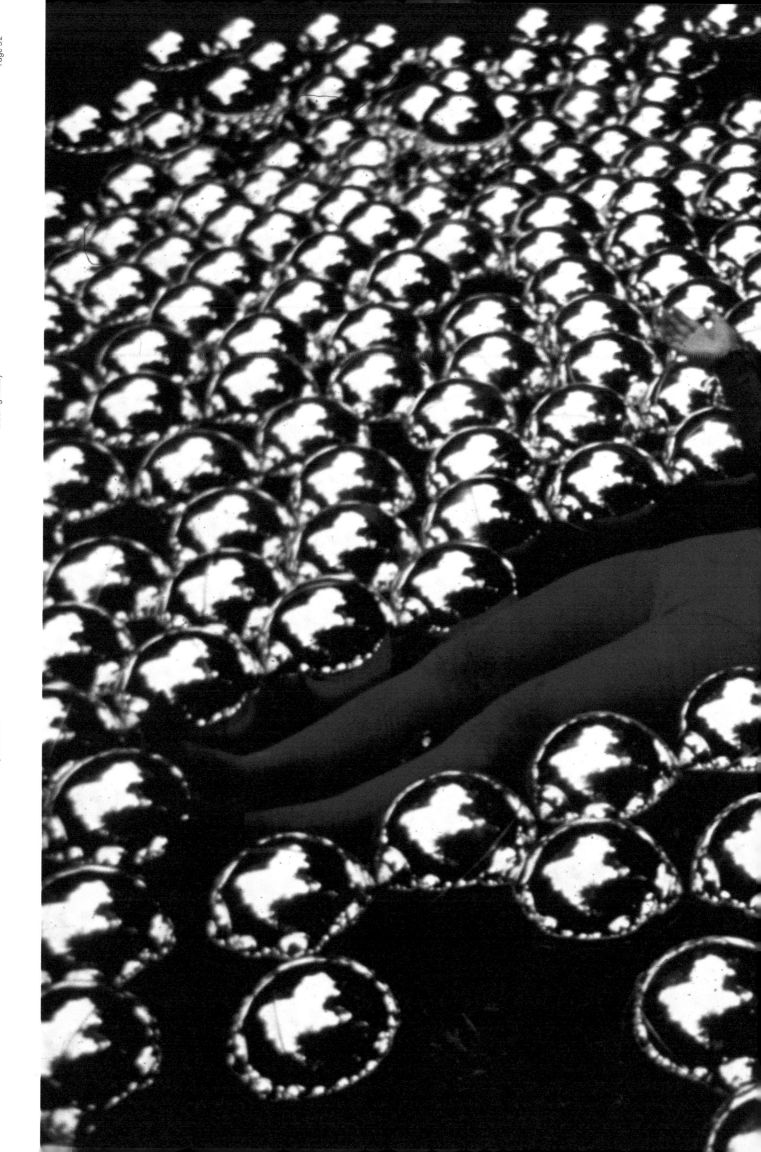

33rd Venice Biennale, 1966

The artist in her Narcissus Garden

Yayoi Kusama

Creating Infinity

Yayoi Kusama

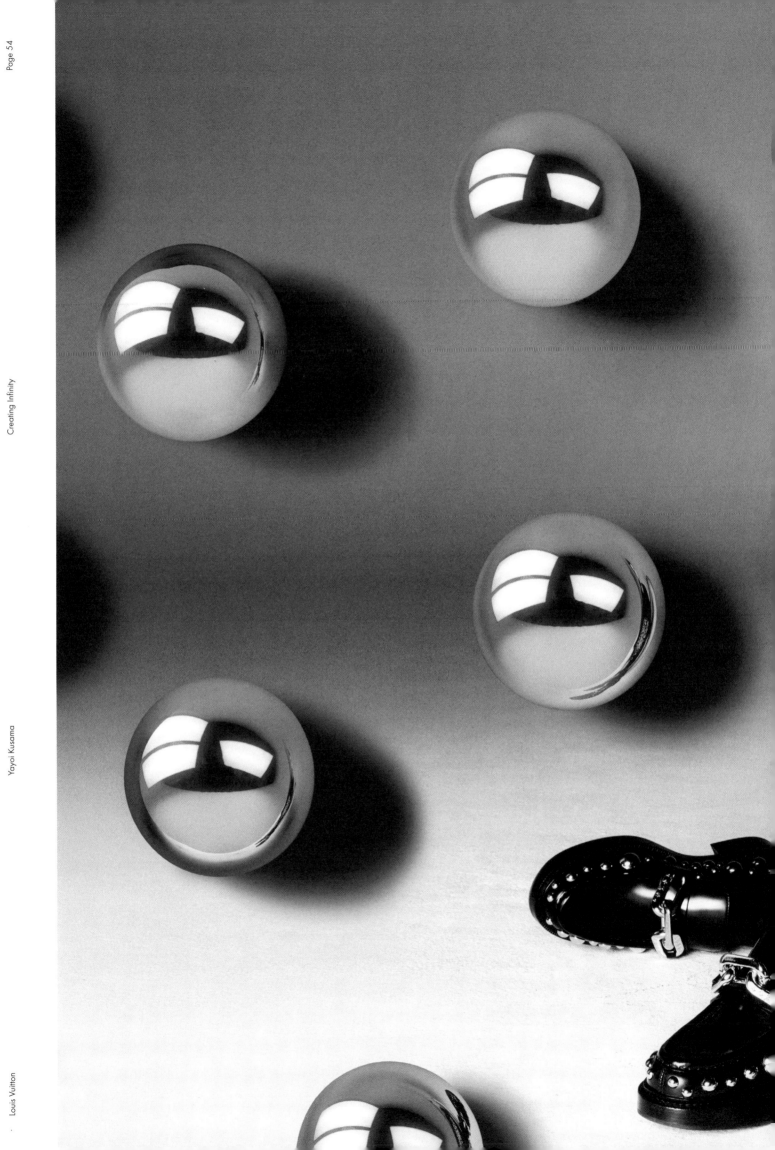

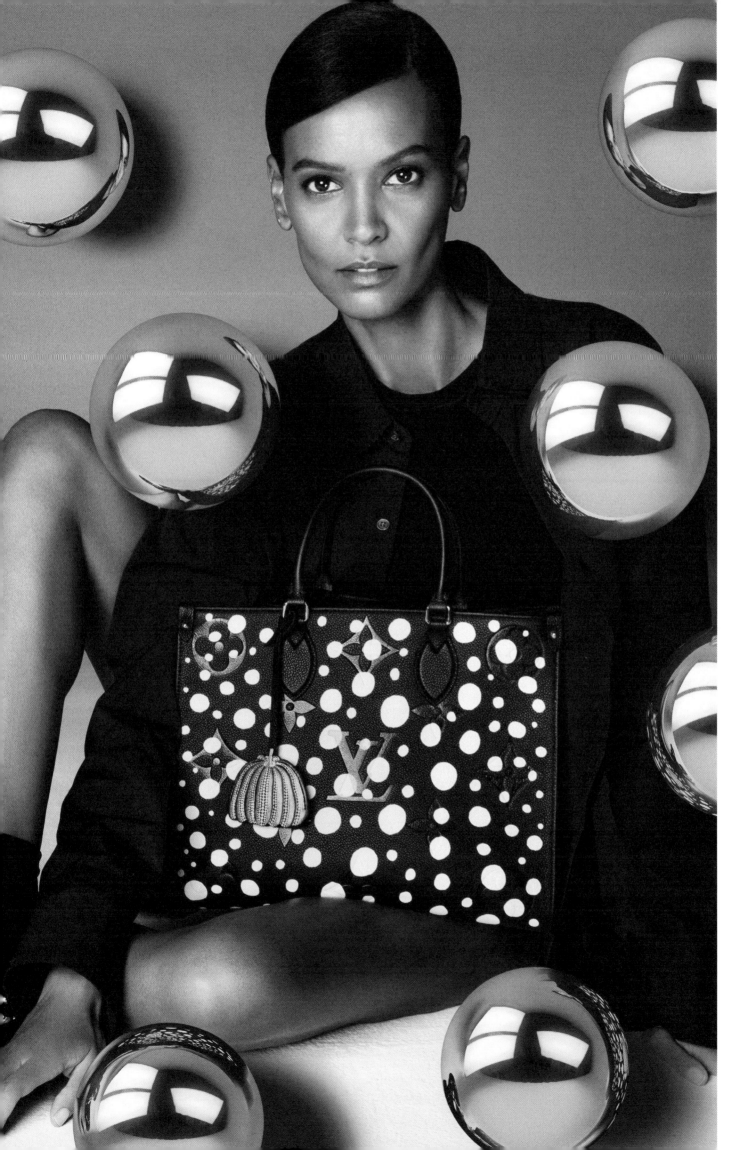

2023

Photograph by Steven Meisel

Liya Kebede for Louis Vuitton

2023

Metal with silver-color finish

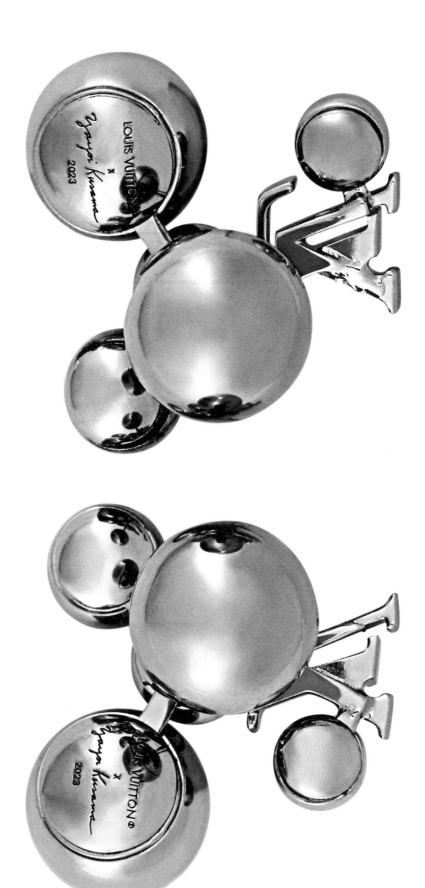

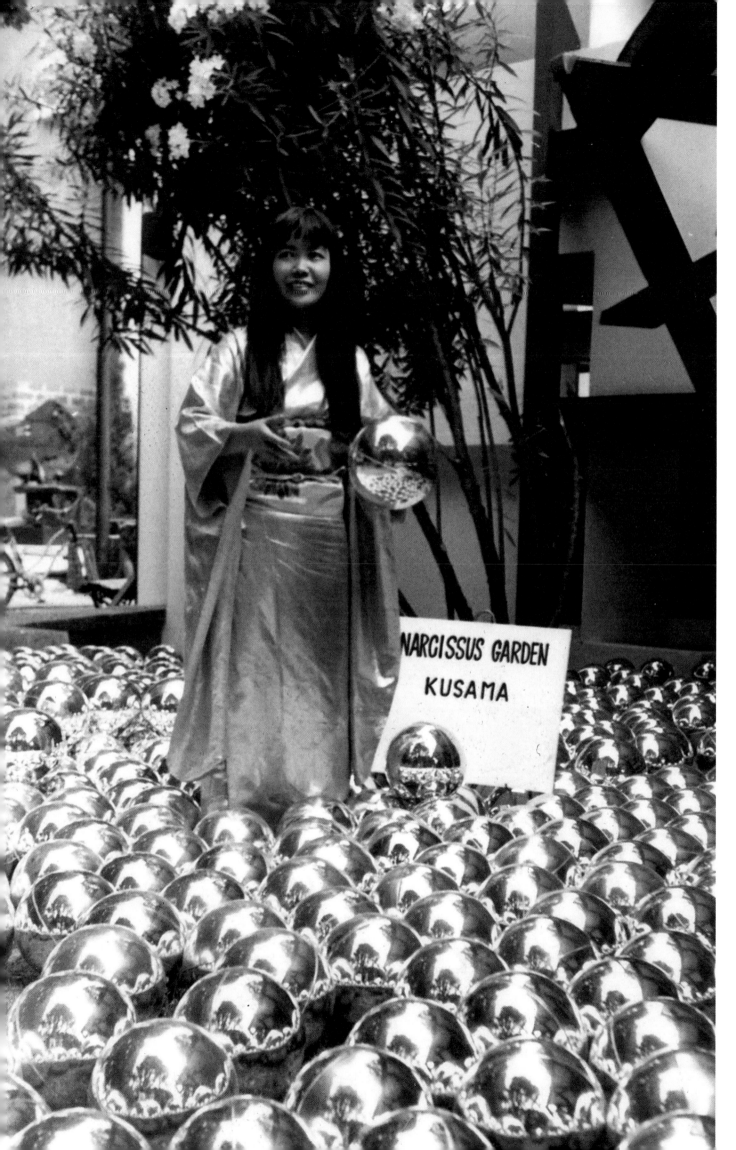

33rd Venice Biennale, 1966

The artist in her Narcissus Garden

Yayoi Kusama

NARCISSUS GARDEN
KUSAMA

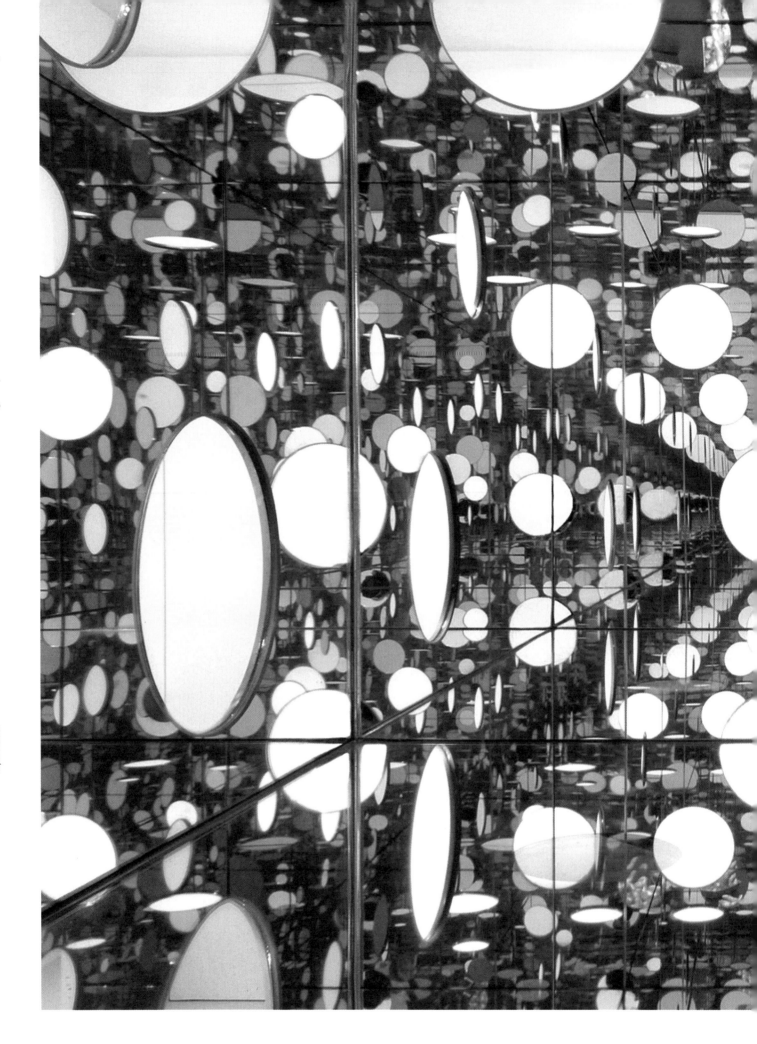

2005

Mirror, glass

The Passing Winter

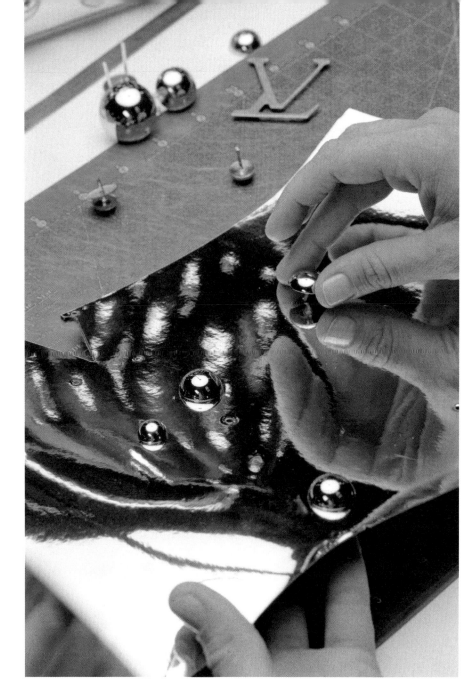

Photograph by Christophe Coënon

2023

Benesse Art Site, Naoshima, 2022

Installation view

Garden, 1966/2022

Metallic lamb leather

Louis Vuitton, Metal Dots dress

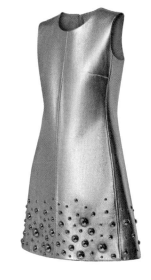
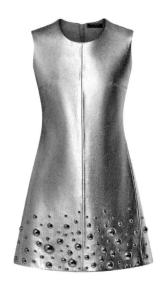
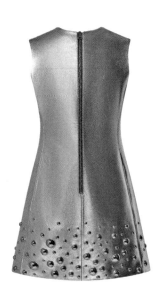
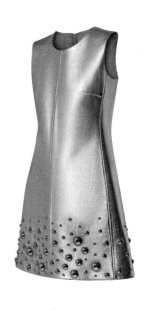
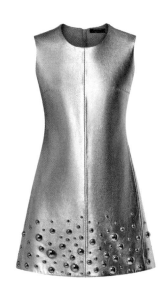

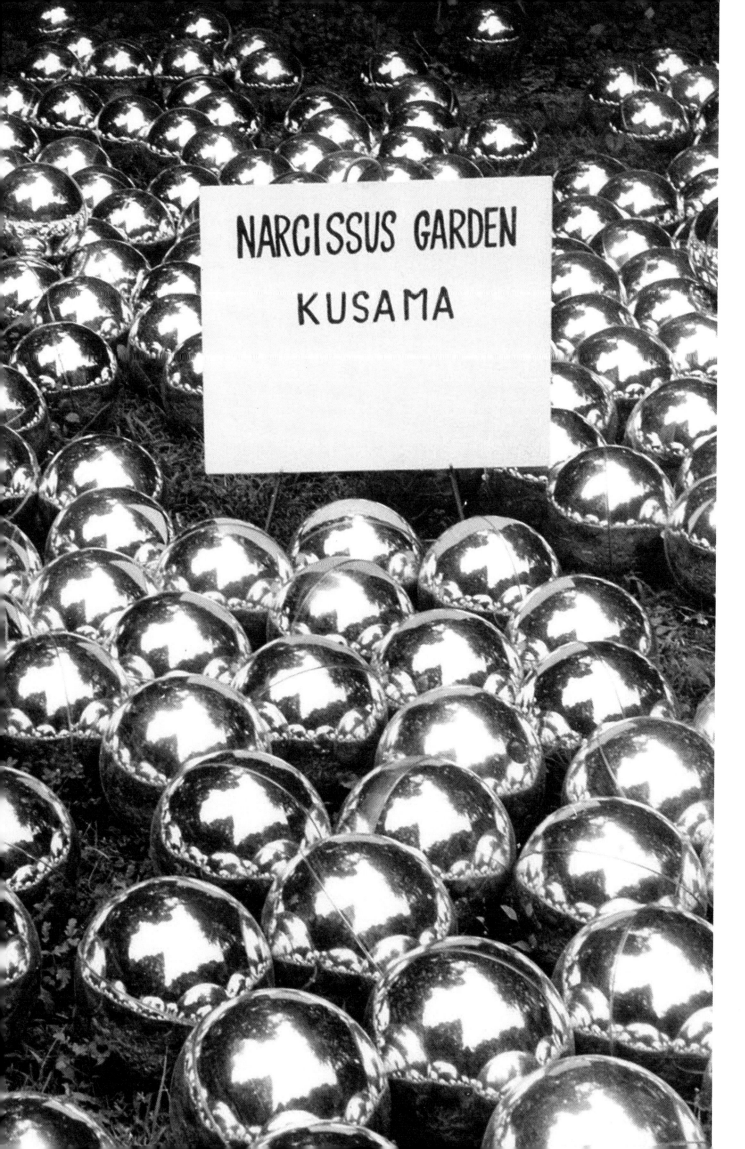

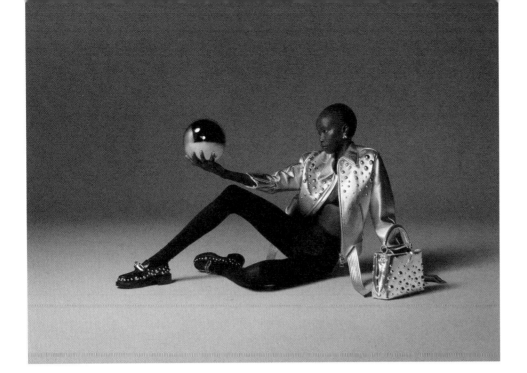

Video directed by Ferdinando Verderi

2023

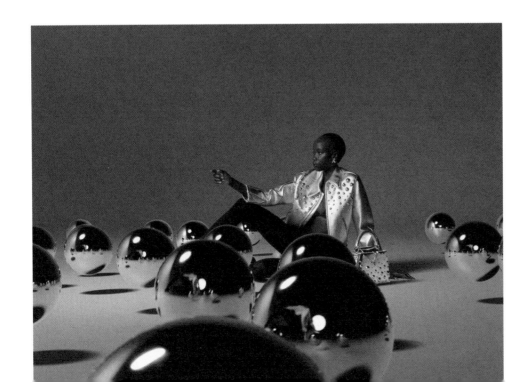

Anok Yai for Louis Vuitton

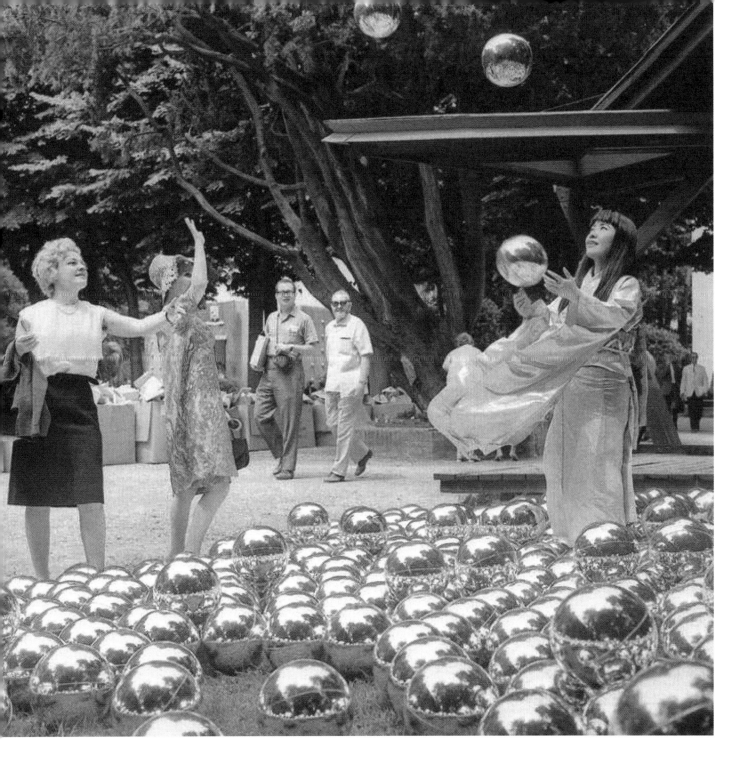

33rd Venice Biennale. 1966

The artist in her Narcissus Garden

Yayoi Kusama

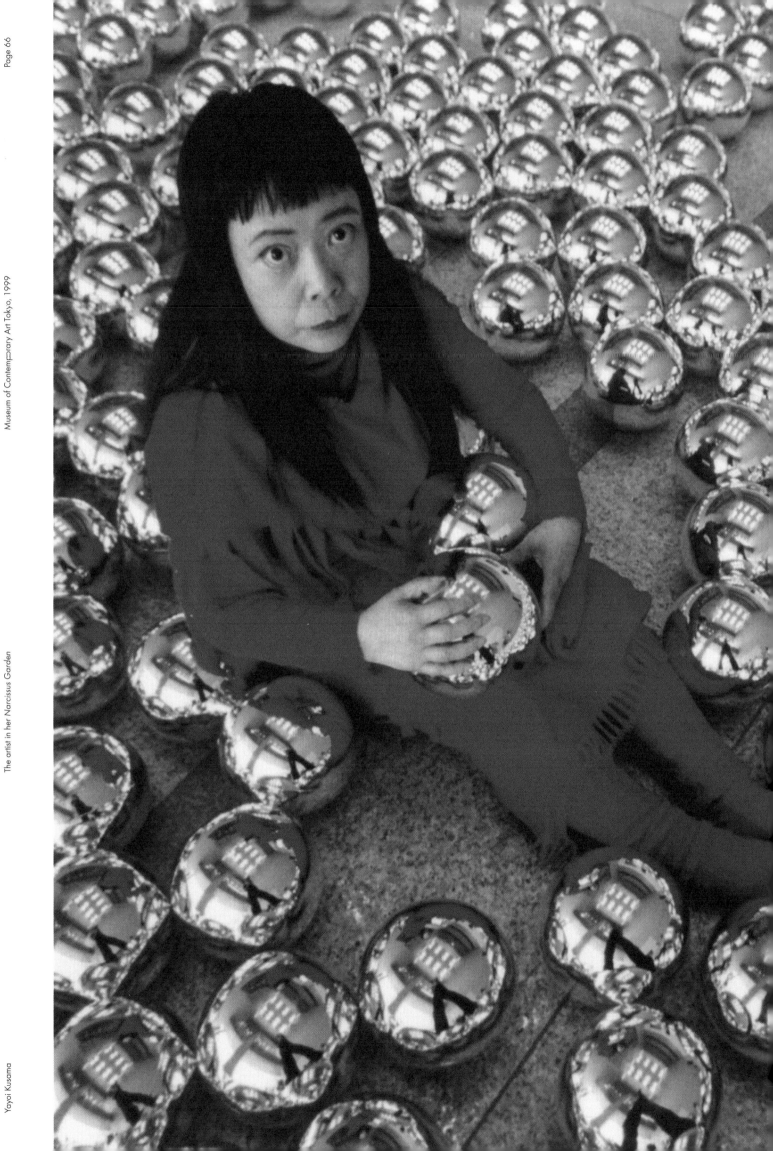

Museum of Contemporary Art Tokyo, 1999

The artist in her Narcissus Garden

Yayoi Kusama

2023

2000

Site-specific installation with convex mirrors

Invisible Life

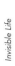

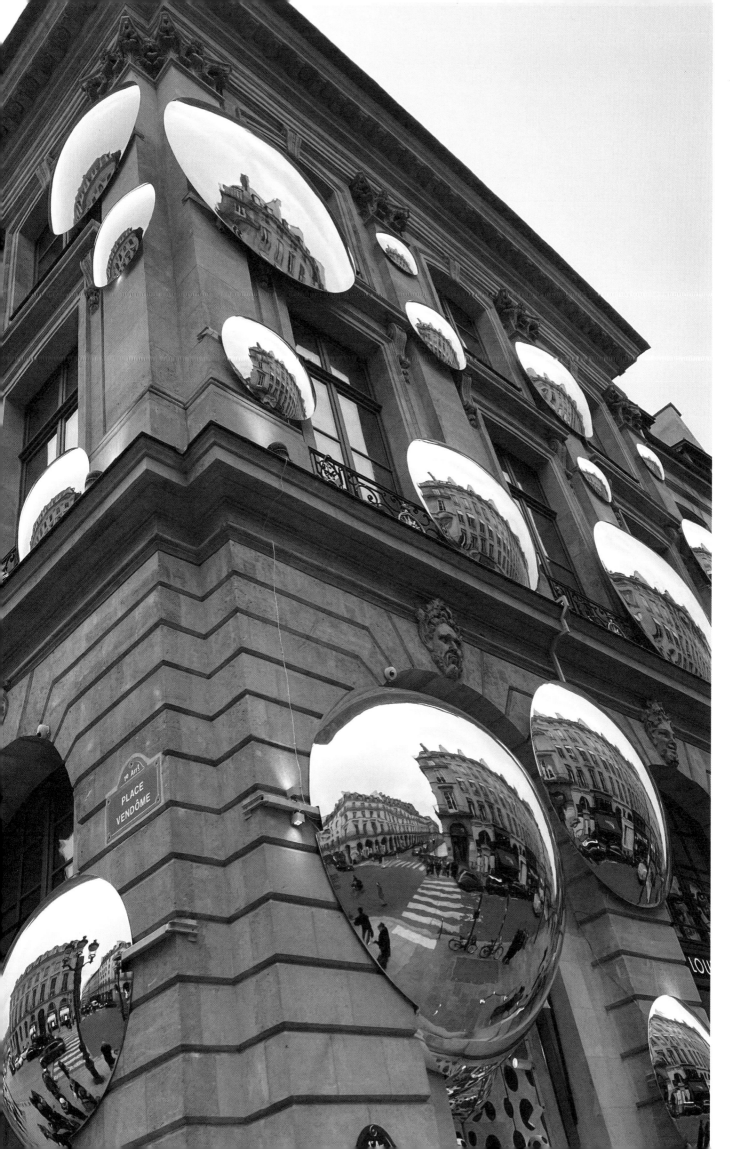

Paris, 2023

Louis Vuitton Place Vendôme store

Louis Vuitton, Metal Dots installation

2006

Stainless steel balls, wire

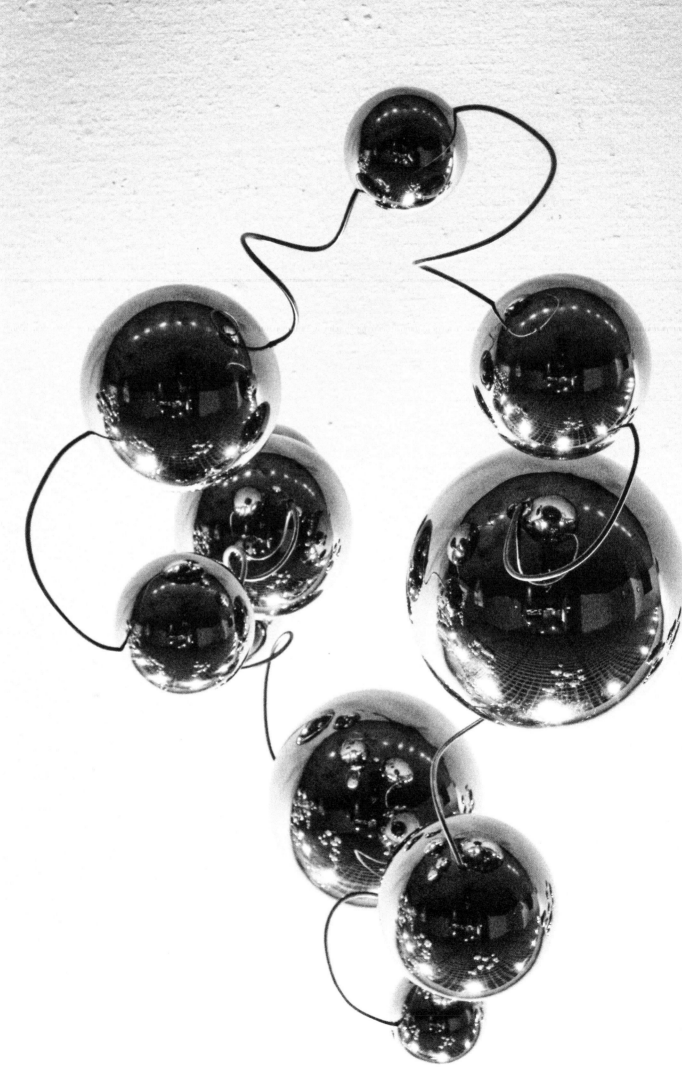

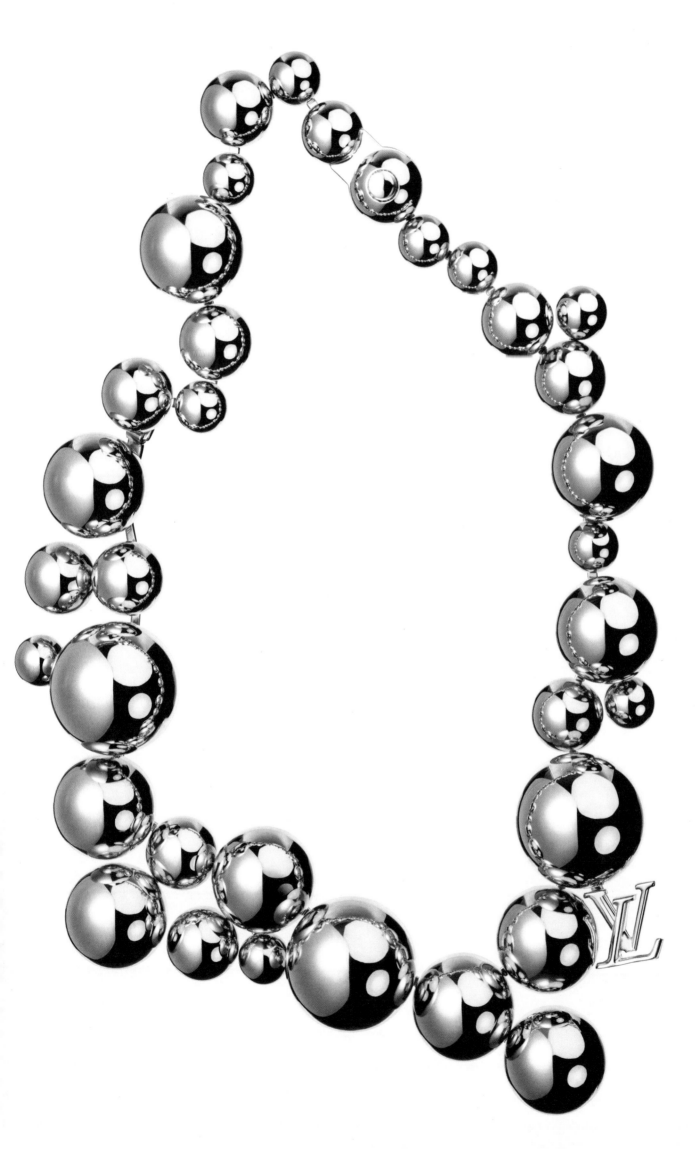

2023

Photograph by Bobby Doherty

Louis Vuitton, Metal Dots necklace

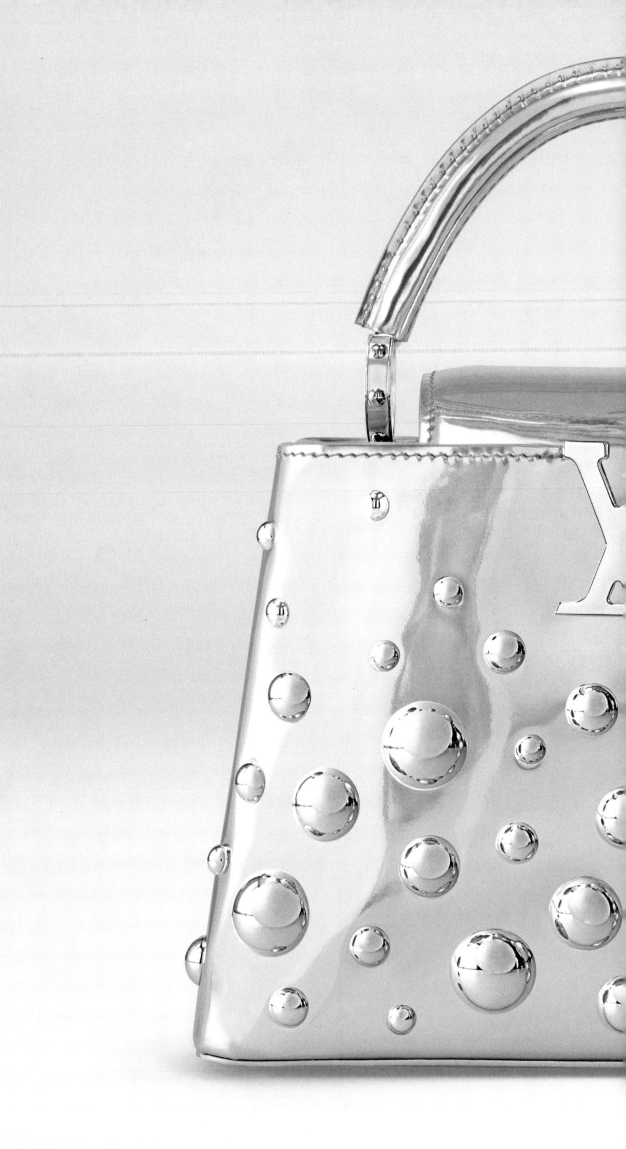

2023

Mirrored silver cowhide leather with 3D silver-finish demi-spheres

Louis Vuitton, Metal Dots Capucines bag

Page 73

2002

Stainless steel balls, nylon thread, mirrors

Rain in Early Spring (interior view of peep-in mirror box)

PUMPKINS

During her early artistic training, Kusama dedicated a whole month to depicting a single pumpkin, an experience she compared to enlightenment. "What appealed to me most," Kusama has said of her affinity with the plant, which she has also likened to a reflection of her own soul—"was the pumpkin's generous unpretentiousness. That and its solid spiritual balance." Although references to pumpkins appear throughout her oeuvre, it wasn't until the early 1980s that pumpkins would find staying power within Kusama's visual lexicon, serving as a grounding force in her dynamic practice. When Kusama returned to making *Infinity Mirror Rooms*, one of her 1960s innovations, in the early 1990s, her first one was filled with pumpkins. Just a few years later, for her first permanent outdoor sculpture, Kusama installed a pumpkin at the end of an old pier in Japan. Yellow with black spots, the large winter squash sits peacefully to this day at the water's edge as if taking in the horizon. Reflecting, in the artist's own words, the "vast and boundless … provisions of nature," Kusama's pumpkins come in a variety of forms and colors, sometimes lit from within like lanterns, and other times covered in iridescent mosaics. With every other rib removed, a Kusama pumpkin might double as an octopus, with its spots evoking tentacle suckers, while gourds shaped like pumpkins in waist-cinching belts are given melancholic titles, as in 2016's *The Sun Has Gone Down, I Am Scared as Much as Being Alone.* On Kusama's own head, in the robot replica of the artist made in collaboration with Louis Vuitton, she wears a red pumpkin in the shape of her iconic bob wig. *Fiona Alison Duncan*

Louis Vuitton, Pumpkin on Monogram (detail)

Photograph by Christophe Coënon

Yayoi Kusama

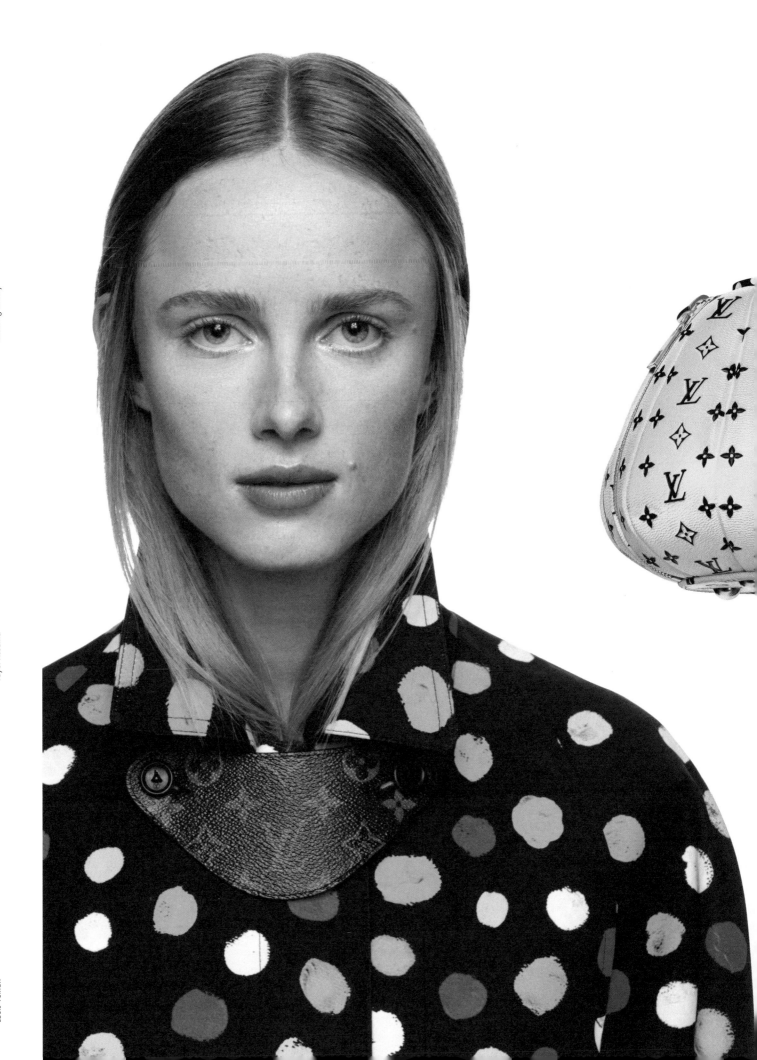

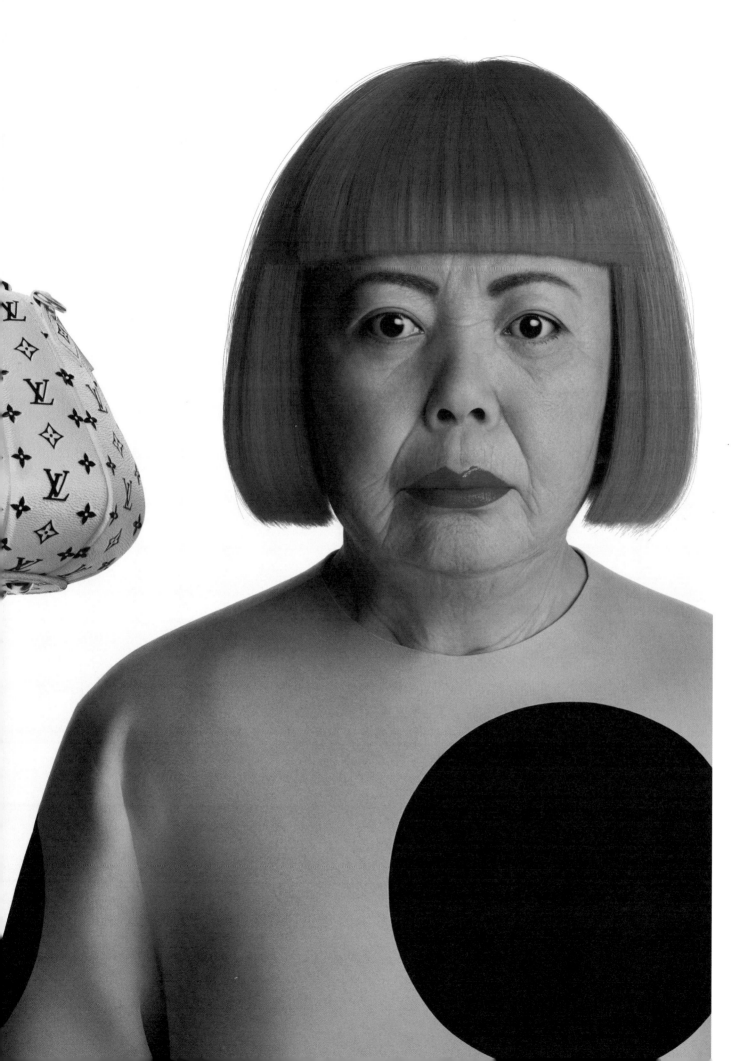

2022

Photograph by Oliver Hadlee Pearch

Rianne Van Rompaey for Louis Vuitton and Yayoi Kusama

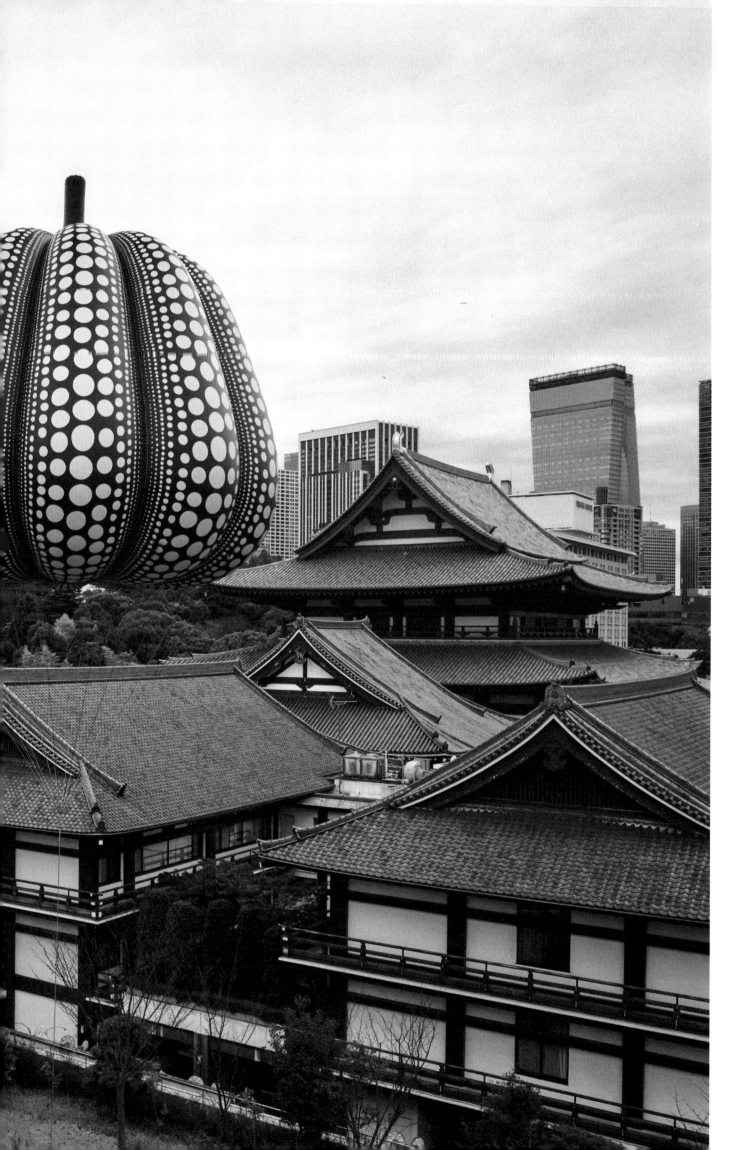

Tokyo, 2022

Photograph by Daici Ano

Louis Vuitton, Pumpkin installation

Creating Infinity

Yayoi Kusama

Louis Vuitton

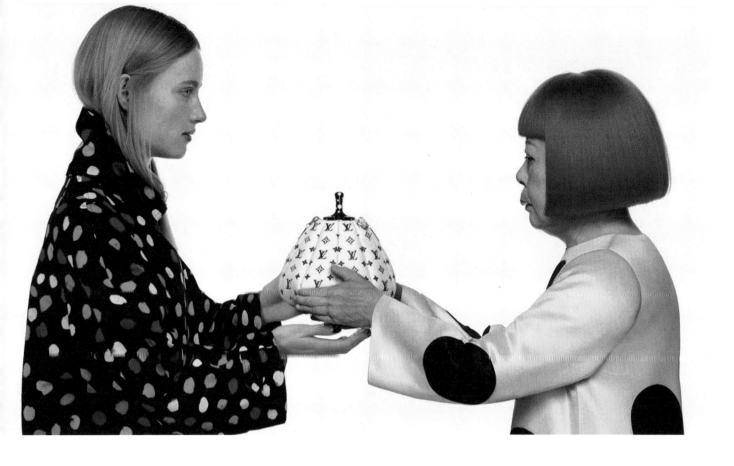

2022

Video directed by Ferdinando Verderi

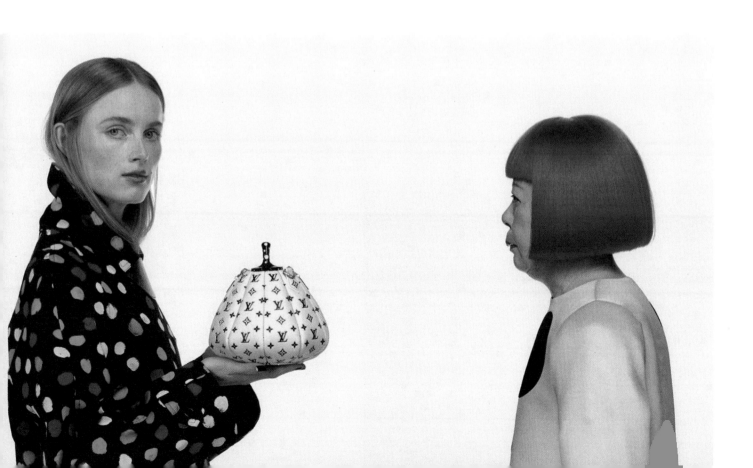

Rianne Van Rompaey for Louis Vuitton and Yayoi Kusama

London, 2023

Photograph by Adrien Dirand

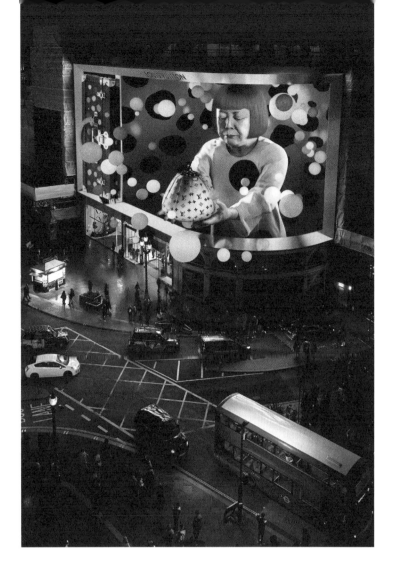

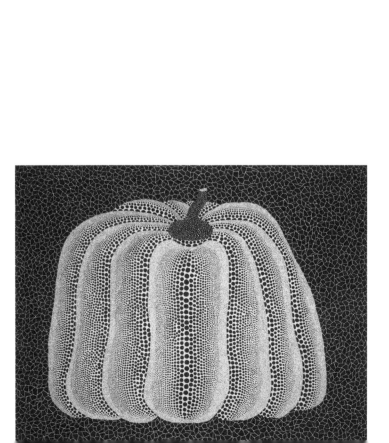

Pumpkin (bottom)

1981

Acrylic on canvas

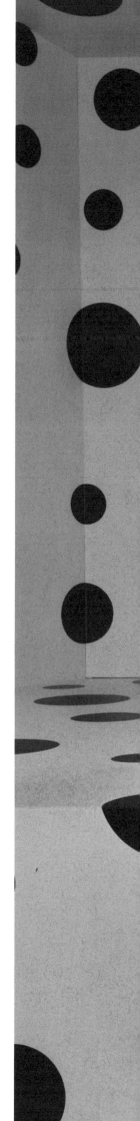

Aichi Triennale, Japan, 2010

The artist with her *Pumpkin*

Yayoi Kusama

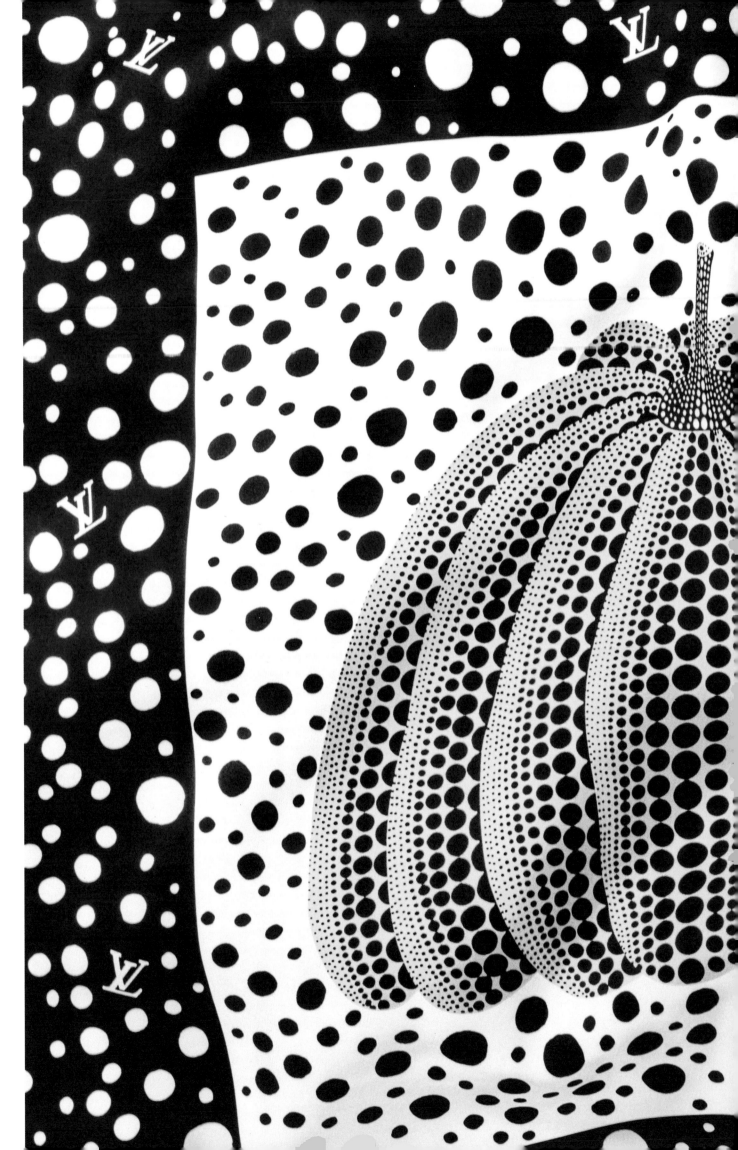

Photograph by Bobby Doherty

2023

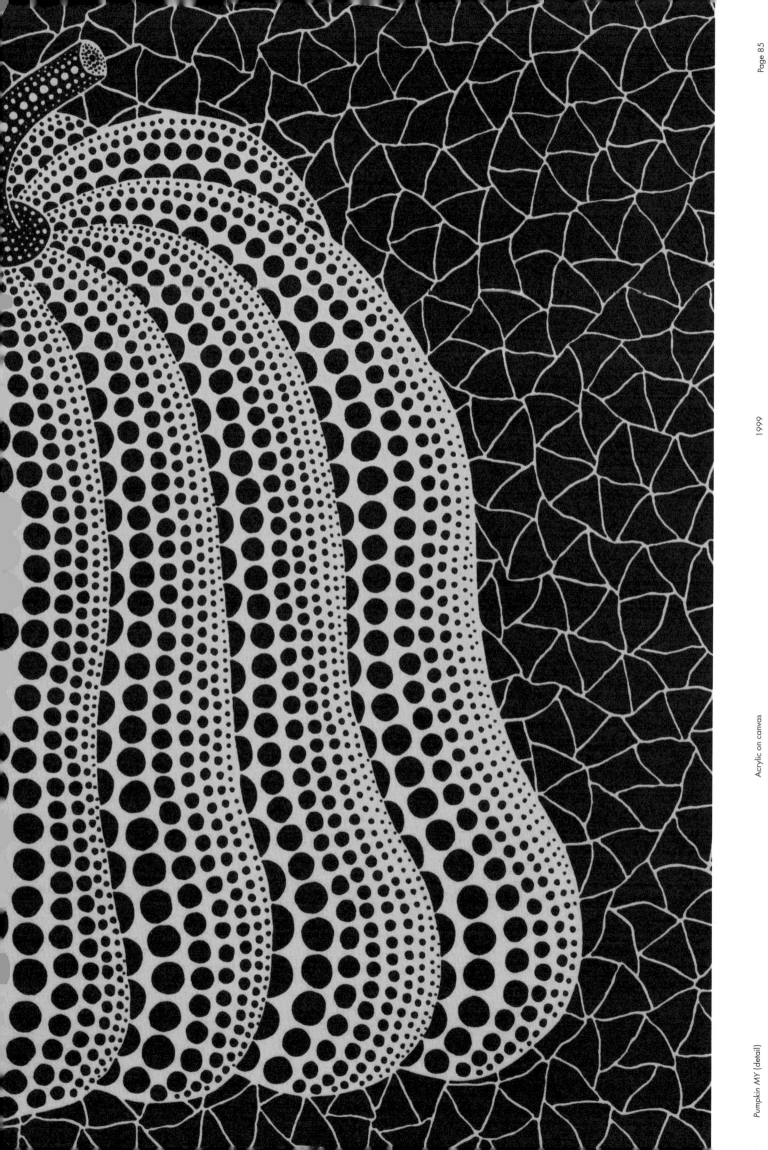

1999

Acrylic on canvas

Pumpkin MY (detail)

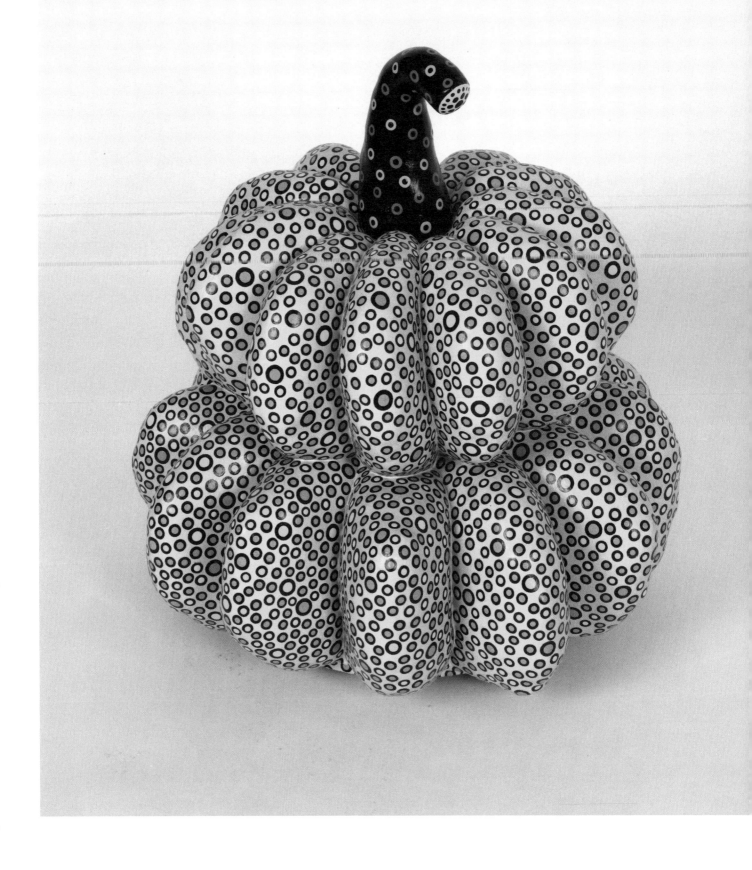

2016

Sewn and stuffed fabric, acrylic, metal

The Sun Has Gone Down, I am Scared as Much as Being Alone

2023

Photograph by Steven Meisel

Zhou Dongyu for Louis Vuitton

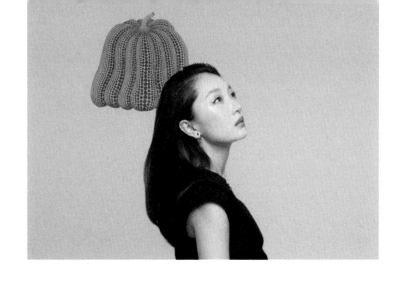

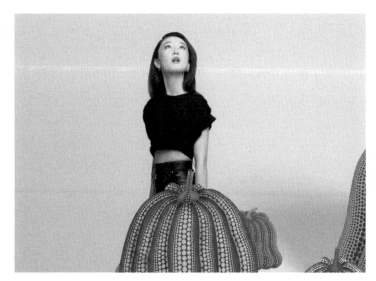

2023

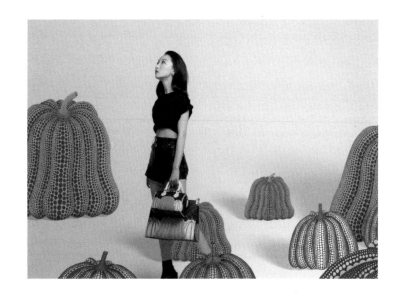

Video directed by Ferdinando Verderi

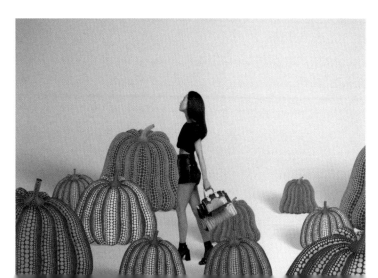

Zhou Dongyu for Louis Vuitton

Creating Infinity

Yayoi Kusama

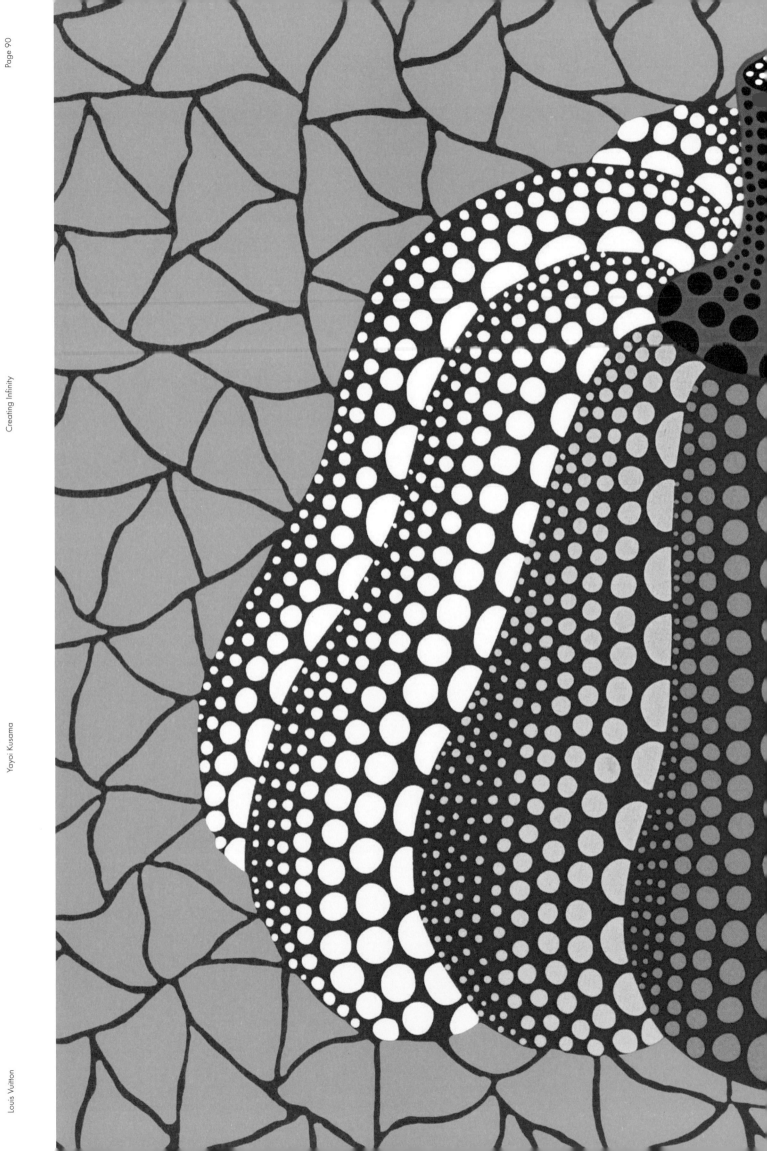

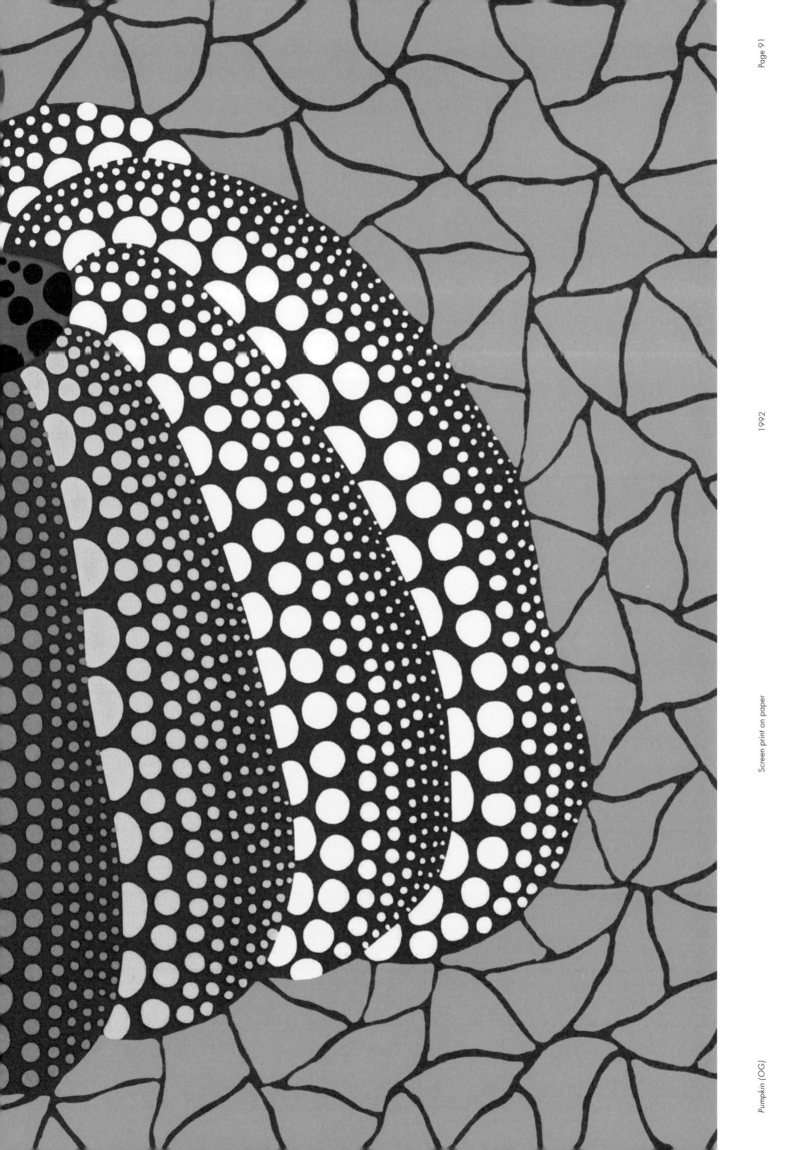

1992

Screen print on paper

Pumpkin (OG)

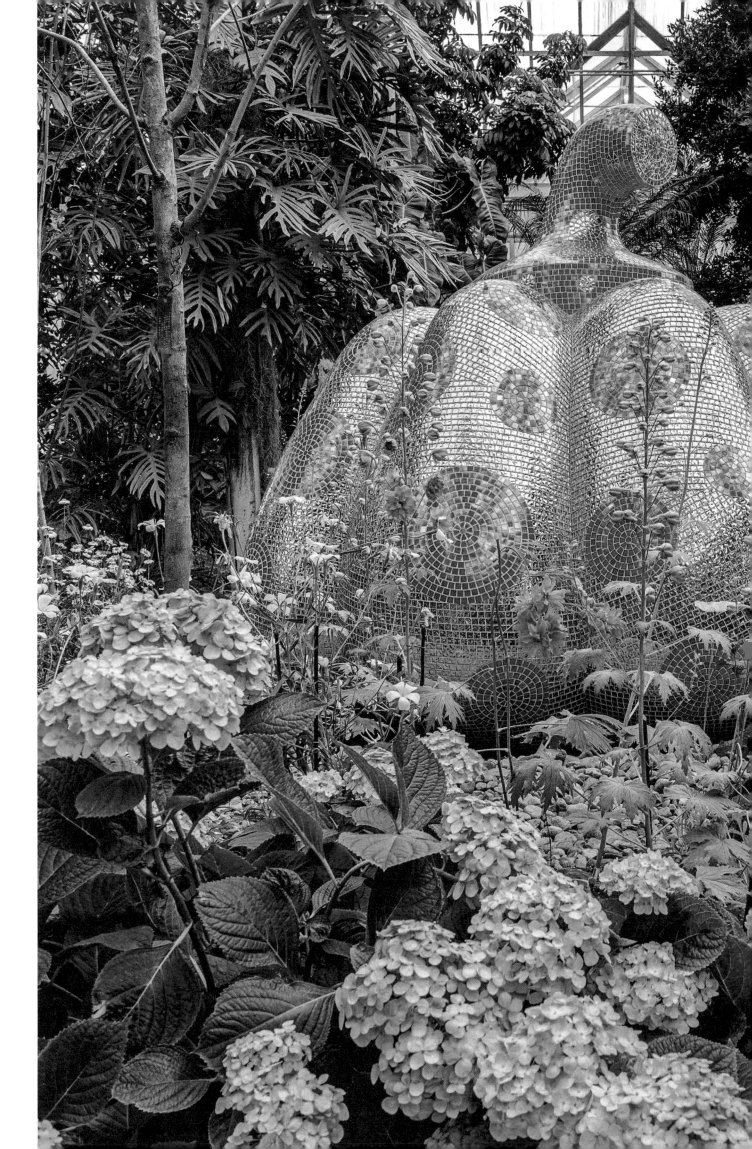

The New York Botanical Garden, 2021

Fiberglass-reinforced plastic, tiles, resin

Starry Pumpkin, 2015

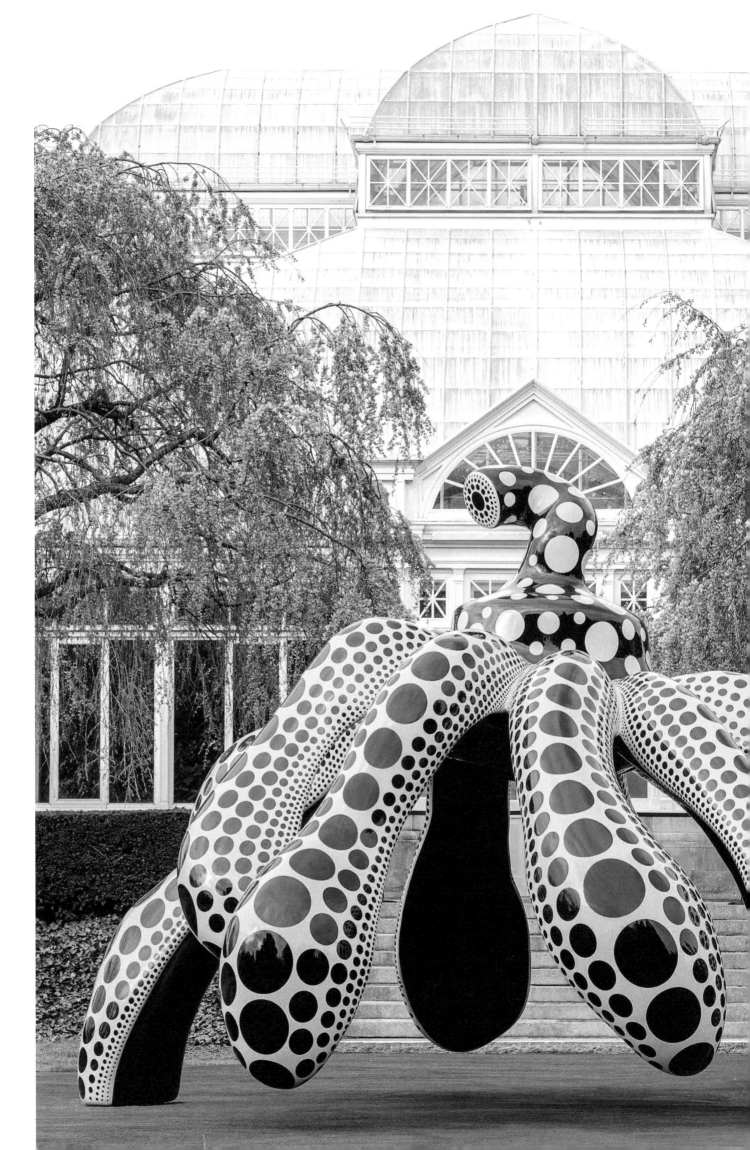

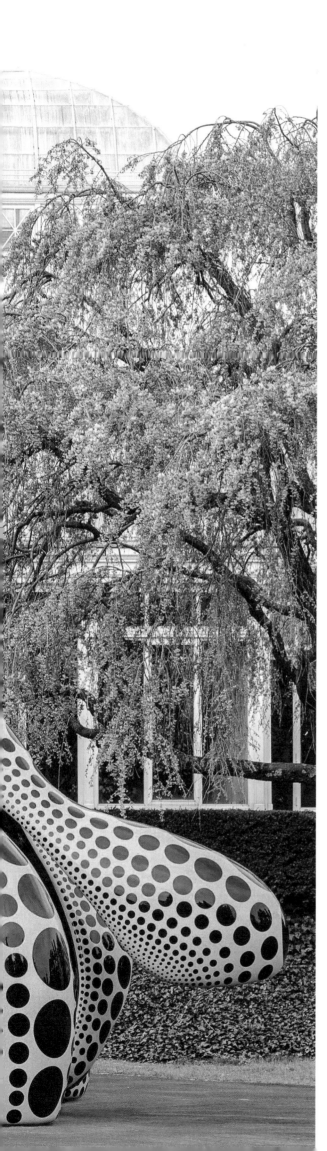

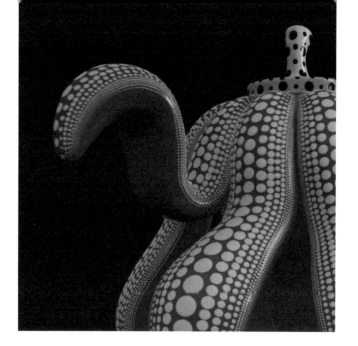

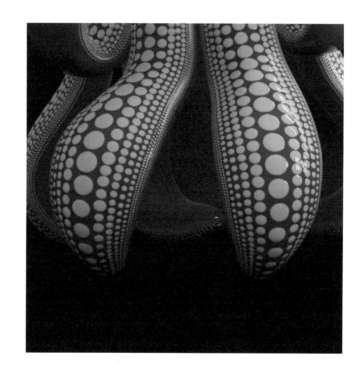

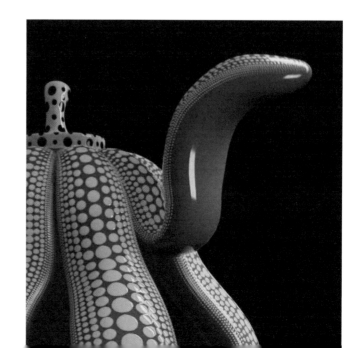

2023

Design by Closer.ltd

Louis Vuitton, Pumpkin 3D rendering

KUSAMA'S SELF-OBLITERATION THROUGH REPETITION (OF POLKA DOTS) LIFTED THE BOUNDARY BETWEEN THE BODY AND ITS SURROUNDINGS – A SIMPLE BUT RADICAL IDEA TO IMPLODE AND BECOME ONE WITH THE ENVIRONMENT. INTERESTINGLY ENOUGH, THESE EXPERIMENTS, ROOTED IN THEORIES OF NON-DUALITY, ALSO RESULTED IN HER UNFETTERED MASS EXPOSURE, IN WHICH SHE AND HER IMAGE BECAME SYNONYMOUS IN EACH OF THOSE POLKA DOTS.

NORA TURATO

2021

Patinated bronze

Pumpkin

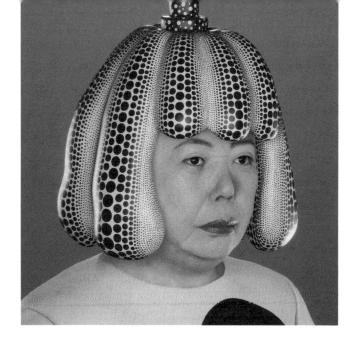

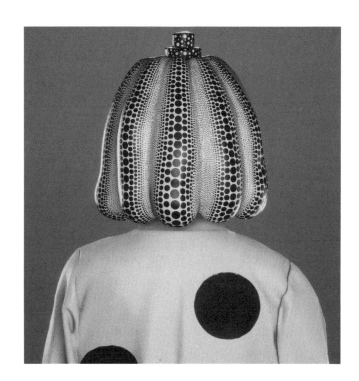

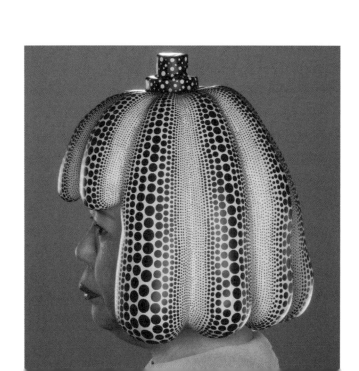

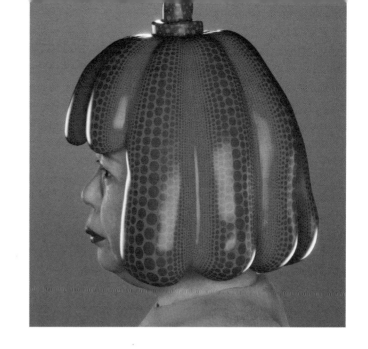

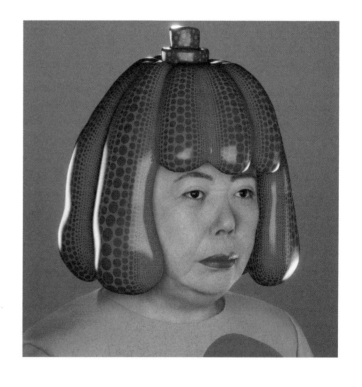

Design by Closer.ltd 2023

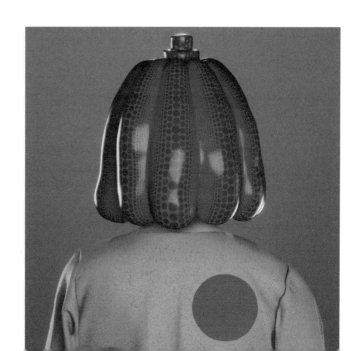

2023

Video directed by Ferdinando Verderi

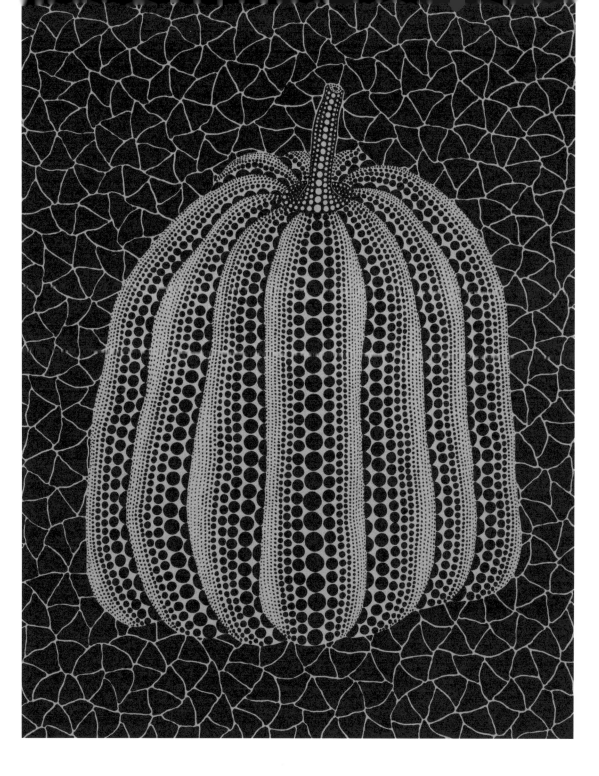

1996

Screen print on paper

Pumpkin (YT)

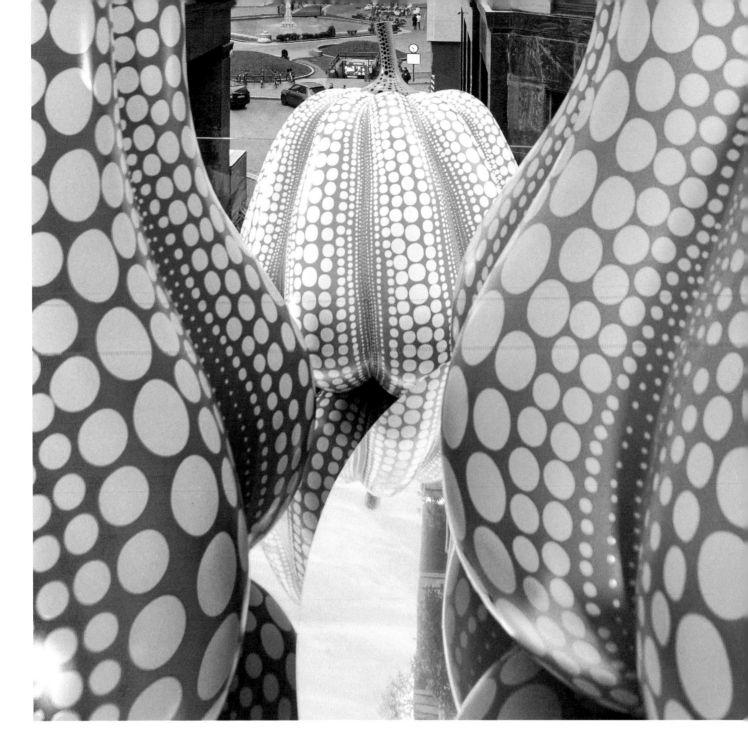

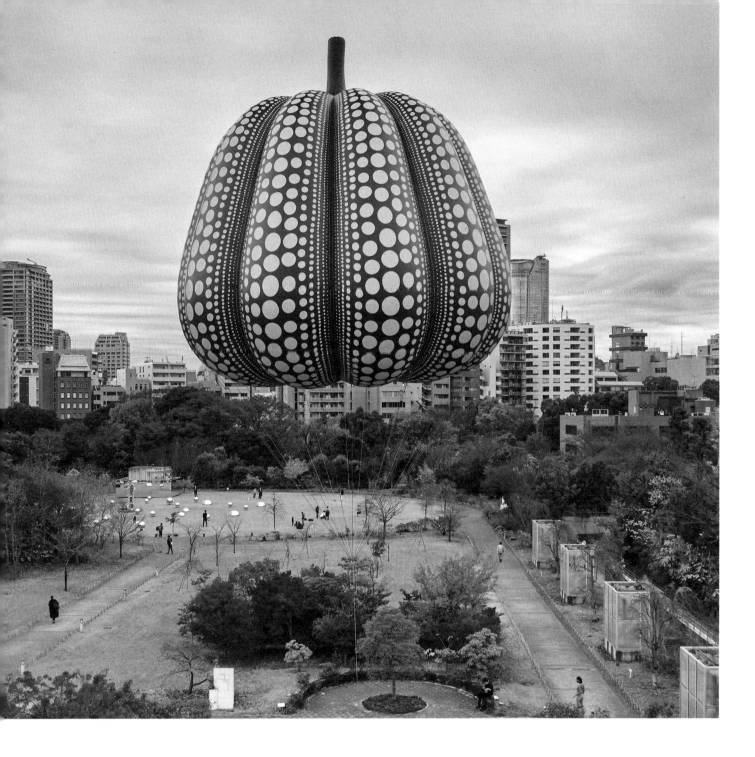

Tokyo, 2022

Photograph by Daici Ano

Louis Vuitton, Pumpkin installation

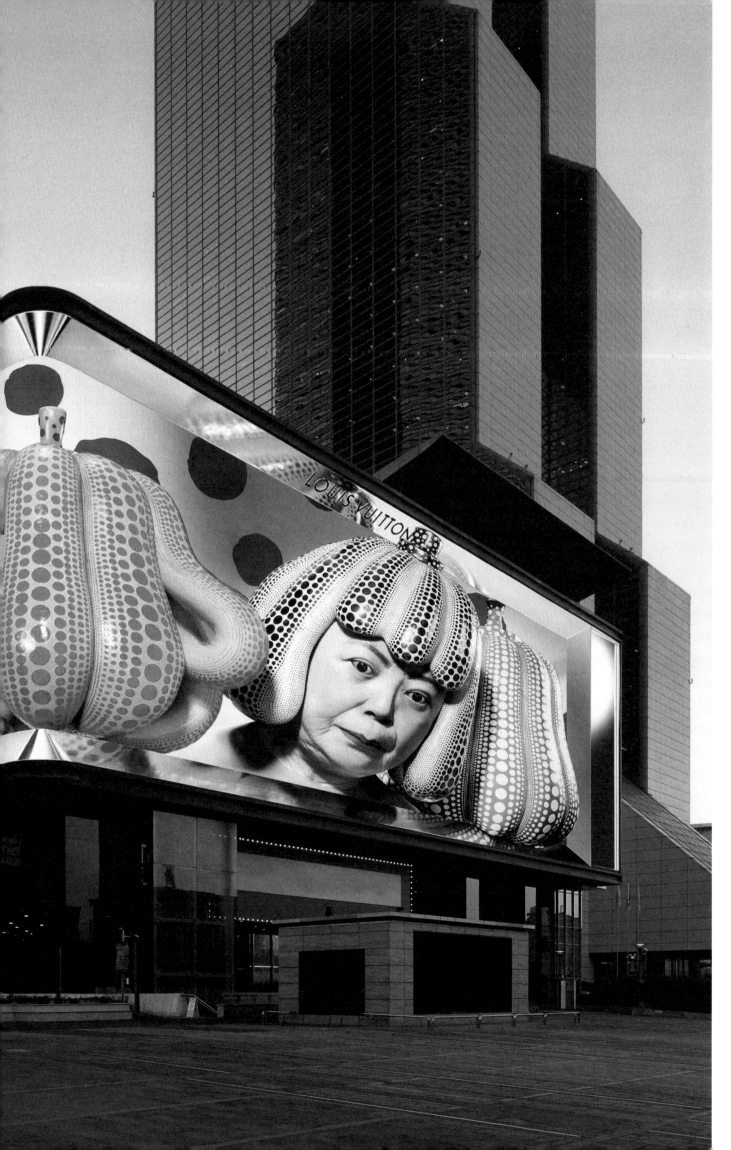

Seoul, 2023

Photograph by Yongjoon Choi

Louis Vuitton, Anamorphic billboard featuring Yayoi Kusama

CREATURES OF HER MIND

Numbering more than nine hundred paintings, Yayoi Kusama's *My Eternal Soul* series, which she started in 2009, synthesizes and expands upon her life's work, incorporating symbols and motifs that she has employed for decades—from her *Infinity Nets* to flowers, fauna, and faces—depicted in bright bold colors, punctuated by black and white. As the curator Philip Larratt-Smith has pointed out, it is as if Kusama is building a "master universal painting" with *My Eternal Soul*, "where each constituent part is a brick in the wall." Indeed, this is how the paintings are often exhibited—in a grid formation, like tiles in a mosaic—although the individual paintings also function in their own right. Among the recurring motifs in the series (and in Kusama's complete oeuvre) are fish and faces. In *My Eternal Soul*, a whole fish might swim within a field of symbols, recalling Kusama's 1970s collages of fish and seashells and her 1980s paintings of polka-dotted fish. Fish are also evoked in the scalelike net pattern she returns to. Faces are even more prevalent, turning up on the surfaces of suns, flowers, starfish, people, and amoebalike matter. Some faces appear to cry as a single line of dots streams from their eyes. Mouths may be agape, puckered, or smiling in a single curved line as in a cartoon. Faces also appear in profile, represented by a simple squiggly shape that recalls musical notes. The presence of faces may seem novel to this series, since Kusama's earlier practice tended more toward abstraction. However, precursors do exist, from Kusama's 1950 *Self-Portrait* depicting a face in a blood-red sunflower, to her *Accumulation of Face No. 2* collages from the 1960s made of magazine cutouts, to (of course) her early mirror room Kusama's *Peep Show or Endless Love Show* (1966), which could only be viewed by looking through a head-sized cutout and being confronted with dozens of reflections of one's own disembodied face.
Fiona Alison Duncan

Louis Vuitton, Faces silk square (detail) Photograph by Bobby Doherty 2023

Yayoi Kusama

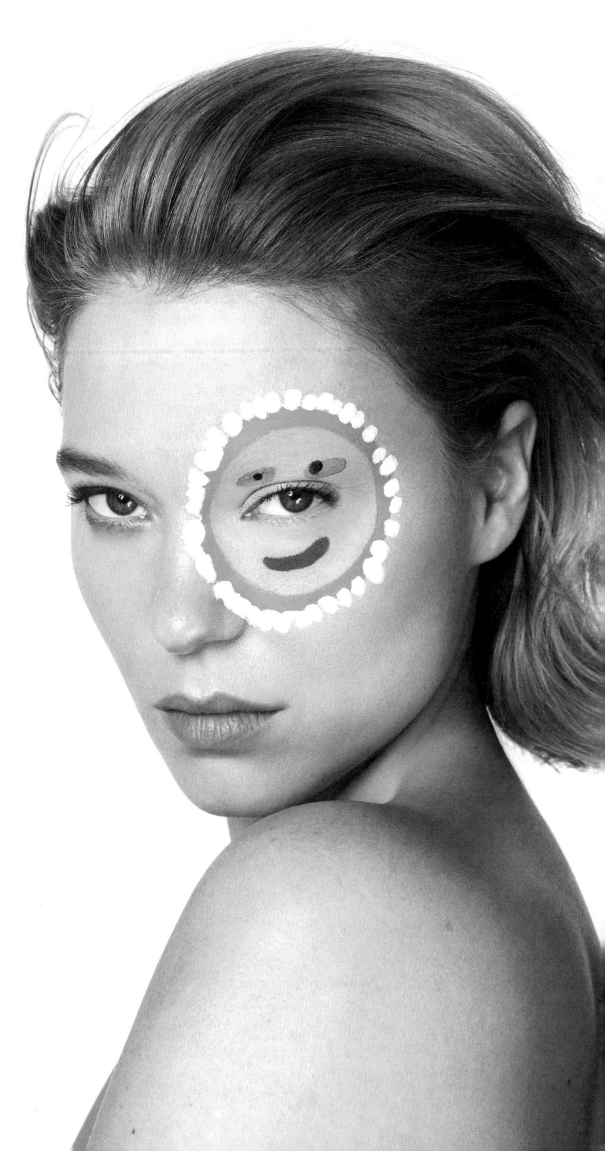

Louis Vuitton

2023

Photograph by Steven Meisel

Léa Seydoux for Louis Vuitton

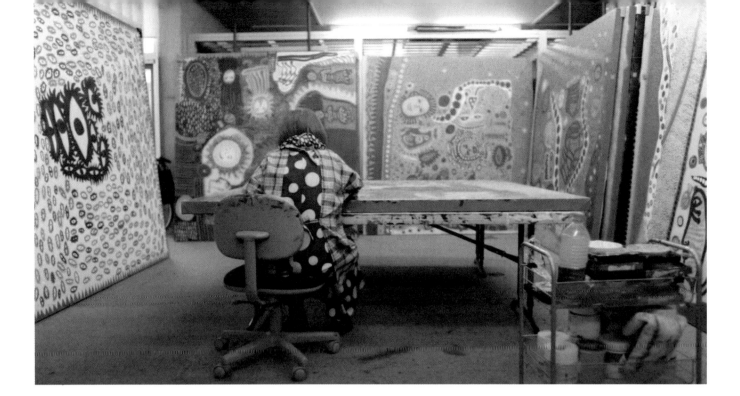

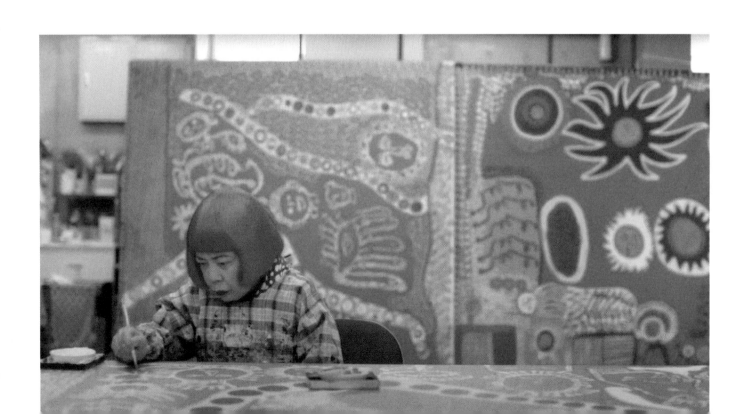

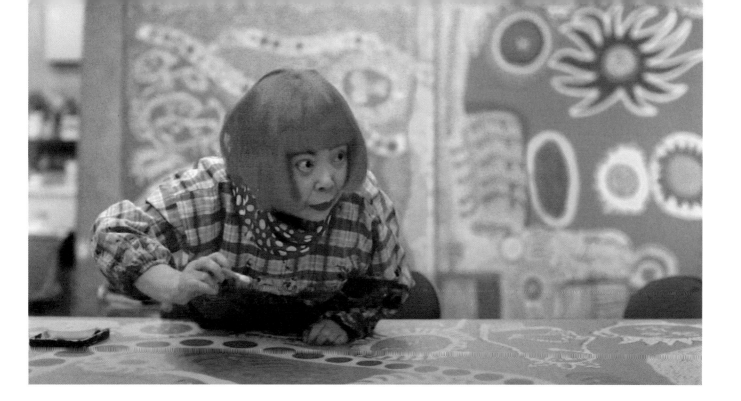

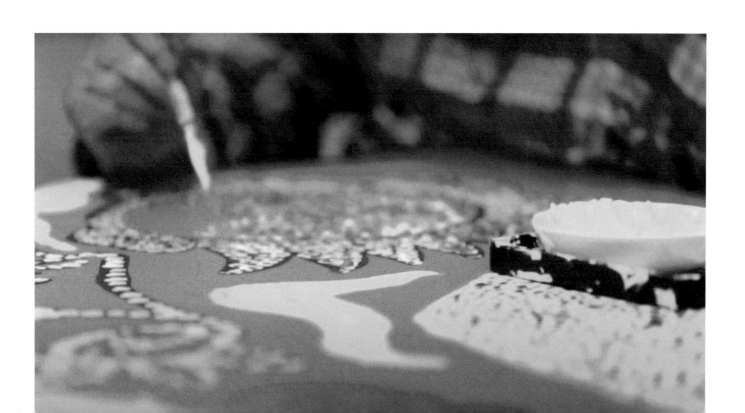

Yayoi Kusama The artist painting *LIVING IN YOUTH* in her studio Tokyo, 2013

London, 2023

Photograph by Adrien Dirand

Louis Vuitton, Installation at the Louis Vuitton New Bond Street store

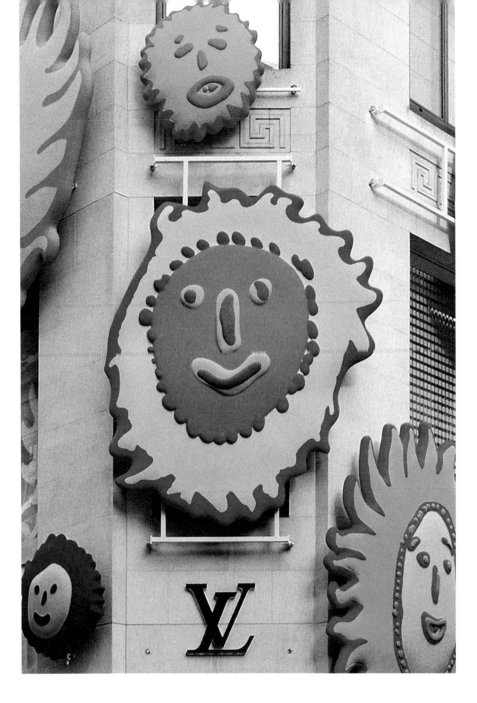

2013

Acrylic on canvas

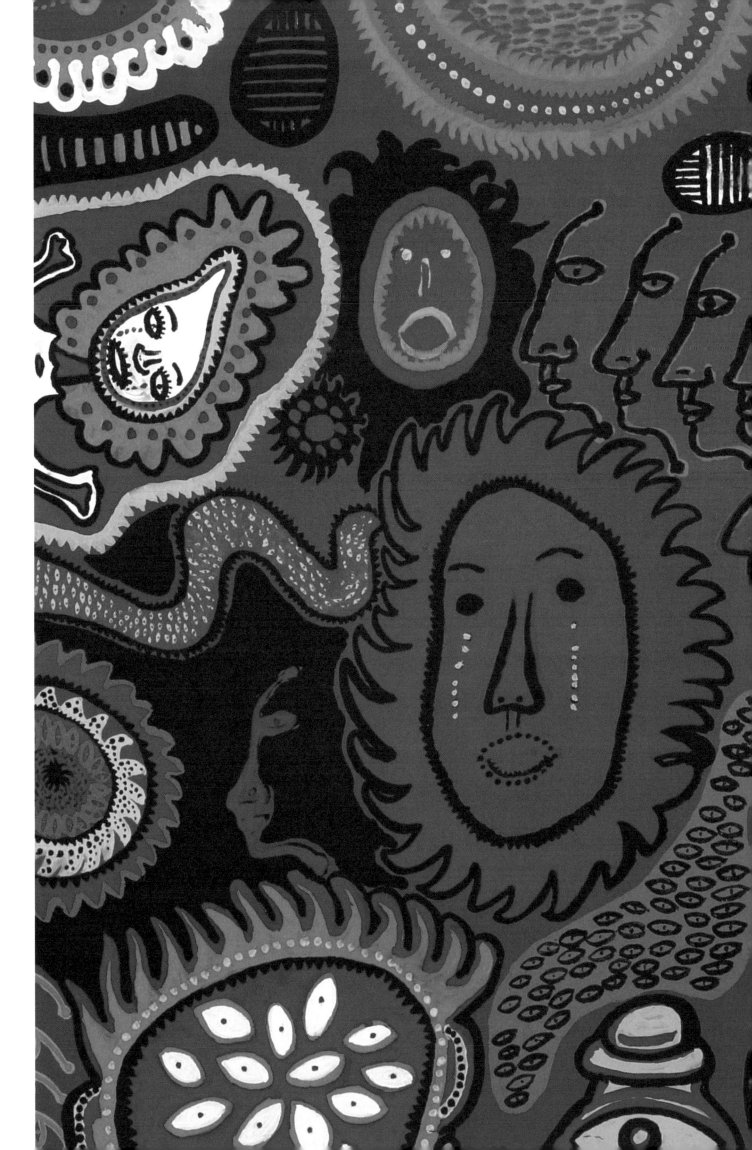

Creating Infinity

Yayoi Kusama

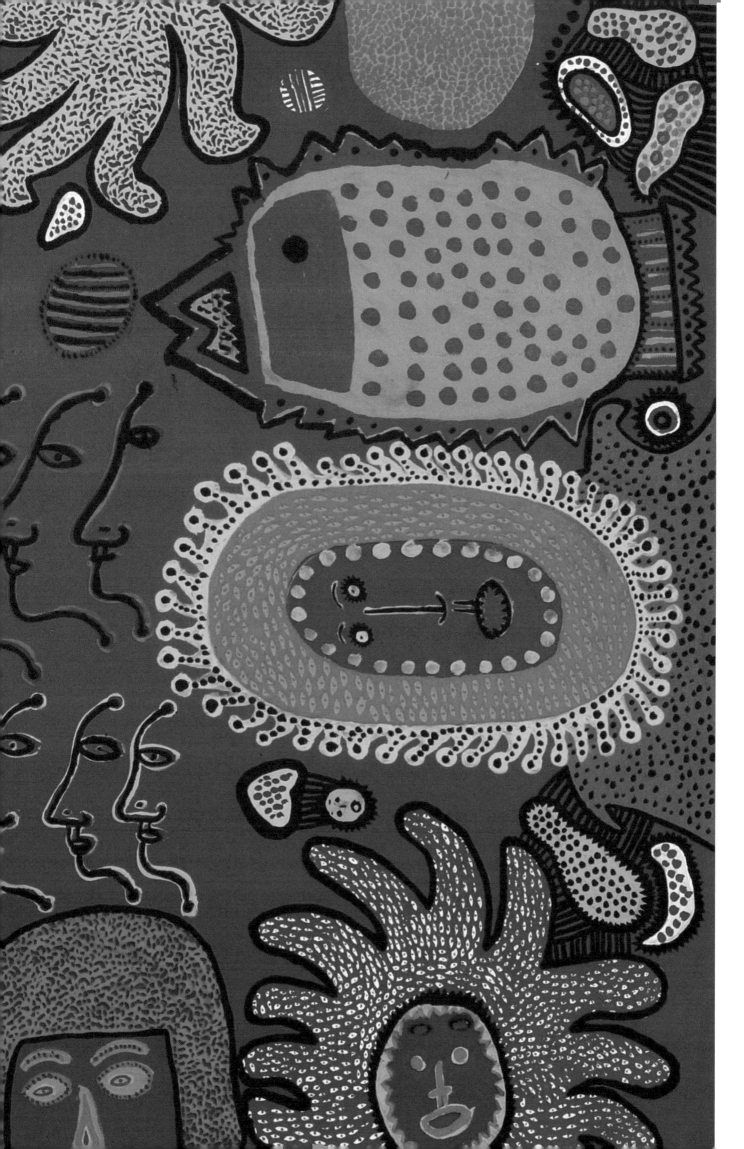

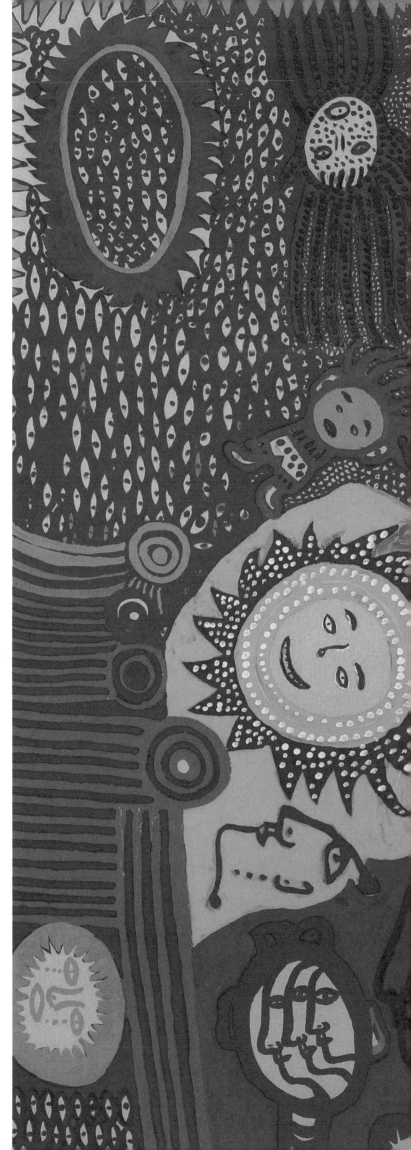

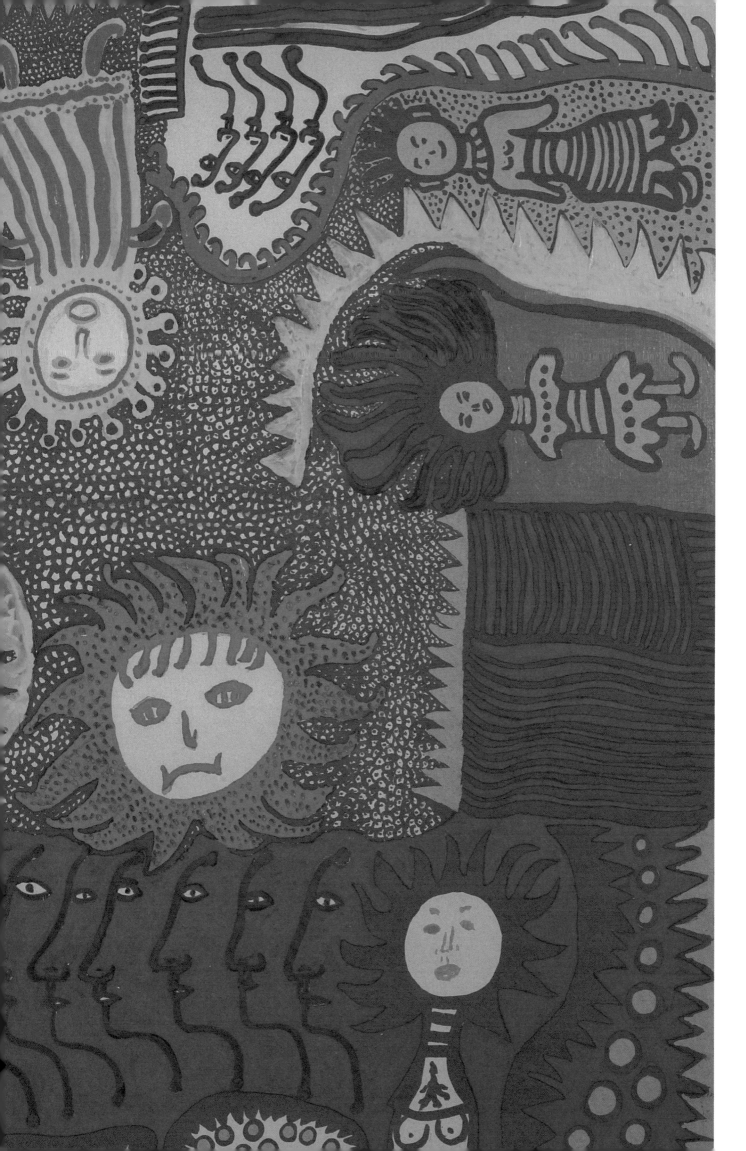

2013

Acrylic on canvas

Creating Infinity

Yayoi Kusama

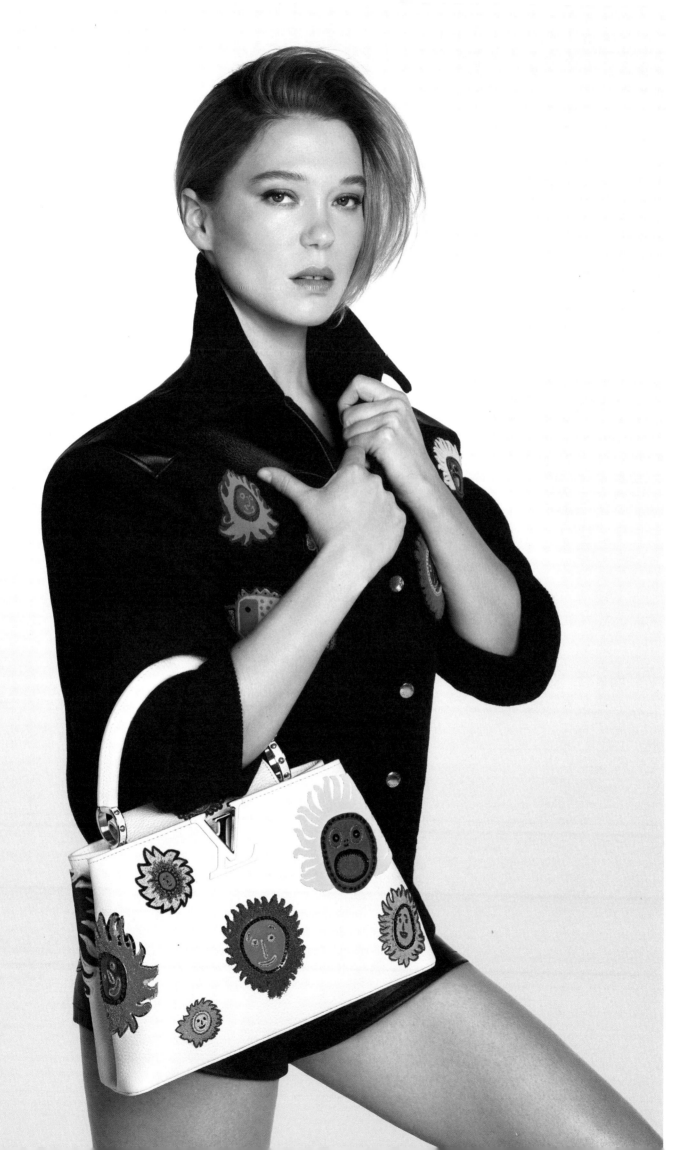

2023

Photograph by Steven Meisel

Léa Seydoux for Louis Vuitton

Photograph by Steven Meisel

2023

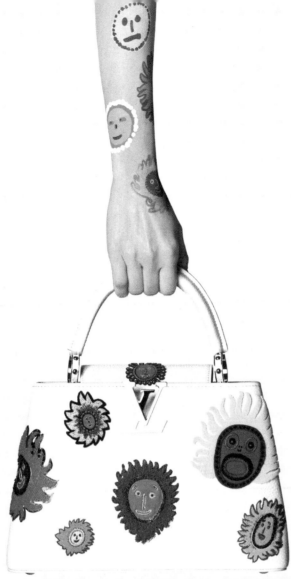

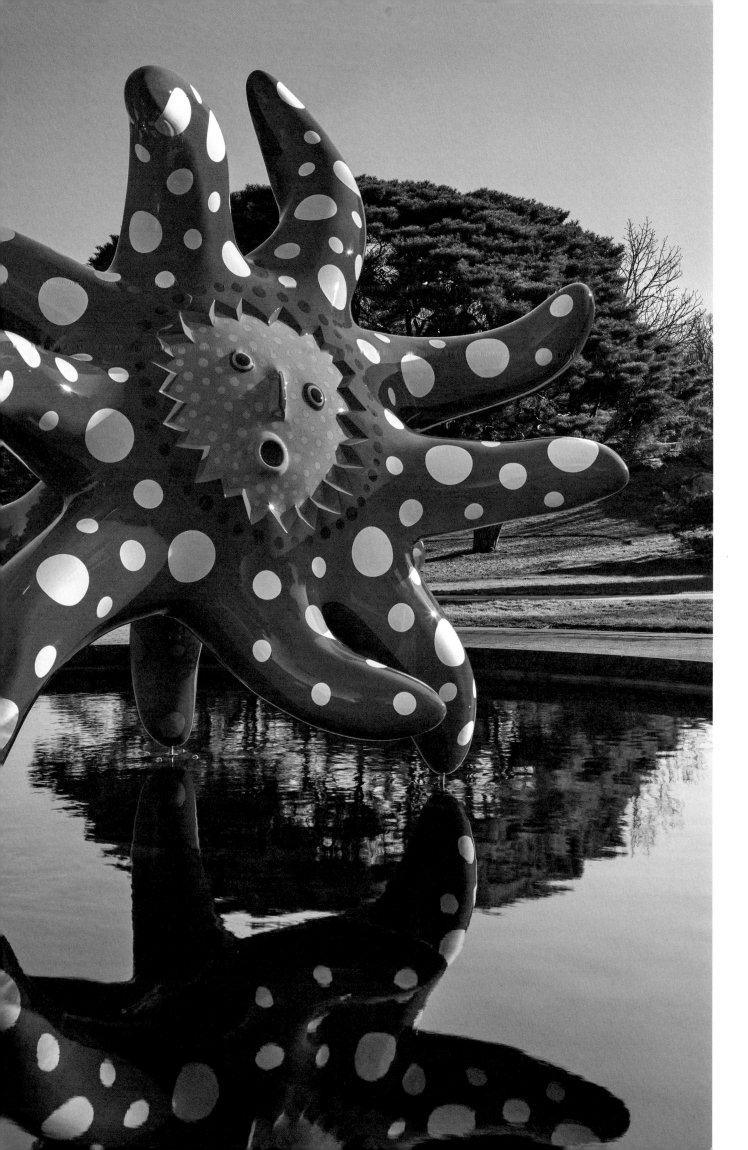

Urethane paint on aluminum

I Want to Fly to the Universe, 2020

Creating Infinity

Yayoi Kusama

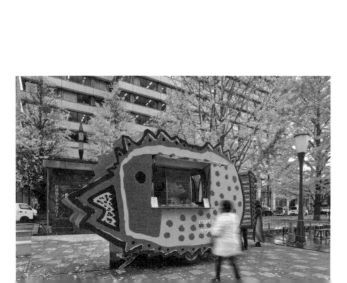

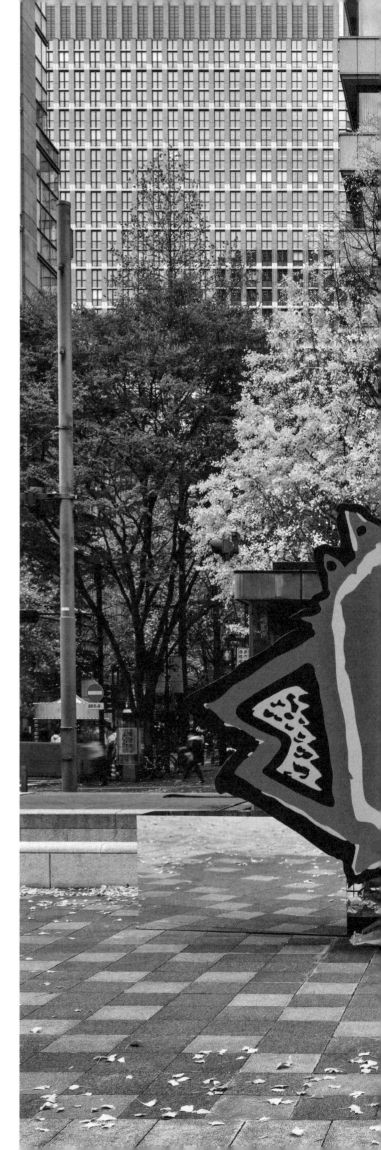

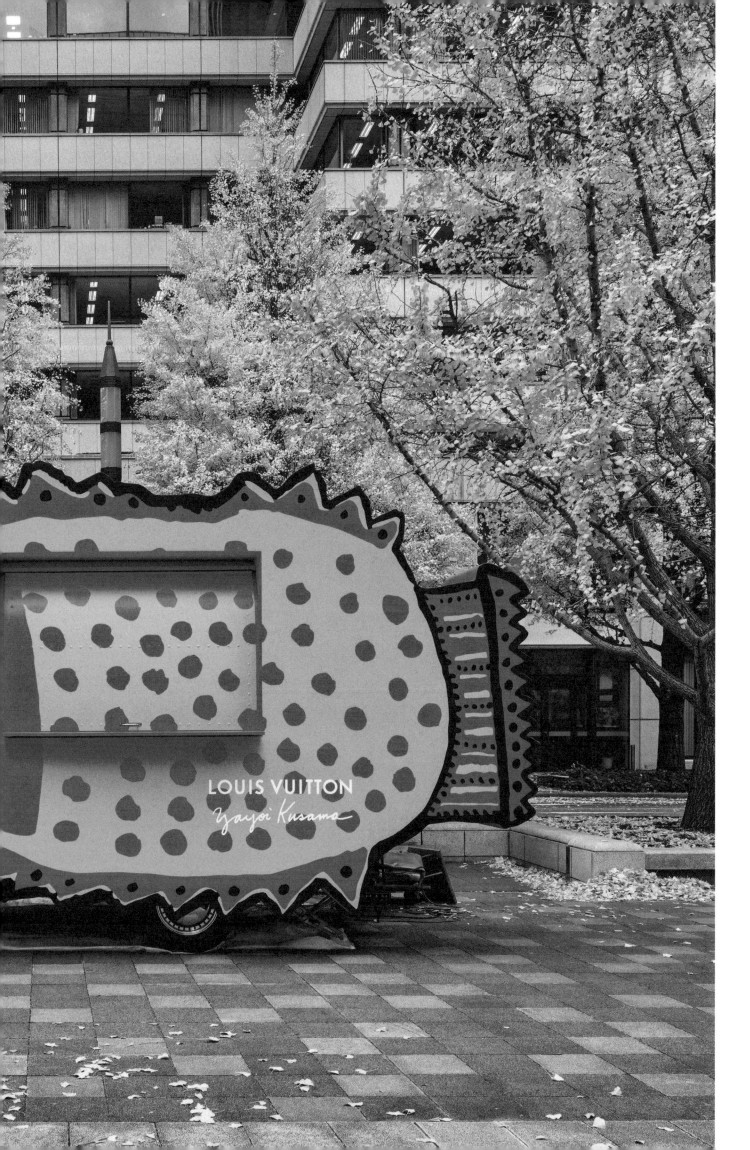

Photograph by Daici Ano

Louis Vuitton, Fish installation

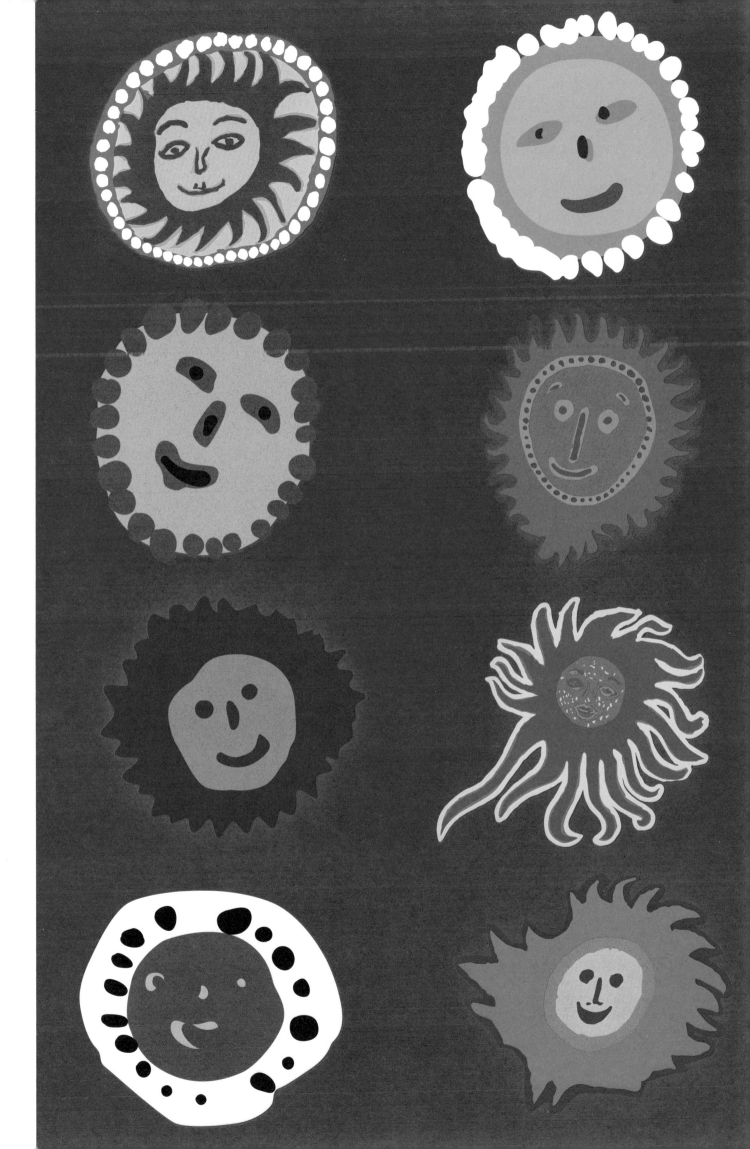

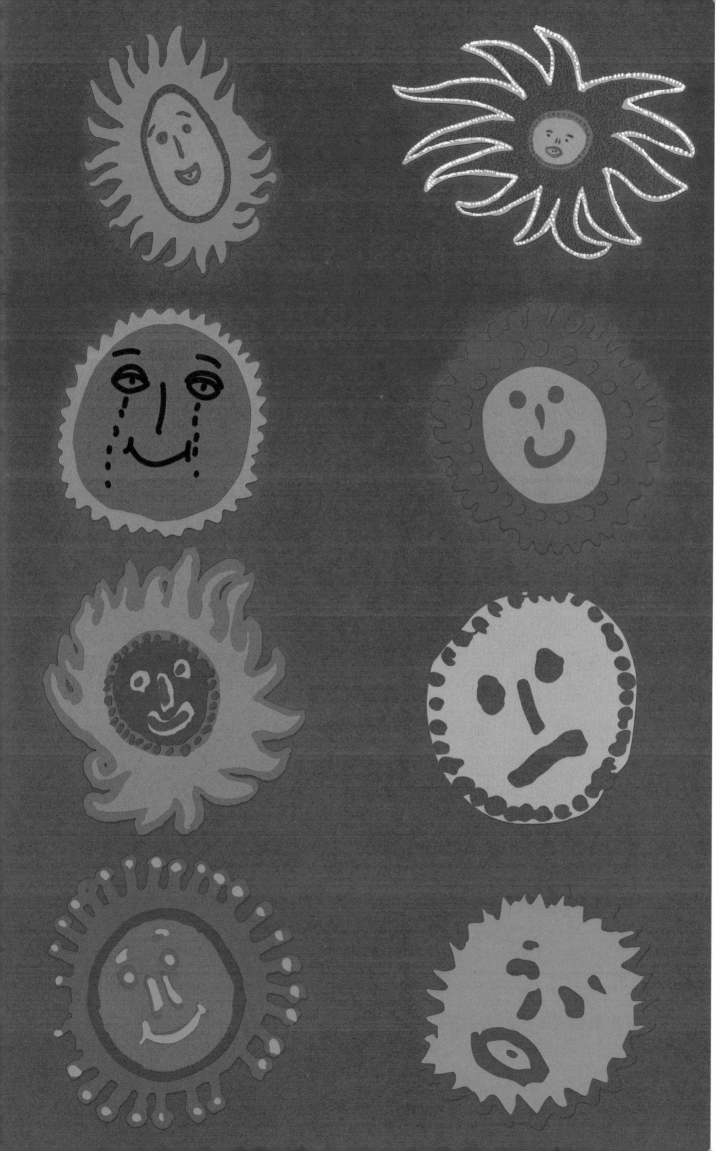

Creating Infinity

Yayoi Kusama

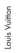

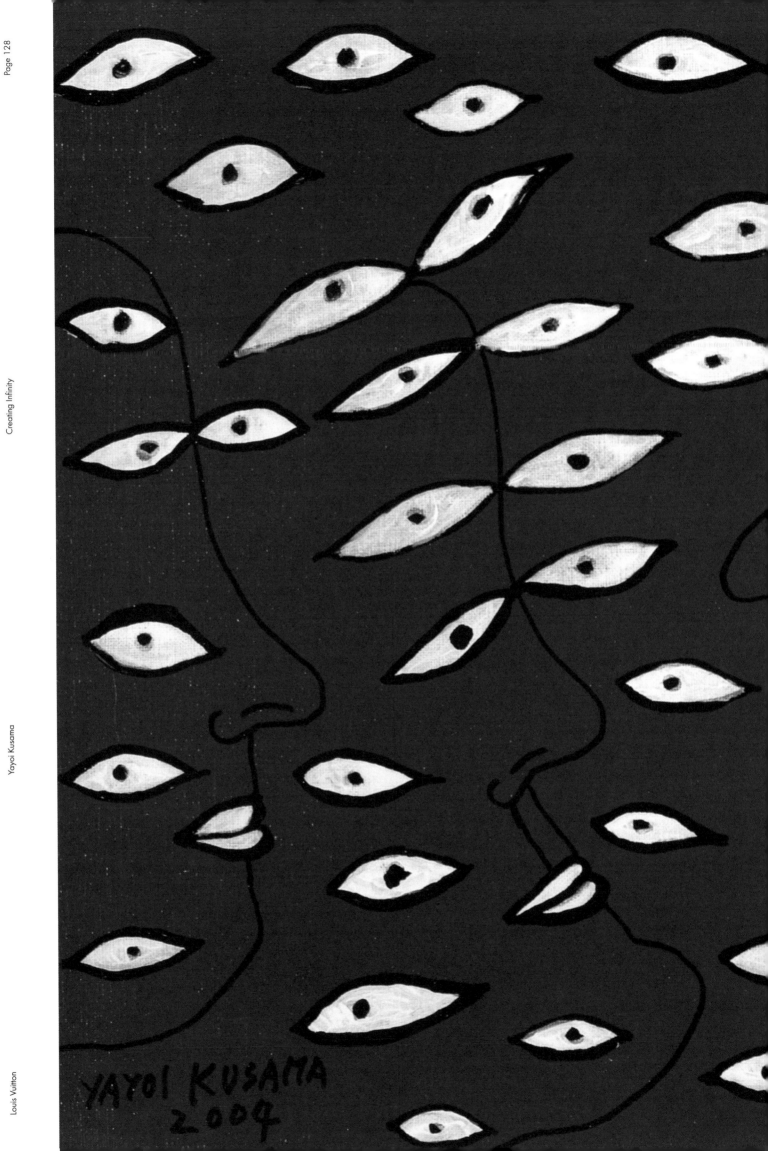

2004

Acrylic and marker on canvas

Waiting for Spring

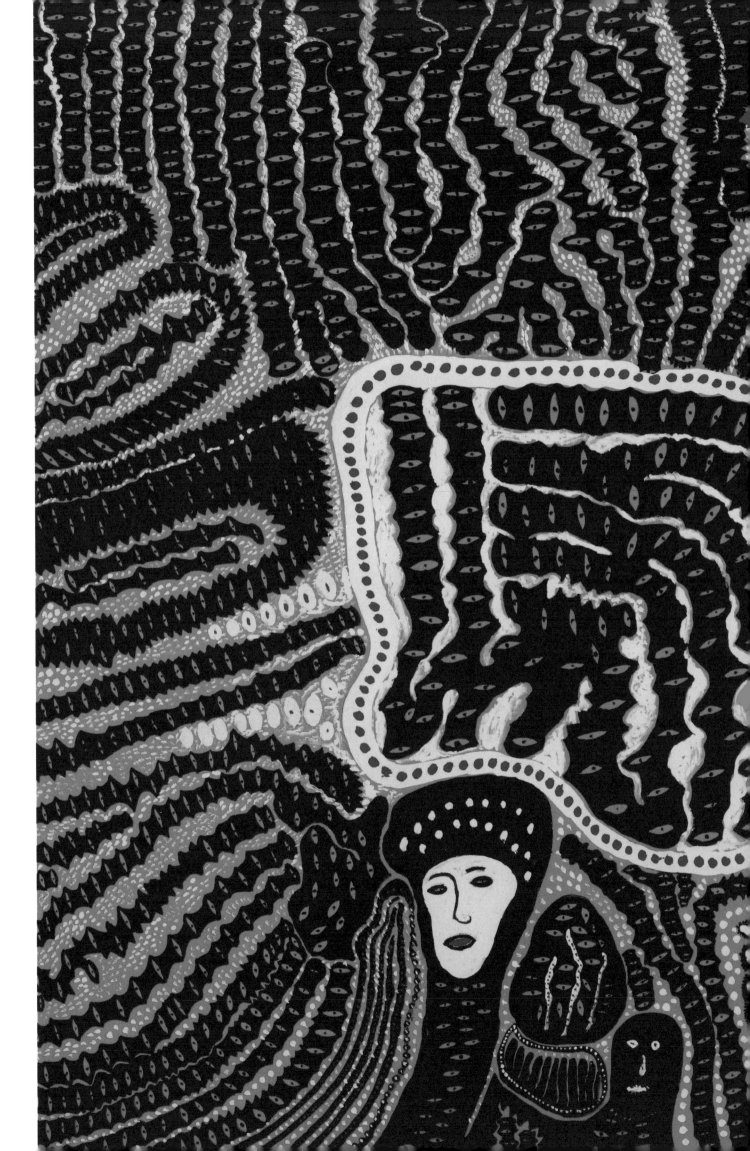

2016

Acrylic on canvas

I SHED TEARS FOR MY PAINFUL MEMORIES, NOW

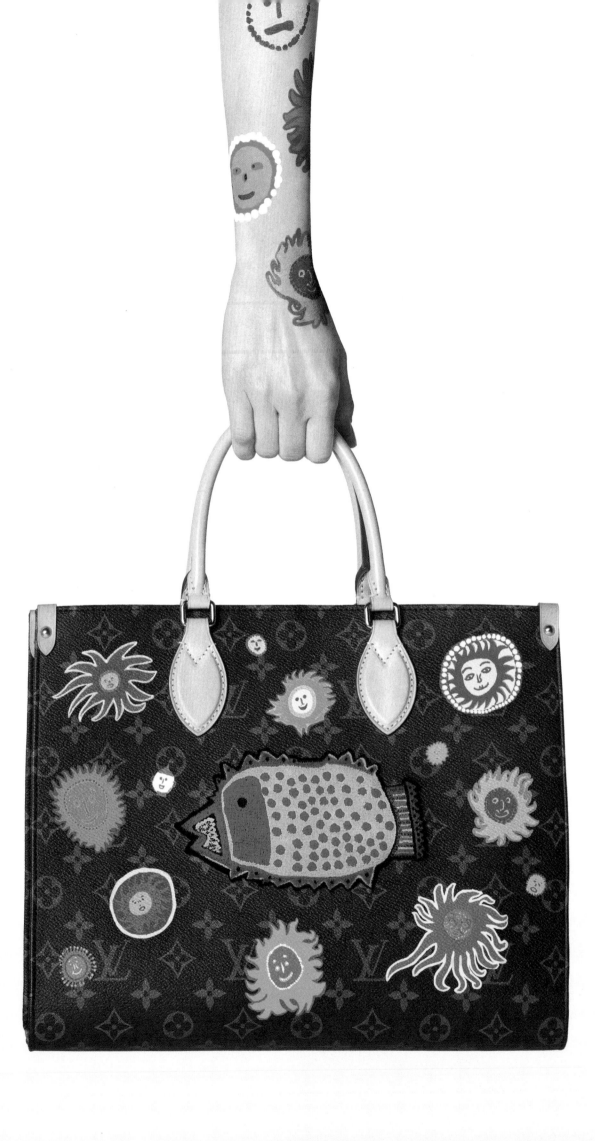

2023

Photograph by Steven Meisel

Louis Vuitton, Fish OnTheGo bag

KUSAMA'S OBLITERATION OF THE SELF IS MIND-SPLITTING, RAPTUROUS, ANGELIC, AND ABYSSAL. HER CHAOS IS BEAUTIFUL AND WORLD-BUILDING. A HYMN, AN ELEGY FOR THE VOID AND ALL OF US WHO MAKE OUR LIVES IN IT.

PRECIOUS OKOYOMON

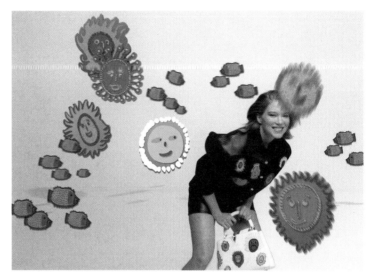

2023

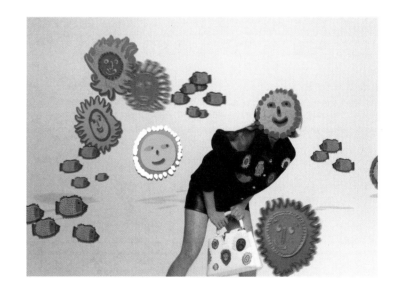

Video directed by Ferdinando Verderi

Léa Seydoux for Louis Vuitton

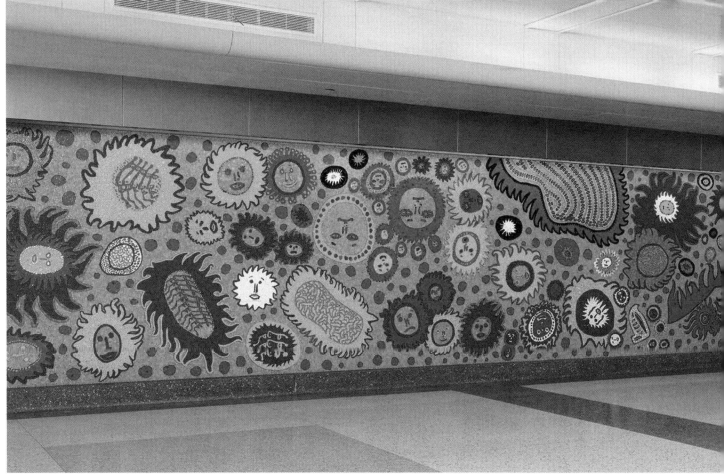

YAYOI KUSAMA CAN BE SUBVERSIVE. I'M CONVINCED THAT IN HER IMMENSE GLASS MOSAIC MURAL IN GRAND CENTRAL STATION IN NEW YORK CITY SHE IS TRYING TO DESCRIBE THE AIR. WE ALL KNOW BY NOW THAT THE AIR AROUND US IS BOTH BEAUTIFUL AND DANGEROUS, TWO CONDITIONS THAT

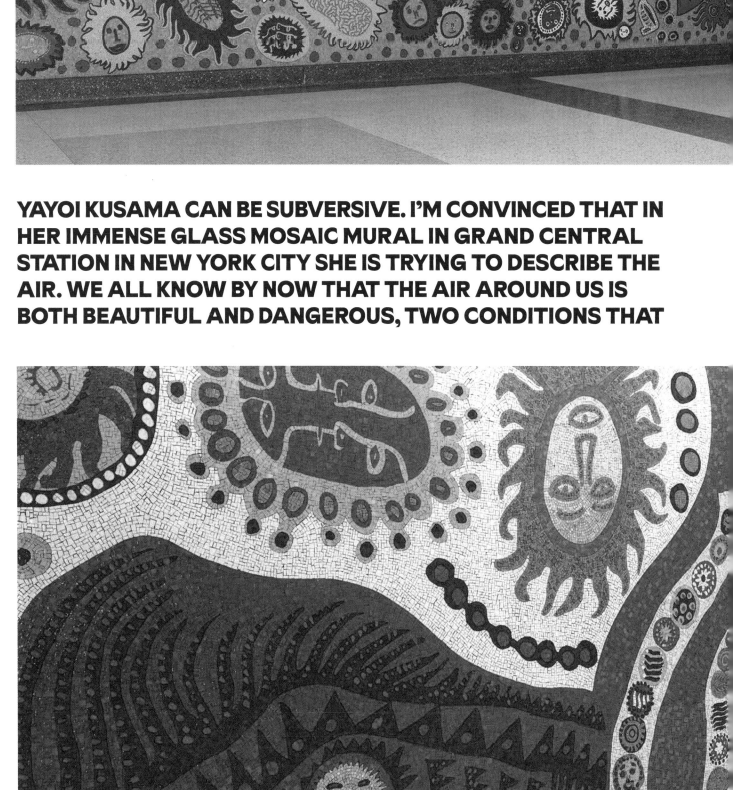

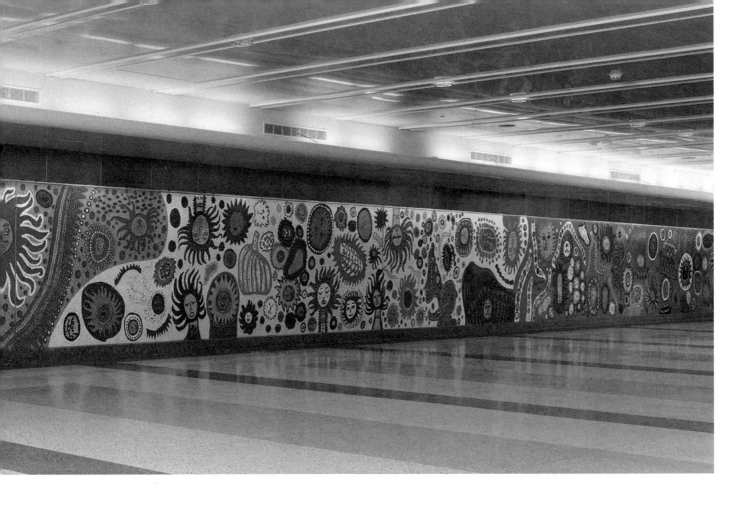

KUSAMA EXCELS AT IMAGINING. SHE CAPTURES THIS WITH SWIRLING SPIKY ORBS THAT SEEMINGLY CHANGE COLOR AS THEY MOVE THROUGH SPACE. WE BECOME TRANSFIXED AND PLAY ALONG WITH HER, MARVELING AT EACH COLORFUL DETAIL. KATHERINE BRADFORD

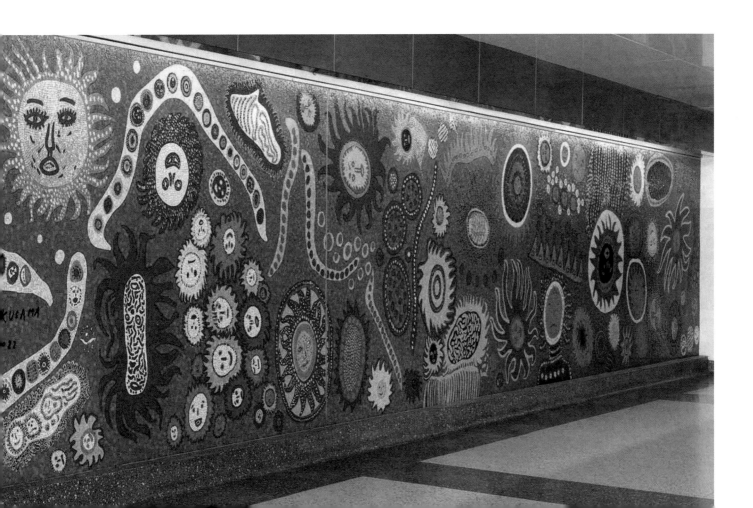

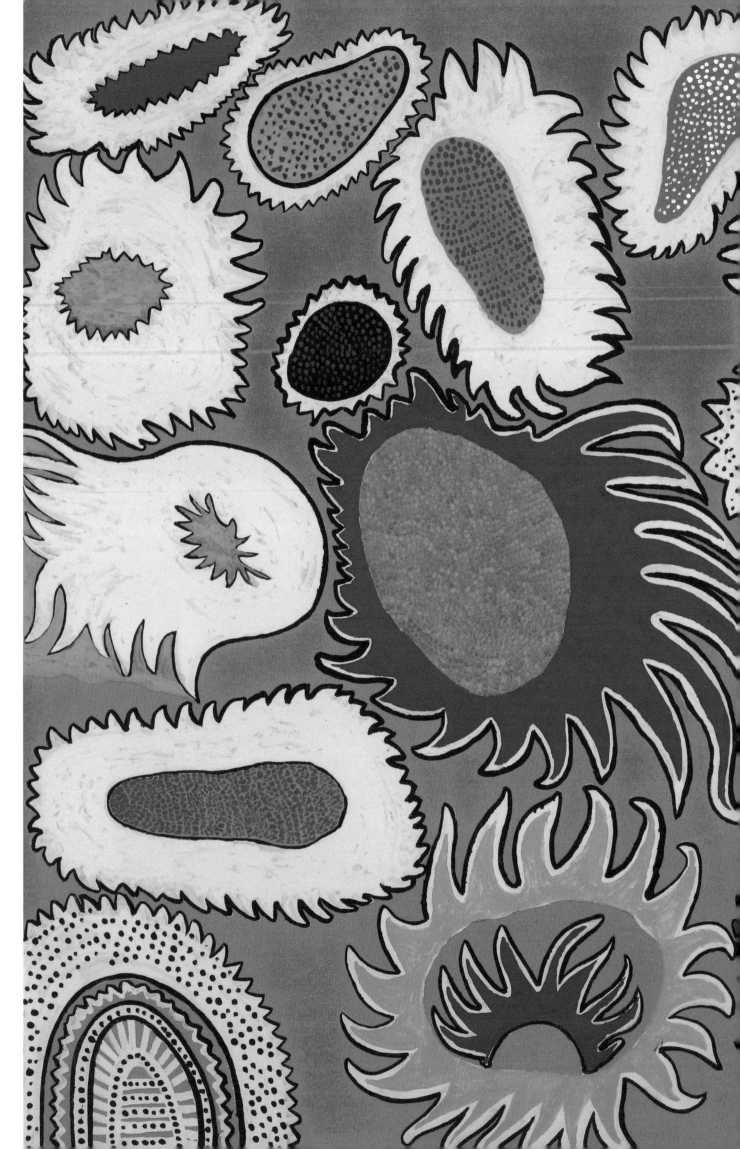

Creating Infinity

Yayoi Kusama

Louis Vuitton

THE GARDEN OF INFINITY

Variously peaceful, manic, mournful, or threateningly sexual, flowers thrive in Yayoi Kusama's art practice and punctuate her biography. Flowers were the first thing that Kusama painted. Growing up on a plant nursery in Matsumoto, Japan, she had plenty of references to draw from. By sixteen, Kusama had filled sketchbooks with near-anatomical illustrations of leaves, stems, and flowers in various states of bloom. In her autobiography, she recalled "snipping off the heads of flowers" and tossing "the tight blossoms into a hole I had secretly dug, until I had accumulated hundreds of them"—a repetitive action that foreshadowed her innovative installations of multiples. In 1950, she titled a somber painting of a sunflower with smirking lips *Self-Portrait*. Five years later, after seeing Georgia O'Keeffe's *Black Iris*, Kusama wrote to the American artist for counsel on "the long difficult life of being a painter." O'Keeffe's reply inspired Kusama's move to New York, where she honed many of her signature motifs and mediums, including soft sculptures such as *My Flower Bed* (1962), a floor-to-ceiling piece reminiscent of a carnivorous Venus flytrap. That same decade, interacting with the "flower power" counterculture, Kusama demonstrated against the war in Vietnam and advocated for peace. "Forget yourself," she proposed, "and become one with nature!" Botanists have noted the semblance of plant biology in Kusama's more abstract painted shapes, while the artist herself has identified a floral origin for the proliferation of patterns in her work. "One day," she explains, "after gazing at a pattern of red flowers on the tablecloth, I looked up to see that the ceiling, the windows, and the columns seemed to be plastered with the same red floral pattern. I saw the entire room, my entire body, and the entire universe covered with red flowers, and in that instant my soul was obliterated and I was restored, returned to infinity, to eternal time and absolute space." *Fiona Alison Duncan*

Louis Vuitton, Flowers for hand-crafted appliqué details

Photograph by Christophe Coënon

2022

Page 141

Creating Infinity

Yayoi Kusama

Louis Vuitton

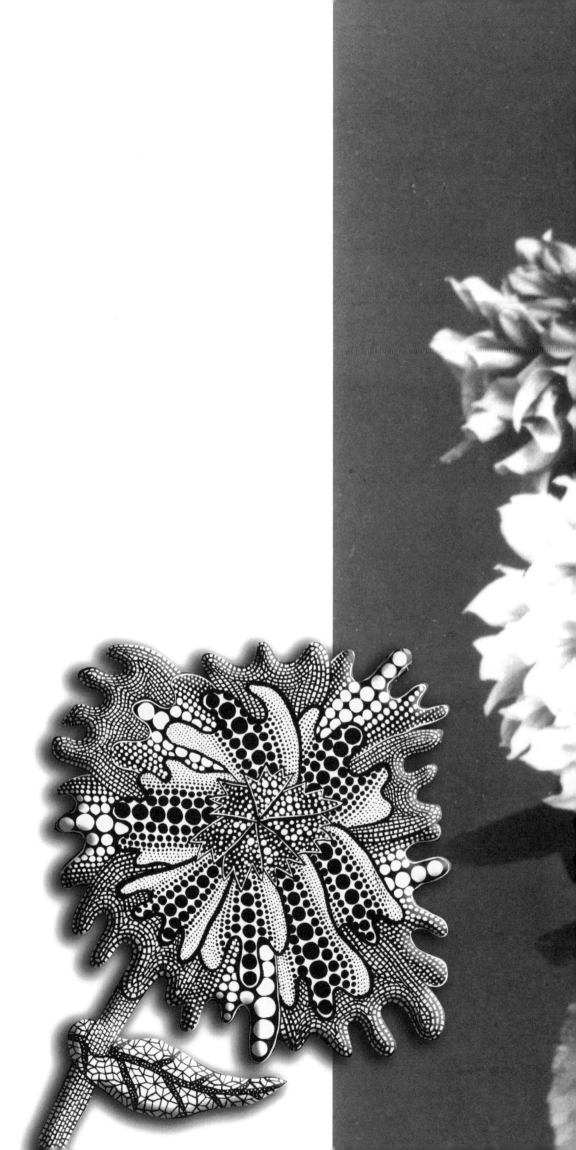

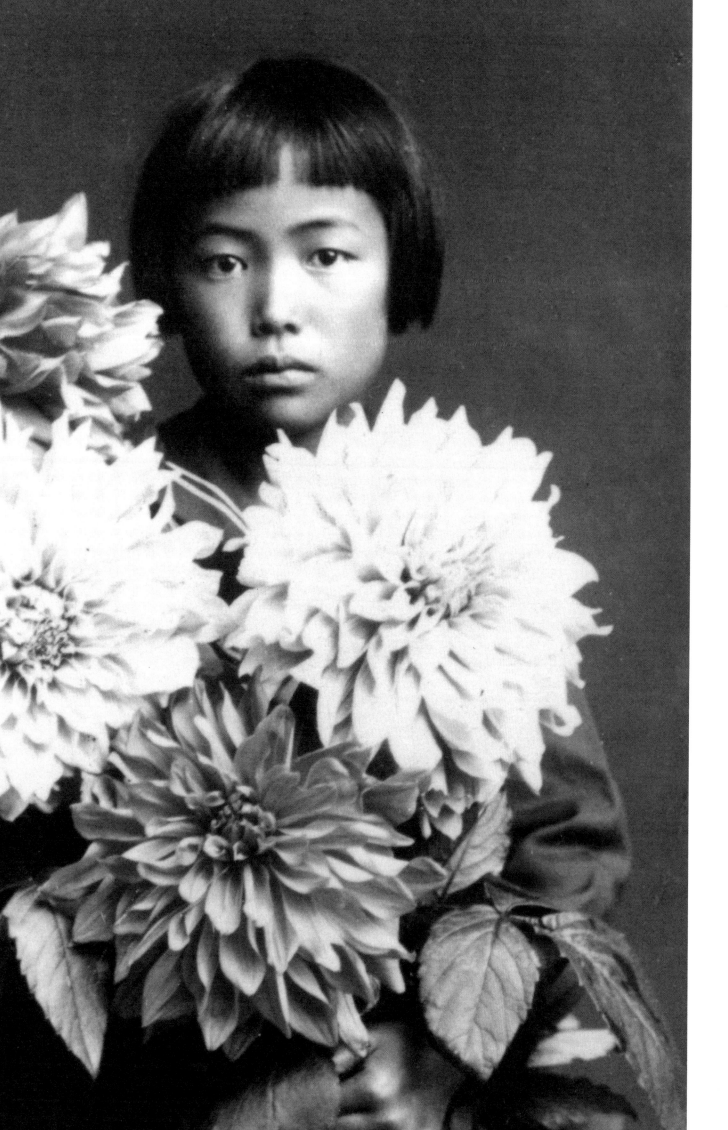

Japan, c. 1939

The artist at approximately 10 years old

Yayoi Kusama

1990

Acrylic on canvas

Summer Flowers (detail)

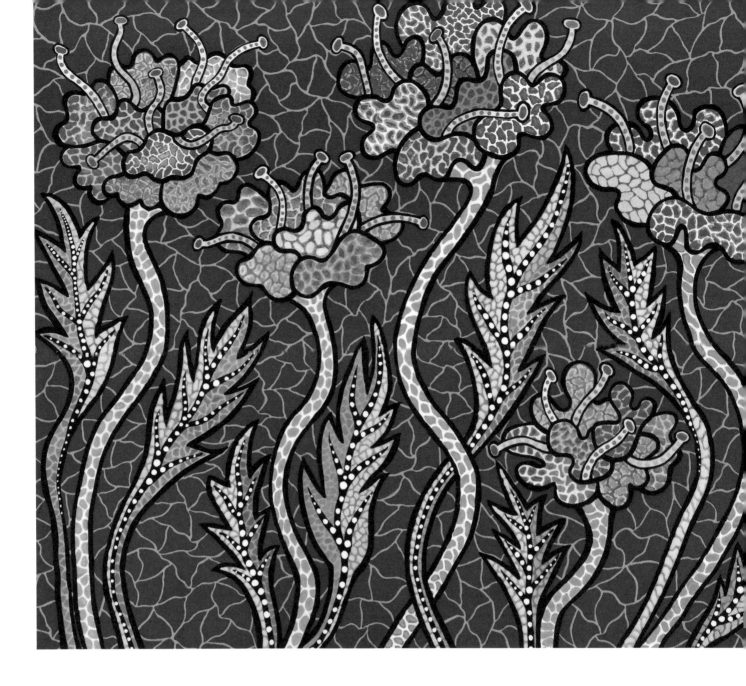

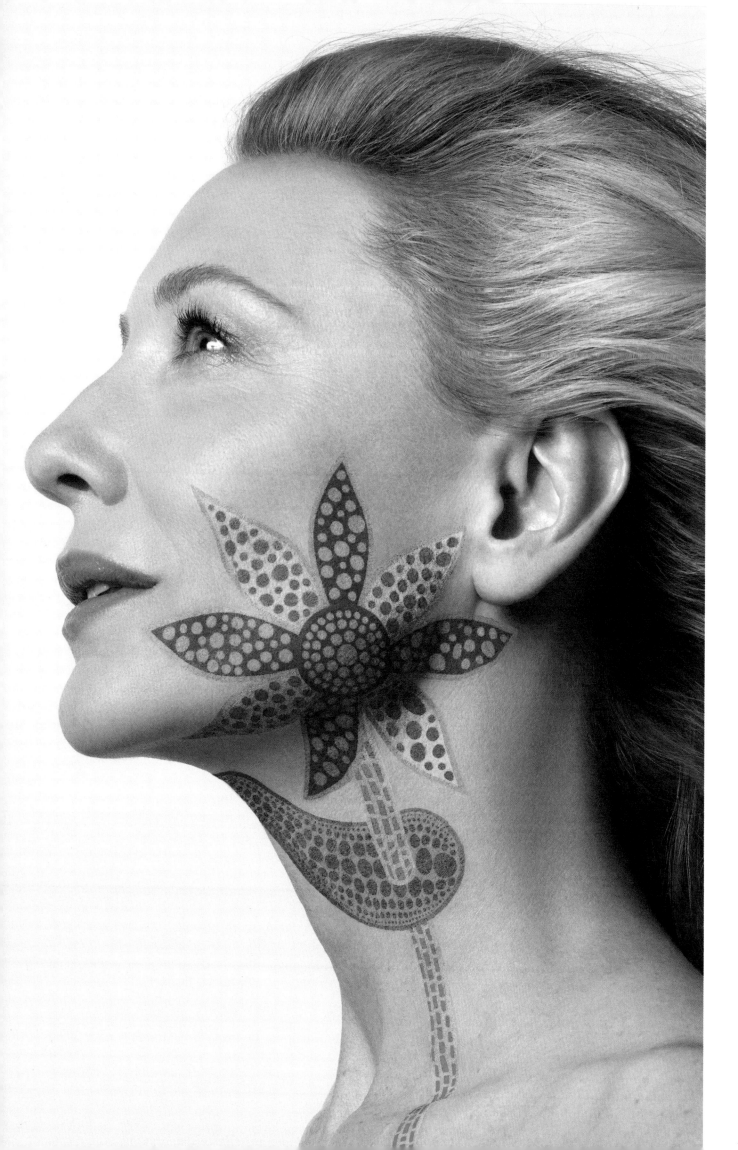

2023

Photograph by Steven Meisel

Cate Blanchett for Louis Vuitton

Yayoi Kusama

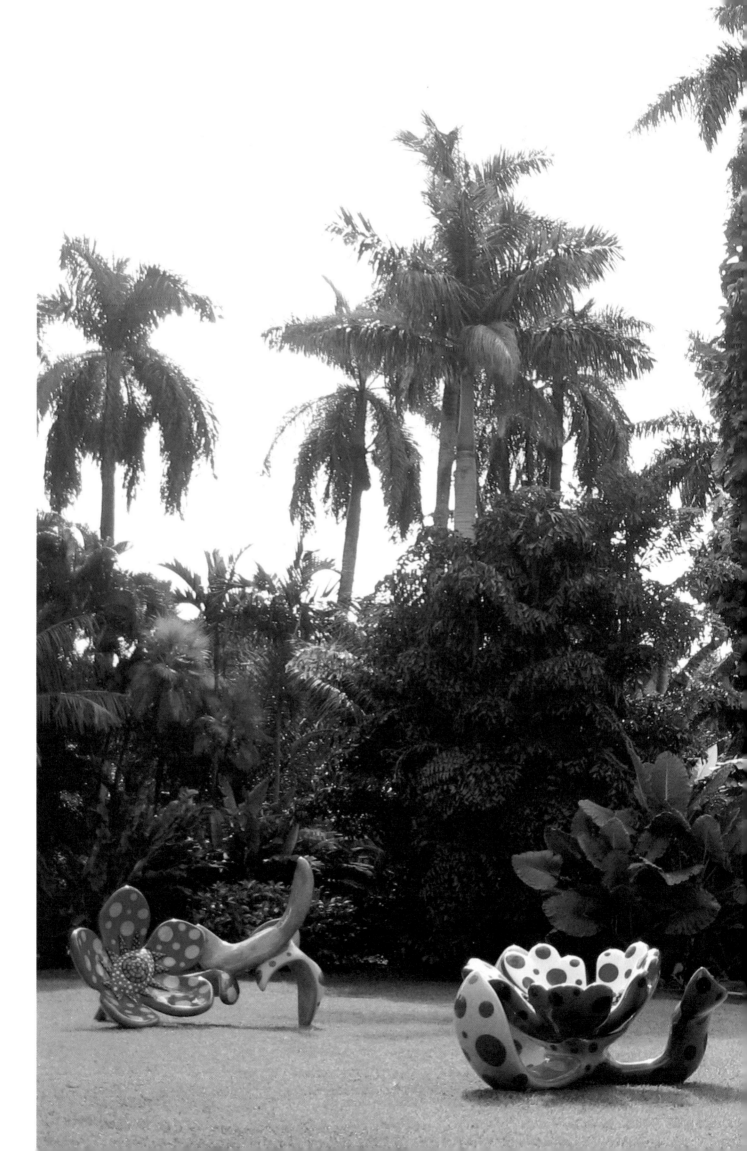

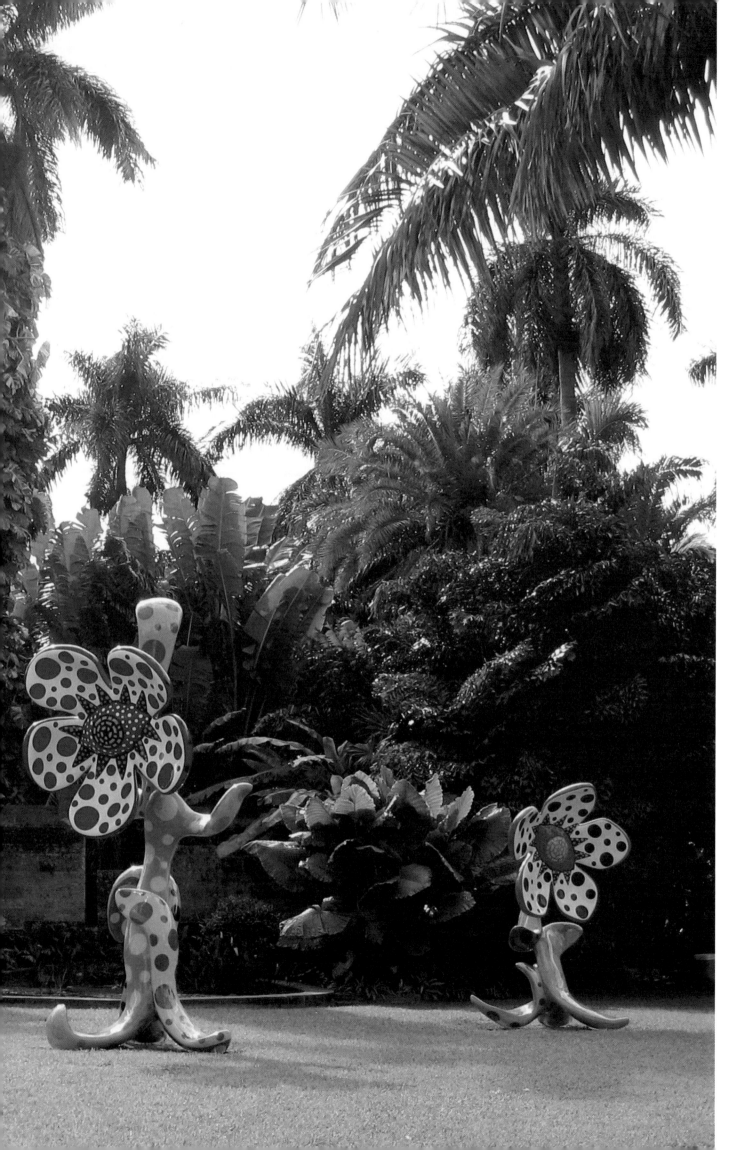

Fairchild Tropical Botanic Garden, Miami, 2009

Installation view

The artist overlooking the water

Seattle, 1957

Fukuoka, 1994

The artist in a field of flowers

Yayoi Kusama

I LOVE ART THAT ALLOWS ITS OWN IDEAS, CONCEPTS, INTENTIONS, AND PLANS TO BE SWALLOWED, MUTATED, AND EVEN HIJACKED BY THE POWER OF AUDIENCE—KUSAMA'S ART DOES THAT TO AN

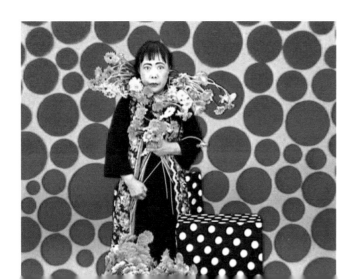

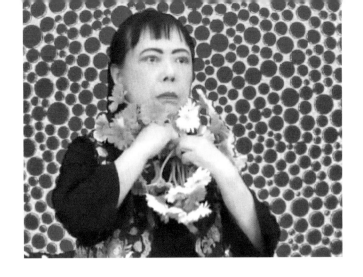

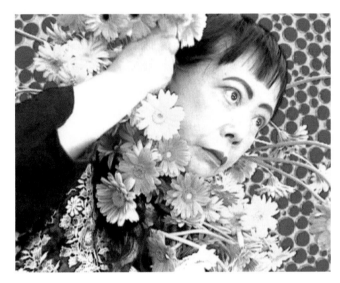

EXTREME. EVERY TIME SOMETHING IS WITNESSED, ENGAGED, OR ENCOUNTERED, IT IS OTHERED BY THAT INTERACTION—IT IS A BEAUTIFULLY GENERATIVE AND CATEGORY-COLLAPSING EXPERIENCE. RYAN TRECARTIN

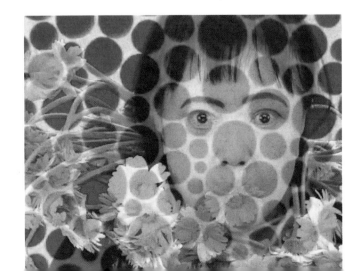

1999

Performance film still; video; duration 1:21 minutes

Flower Obsession (Gerbera)

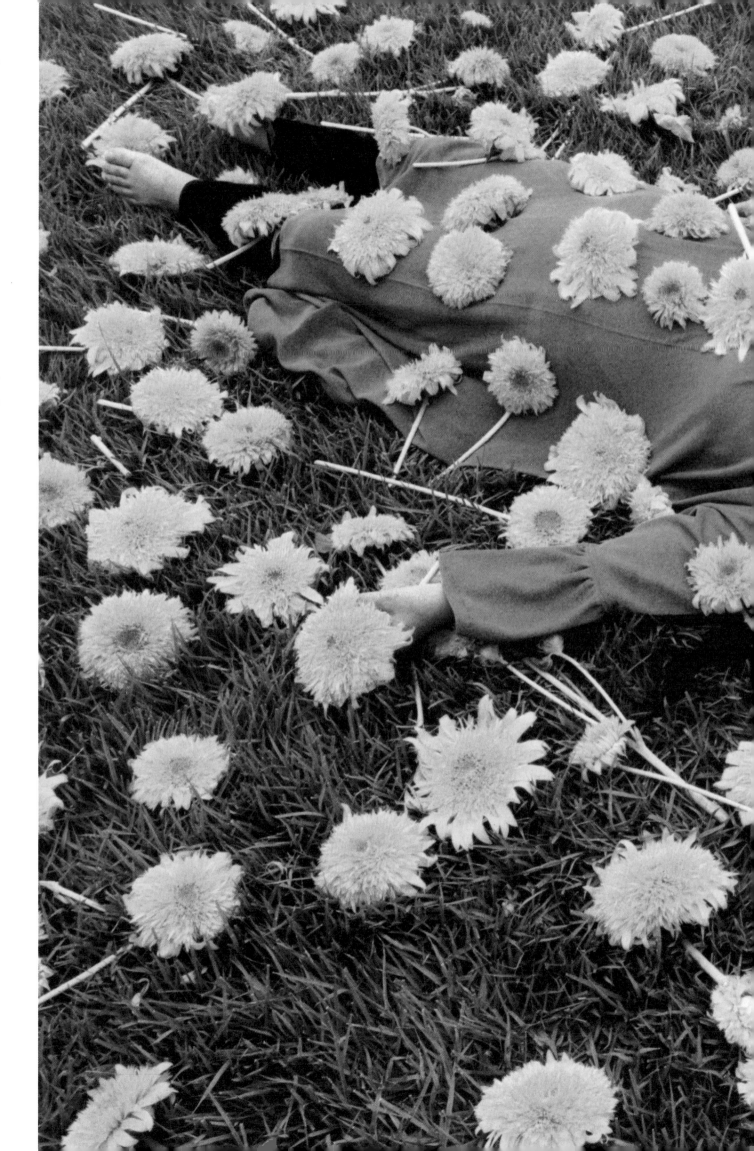

Creating Infinity

Yayoi Kusama

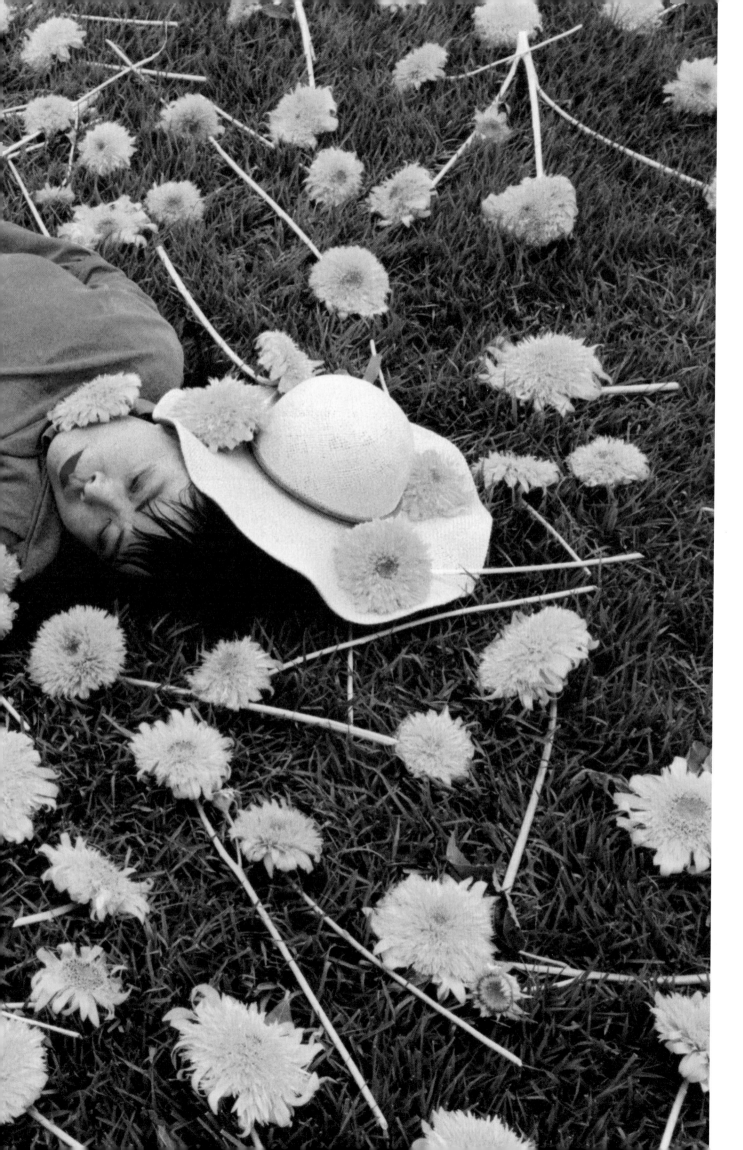

2000

Performance film still; video; duration: 2:40 minutes

Flower Obsession (Sunflower)

2019

Urethane paint on stainless steel

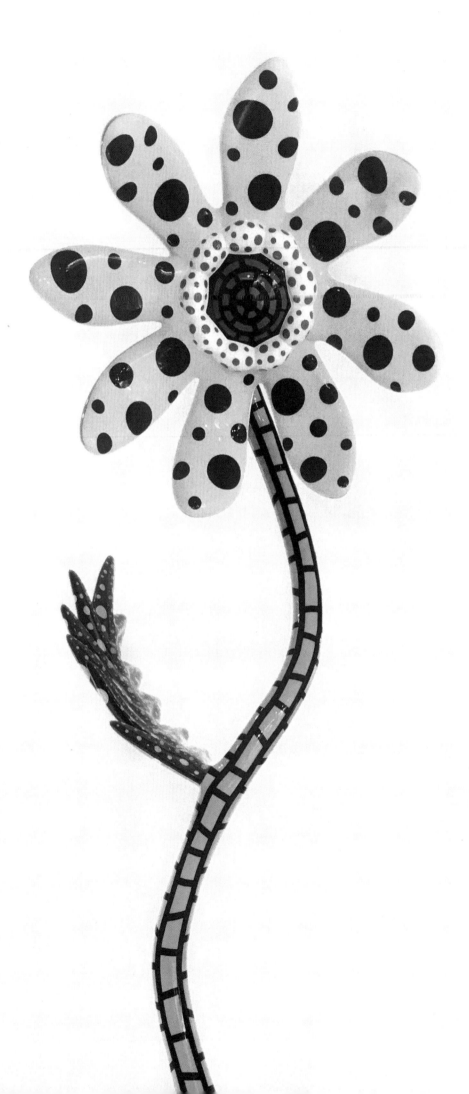

1945

Pencil in notebook

Untitled (Flower Sketches) (details)

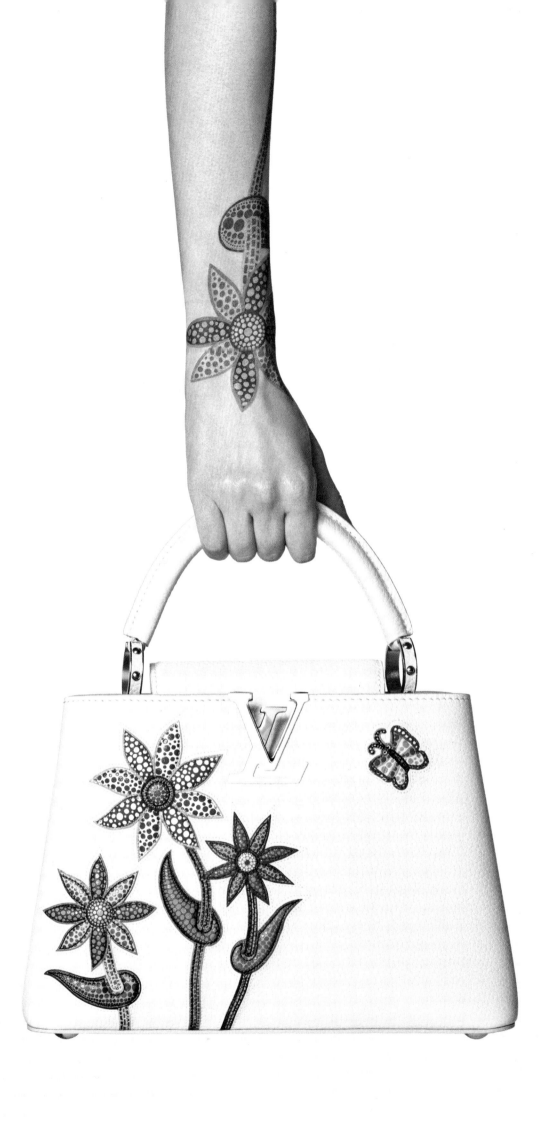

2023

Photograph by Steven Meisel

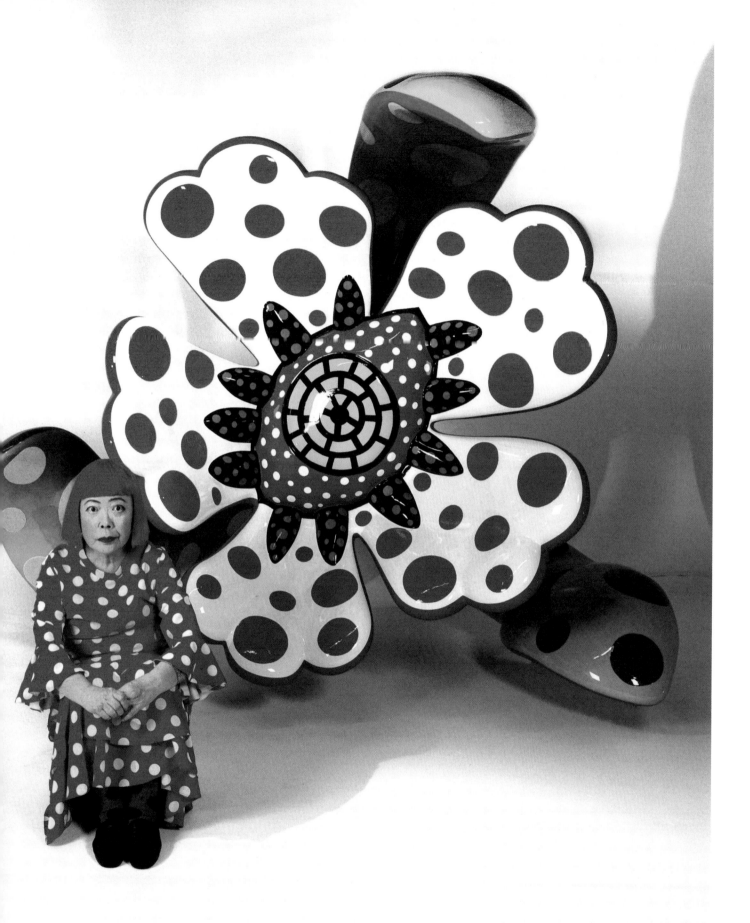

2010

Artist with her Flowers That Bloom at Midnight

Yayoi Kusama

Creating Infinity

Yayoi Kusama

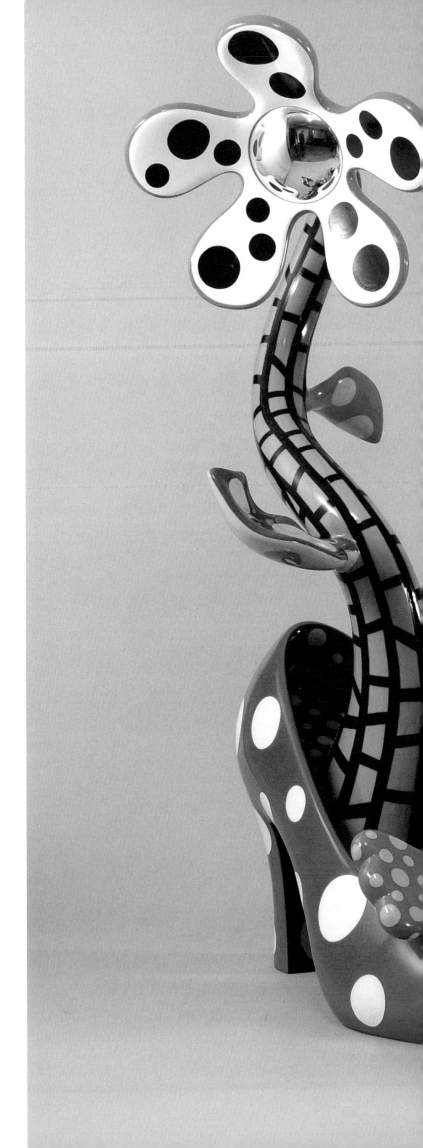

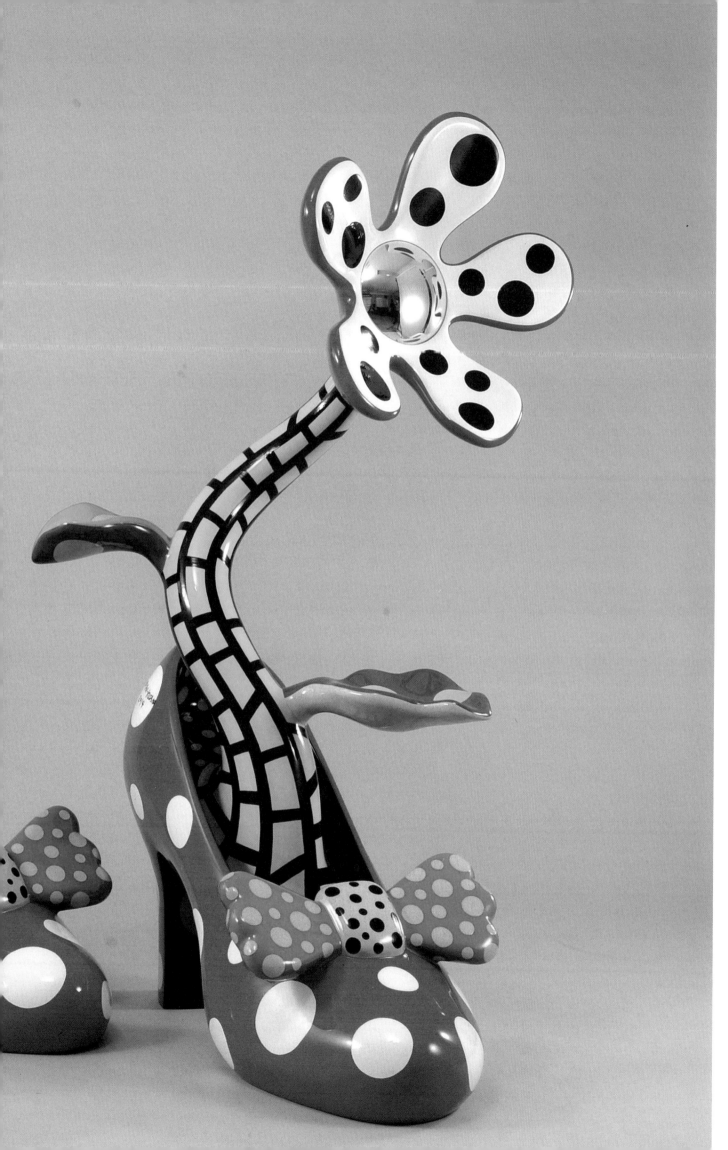

2014

Fiberglass-reinforced plastic, stainless steel

High Heels for Going to Heaven

Creating Infinity

Yayoi Kusama

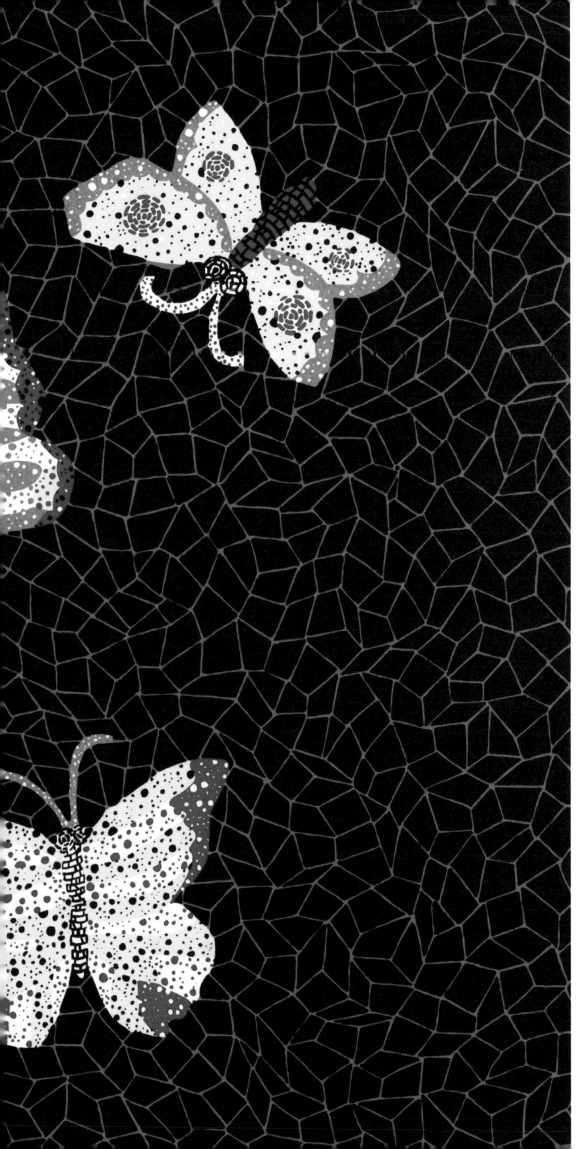

1985; edition of 10

Screen print on paper

Butterfly

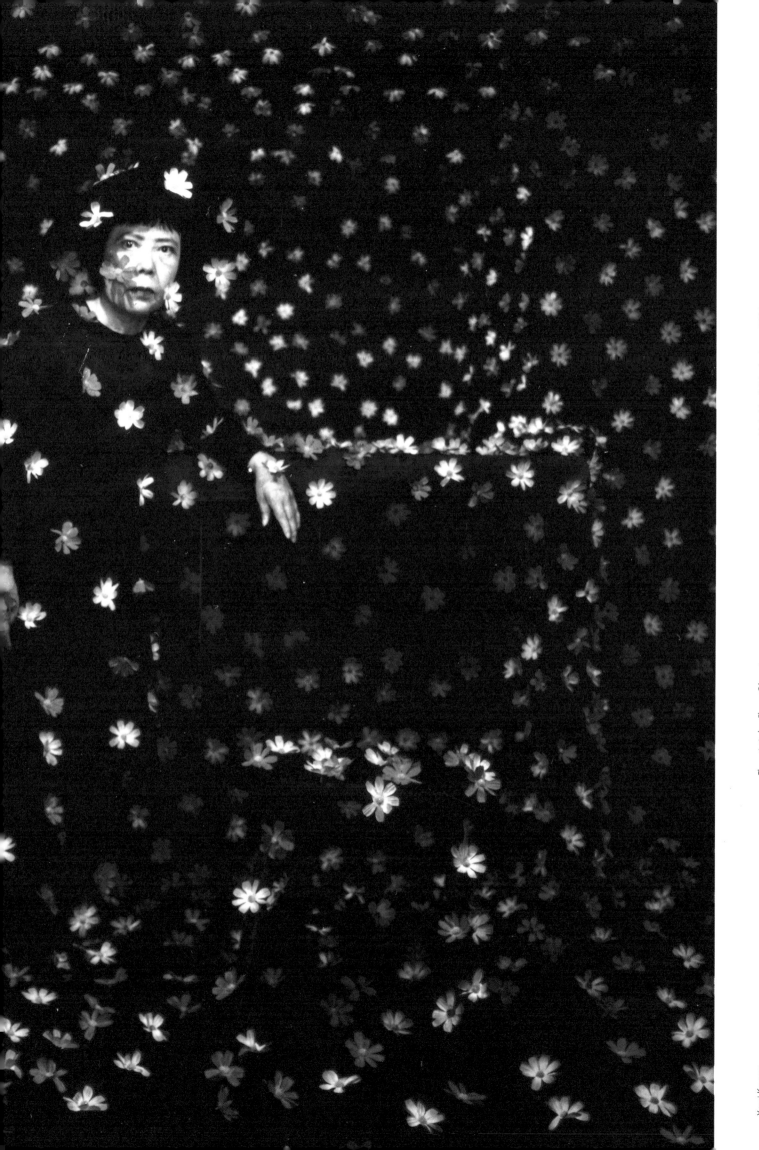

Noko Island, Fukuoka, Japan, 1994

The artist in her *Flower Obsession*

Yayoi Kusama

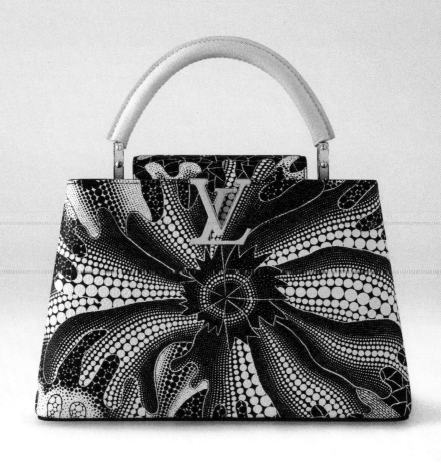

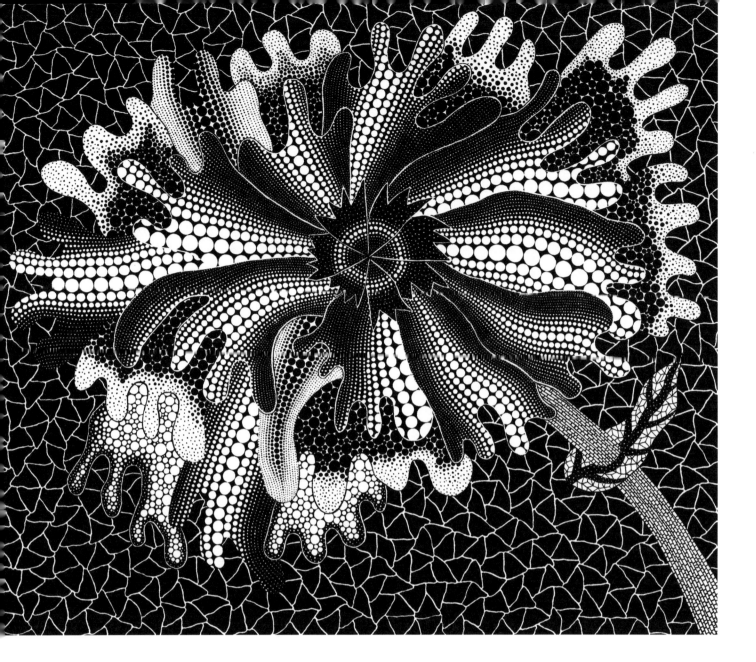

YAYOI: HER CONSTELLATIONS OF FRACTAL NODES DISTINCTLY LOVELY IN TONE SHIMMER / AND HER COMMITMENT TO THE SETTING AGAINST AND WITHIN THE FRACTAL VISUALLY TRACES PATTERNS AS IF SHARED FROM INSIDE A DEEP DREAM.

ARCA

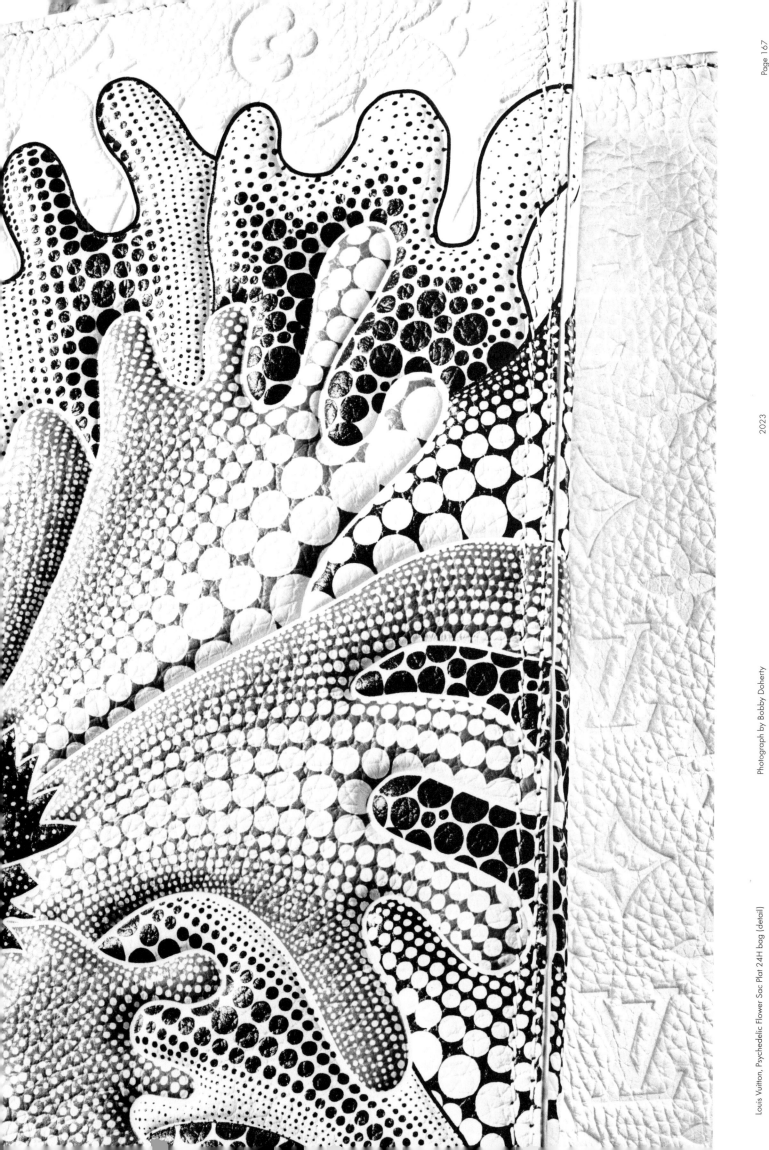

2023

Photograph by Bobby Doherty

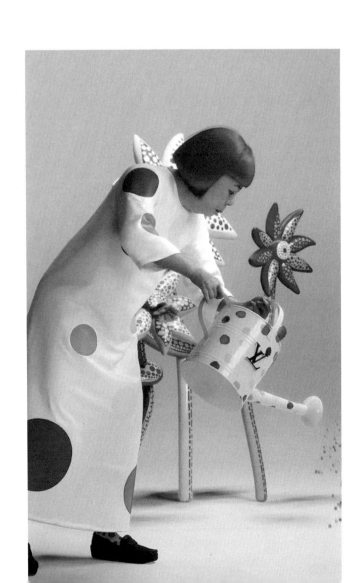

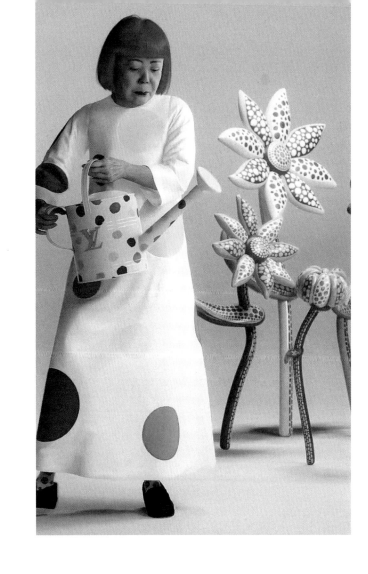

2023

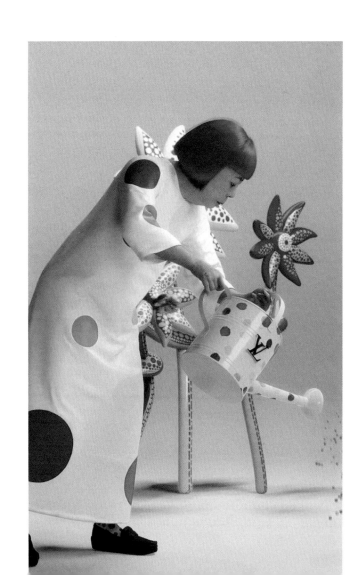

Design by Closer.ltd

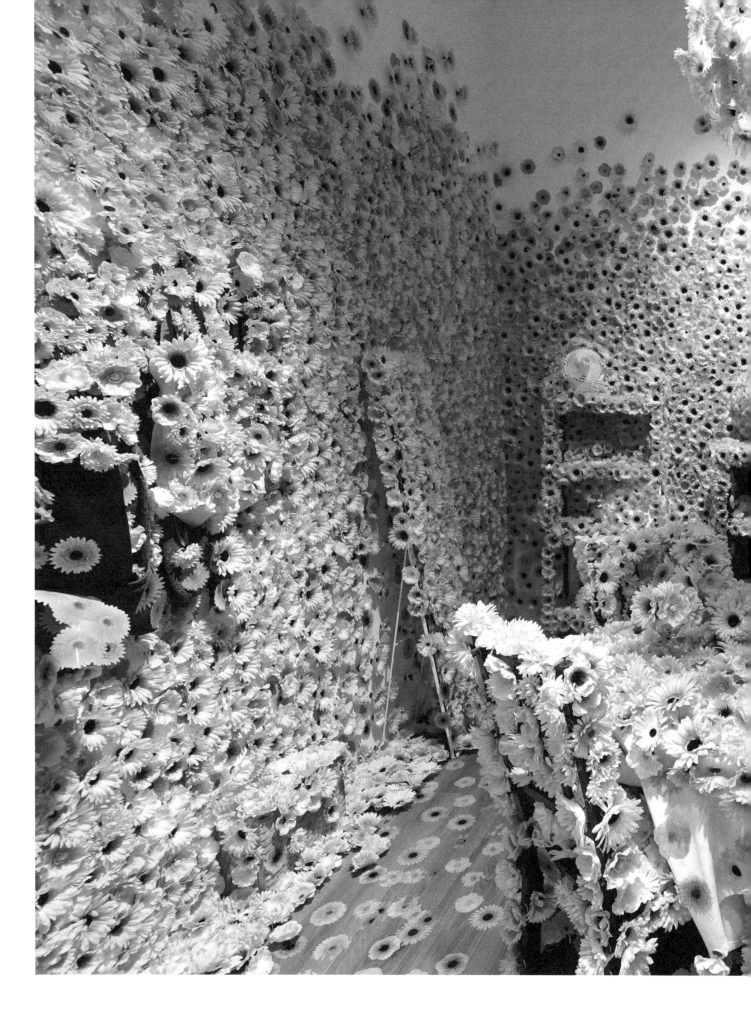

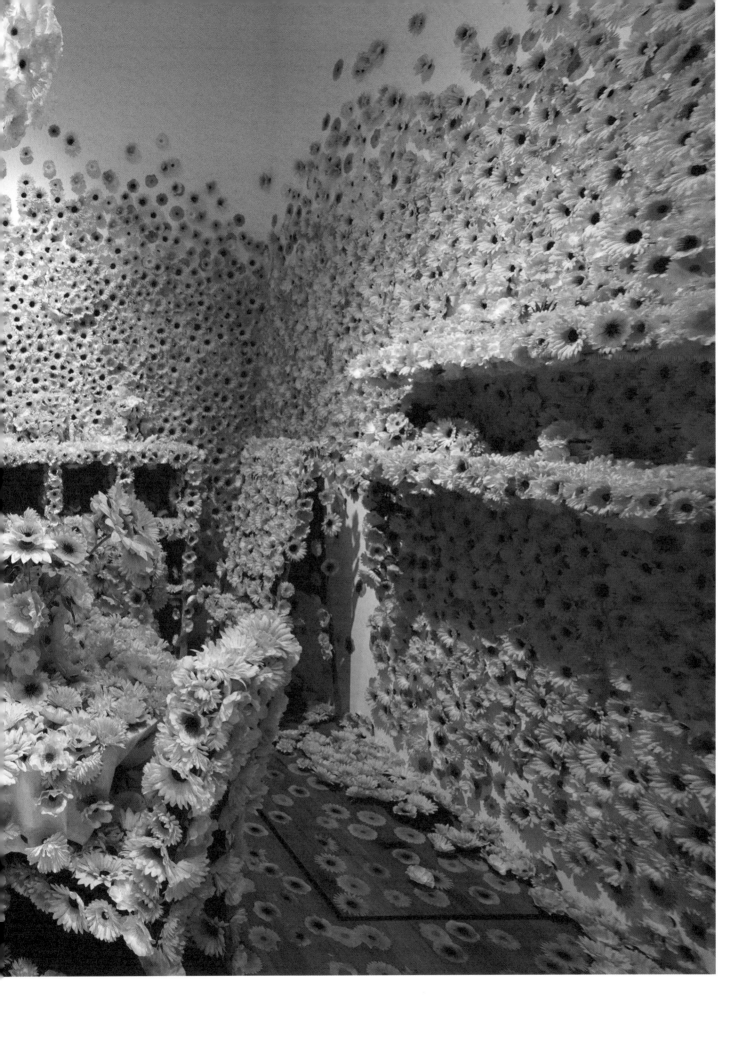

Yayoi Kusama Museum, Tokyo, 2020

Installation view

Flower Obsession, 2017/2020

PAINTING EACH DOT

"I convert the energy of life in dots of the universe, and that energy along with love flies into the sky."—Yayoi Kusama

In a play authored by Kusama in 1971, her main character Tokyo Leee encounters a young American in New York's "Pumpkins Square Park" who is afraid of being drafted during the war in Vietnam. Offering to paint him with "her magic polka dots," Leee explains: "Bad people have trouble seeing them; perhaps they might make you invisible." In real-life protests against the same war, Kusama had painted naked young protesters with polka dots as she advocated for "self-obliteration"—a transcendence of the ego, a union with nature and eternity, and a way for all humans to be seen as equal. Nowadays, with the advent of facial-recognition technology, obfuscating one's identity with "magic polka dots" doesn't sound so outlandish, and while this isn't a connection Kusama made herself, it points to the wide-ranging relevance of her painted dots. Kusama has likened the polka dot to "the form of the sun, signifying masculine energy, the source of life," and "the form of the moon, symbolizing the feminine principle of reproduction and growth." Earth, for her, is a polka dot as well—"one polka dot among millions of others," "one orb full of hatred and strife amid the peaceful, silent spheres." If painting polka dots is a bid for peace and love from Kusama, it is not naive; it comes from an intuitive awareness of the building blocks of life in our universe. The affinity Kusama sees between the "ten billions of bubbles inside my body" and the "ten billions of stars that twinkle in the heavens" is in line with recent science proving that humans and the galaxy share approximately 97 percent of the same atoms; said another way, we are all made of stardust. *Fiona Alison Duncan*

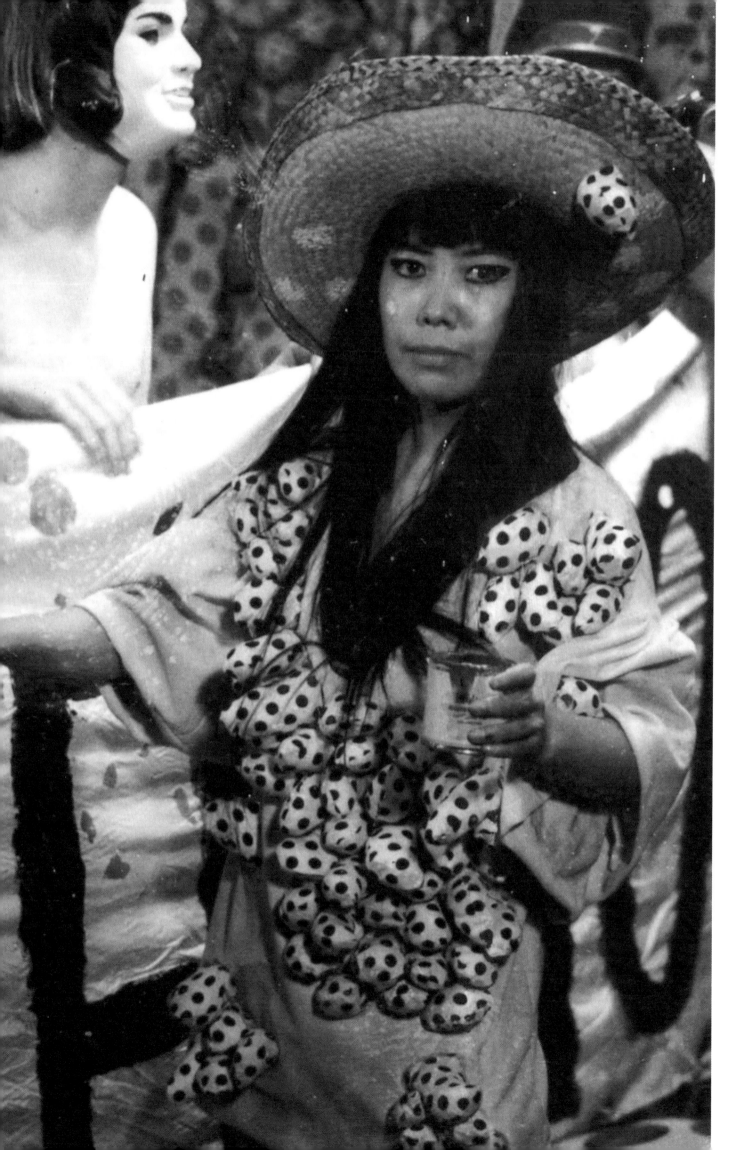

New York, c. 1968

The artist at her *Self-Obliteration Happening*

Yayoi Kusama

Creating Infinity

Yayoi Kusama

Louis Vuitton

2023

Video directed by Ferdinando Verderi

Gisele Bündchen for Louis Vuitton

Creating Infinity

Yayoi Kusama

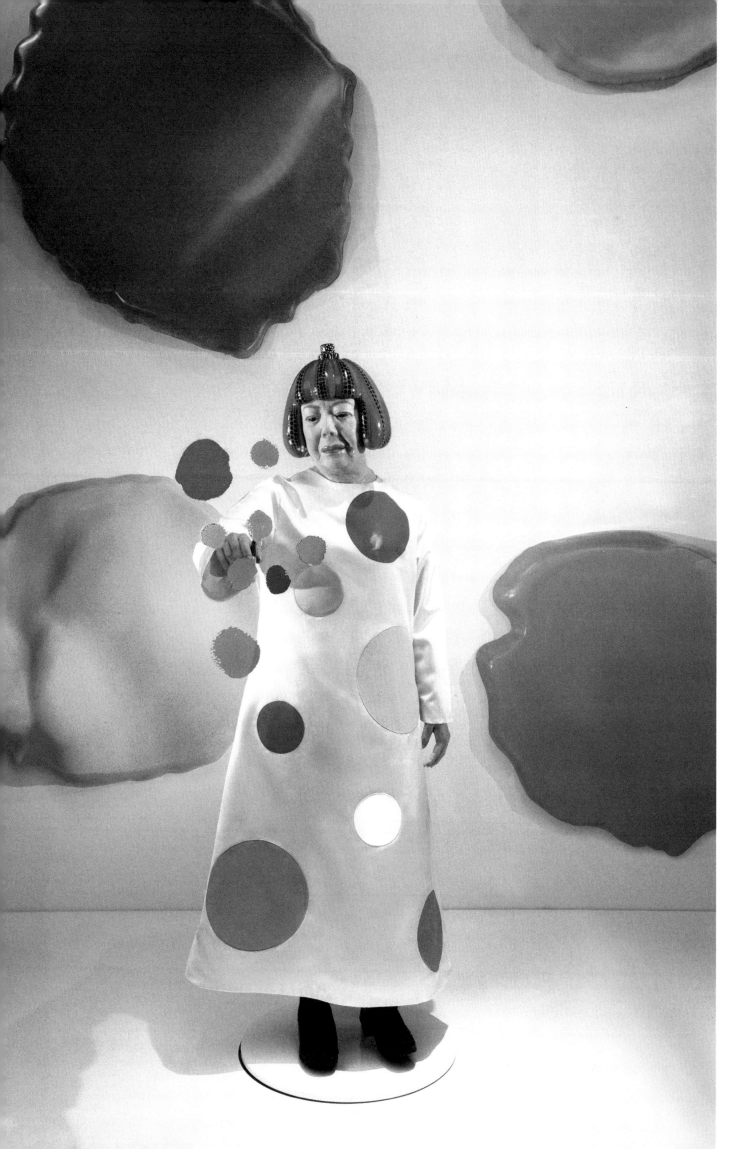

Louis Vuitton Fifth Avenue store, New York, 2023

Photograph by Harry Bowley

Louis Vuitton, Yayoi Kusama Painted Dots installation

YAYOI KUSAMA'S FEARLESS EXPERIMENTATION INSPIRES ME ENDLESSLY. HER INNOVATIVE USE OF REPETITIVE PATTERNS AND UNCONVENTIONAL MATERIALS CHALLENGED TRADITIONAL ARTISTIC PRACTICES AND HAS ENCOURAGED ME TO PUSH THE BOUNDARIES OF MY OWN ART, CREATING WORKS THAT ENGAGE THE VIEWER THROUGH IMMERSIVE EXPERIENCES. HER ARRIVAL IN NEW YORK CITY IN THE EARLY 1960S MARKED A SIGNIFICANT SHIFT IN THE CITY'S ART SCENE, AND HER INFLUENCE ON CONTEMPORARY ART CONTINUES TO THIS DAY.

RAÚL DE NIEVES

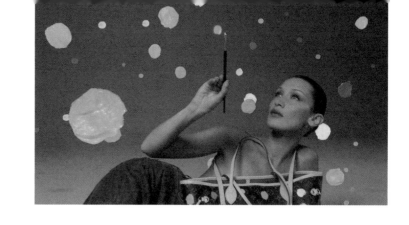

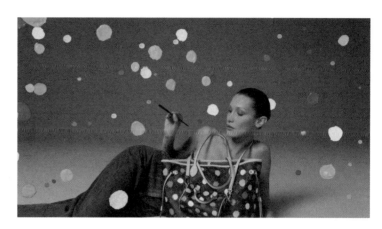

2023

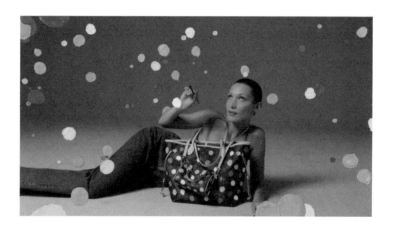

Video directed by Ferdinando Verderi

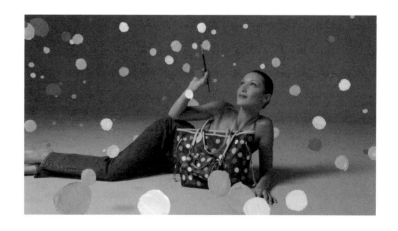

Bella Hadid for Louis Vuitton

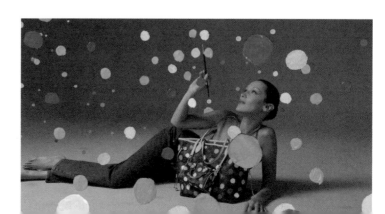

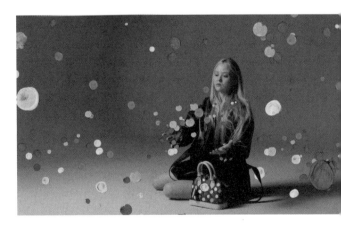
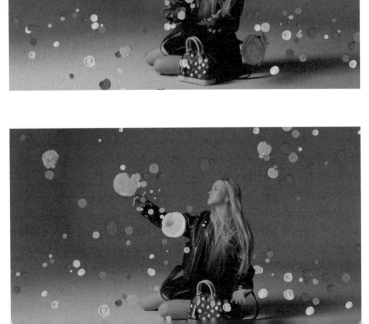
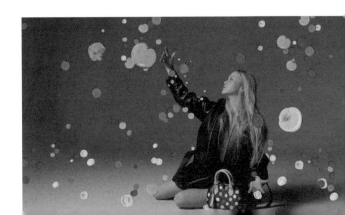

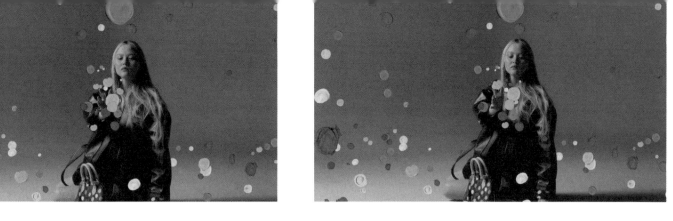

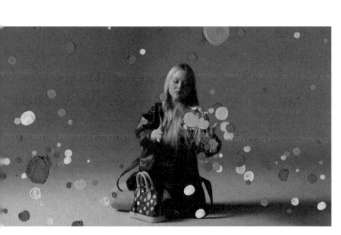

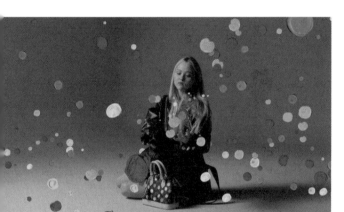

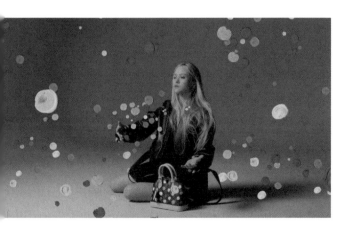

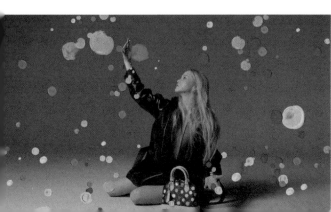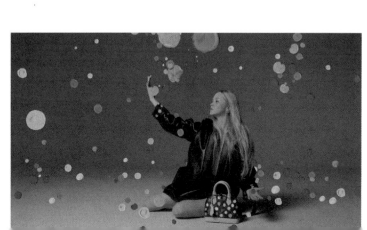

Video directed by Ferdinando Verderi

2023

Devon Aoki for Louis Vuitton

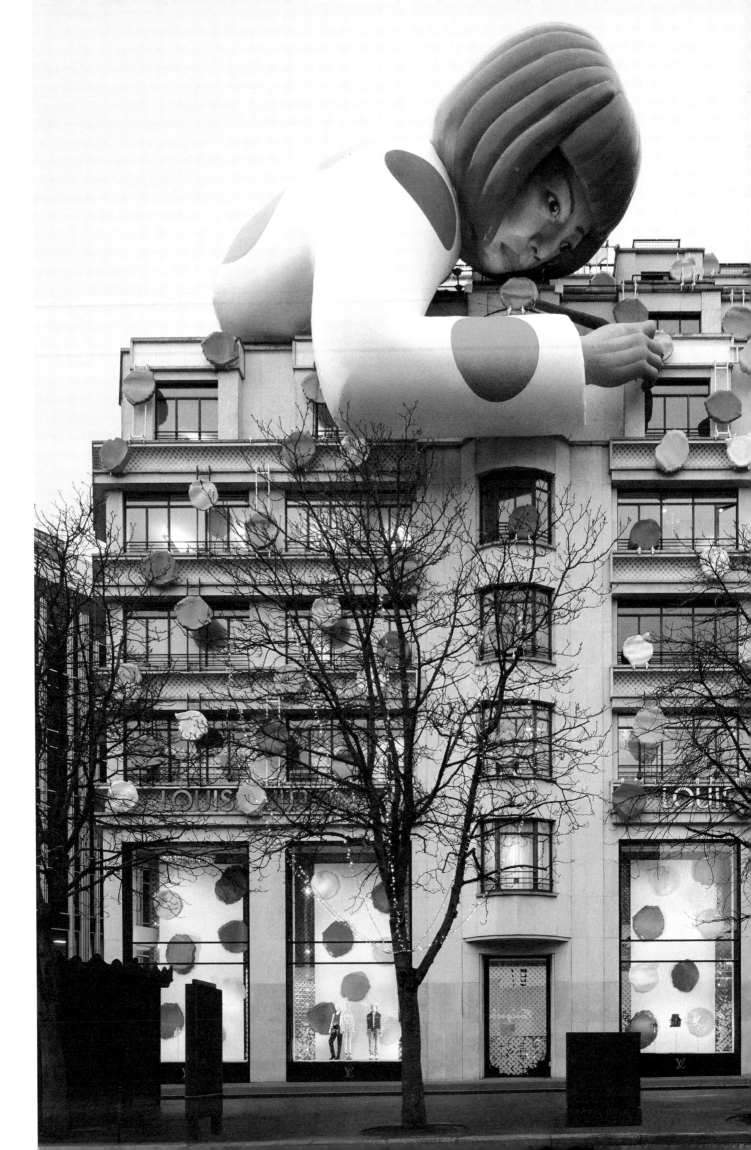

Paris, 2023

Photograph by Adrien Dirand

Louis Vuitton, Yayoi Kusama Painted Dots installation

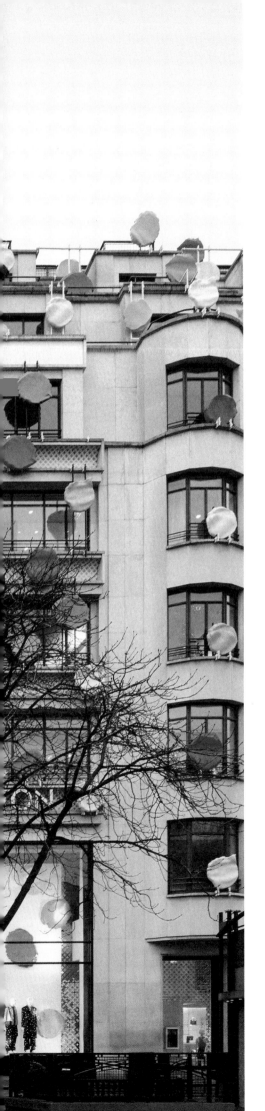

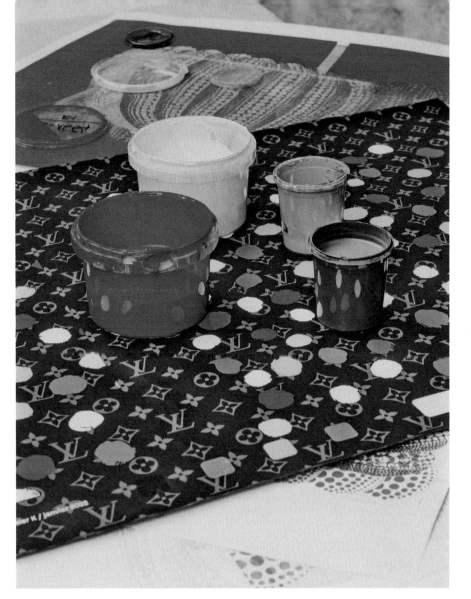

2022

Photograph by Christophe Coënon

Louis Vuitton, Screen-printing color adjustment process

FINANCIAL TIMES

INTERNATIONAL NEWSPAPER OF THE YEAR

EUROPE

FRIDAY 6 JANUARY 2023

3,40€ vendredi 6 janvier 2023 **LE FIGARO** – N° 24 378 – **www.lefigaro.fr** – France métropolitaine uniquement

LE FIGARO

« Sans la liberté de blâmer, il n'est point d'éloge flatteur » Beaumarchais

COMMUNIQUÉ

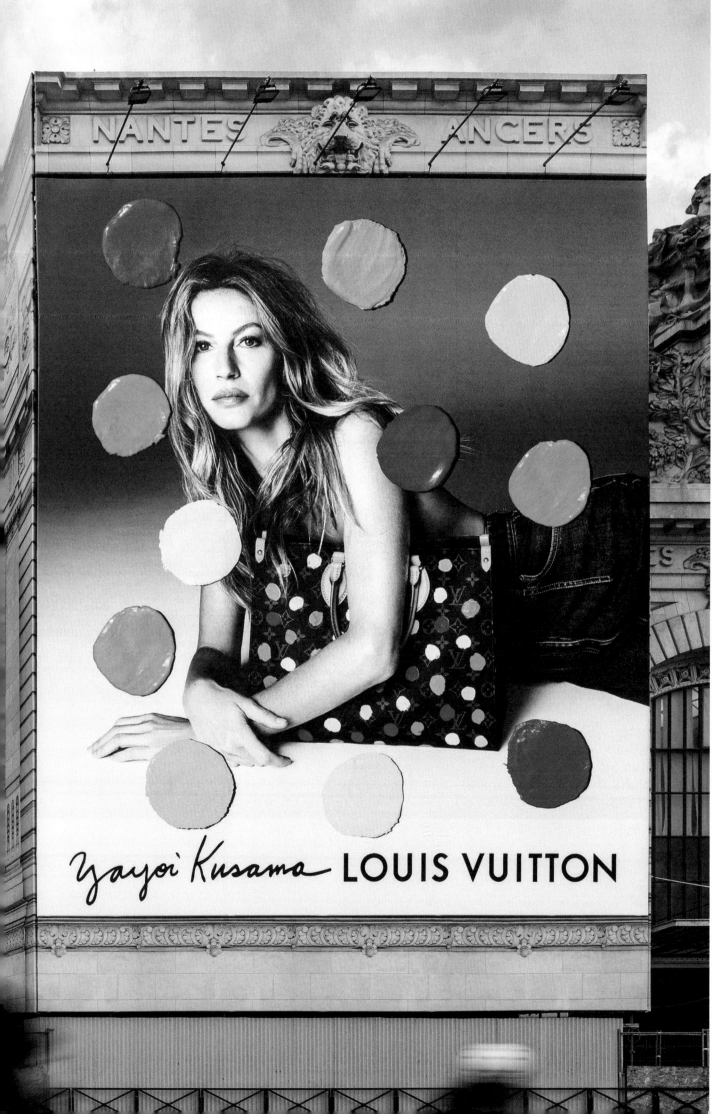

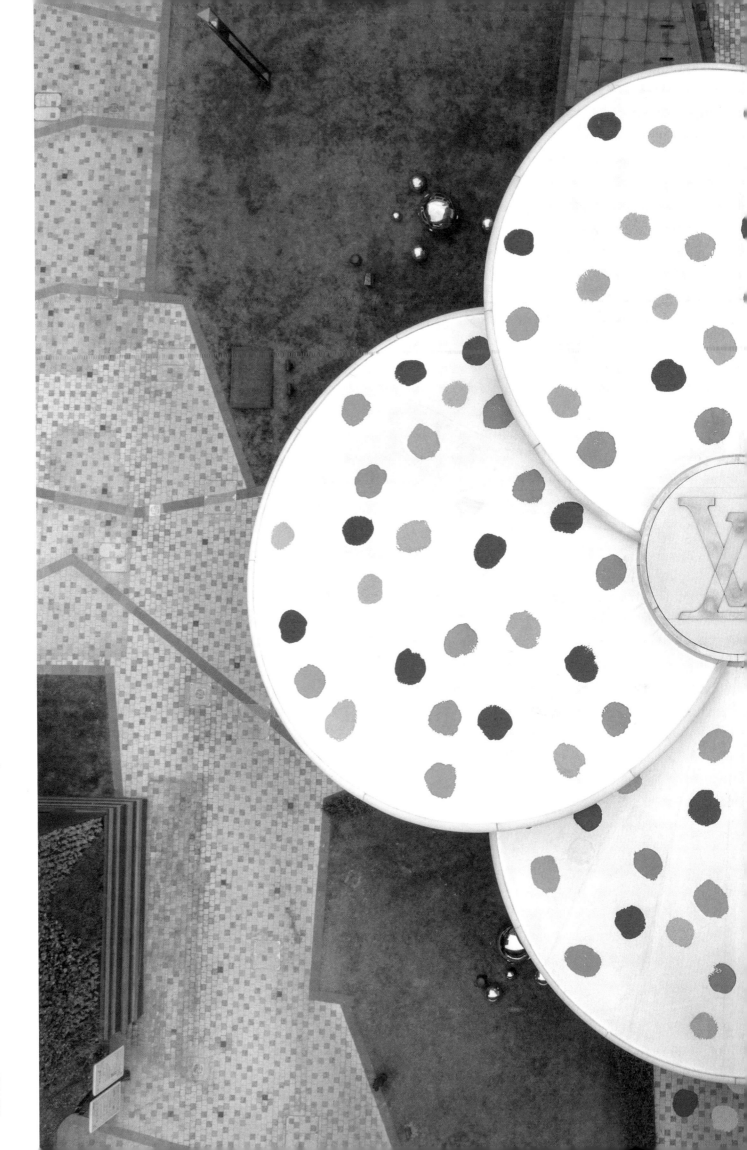

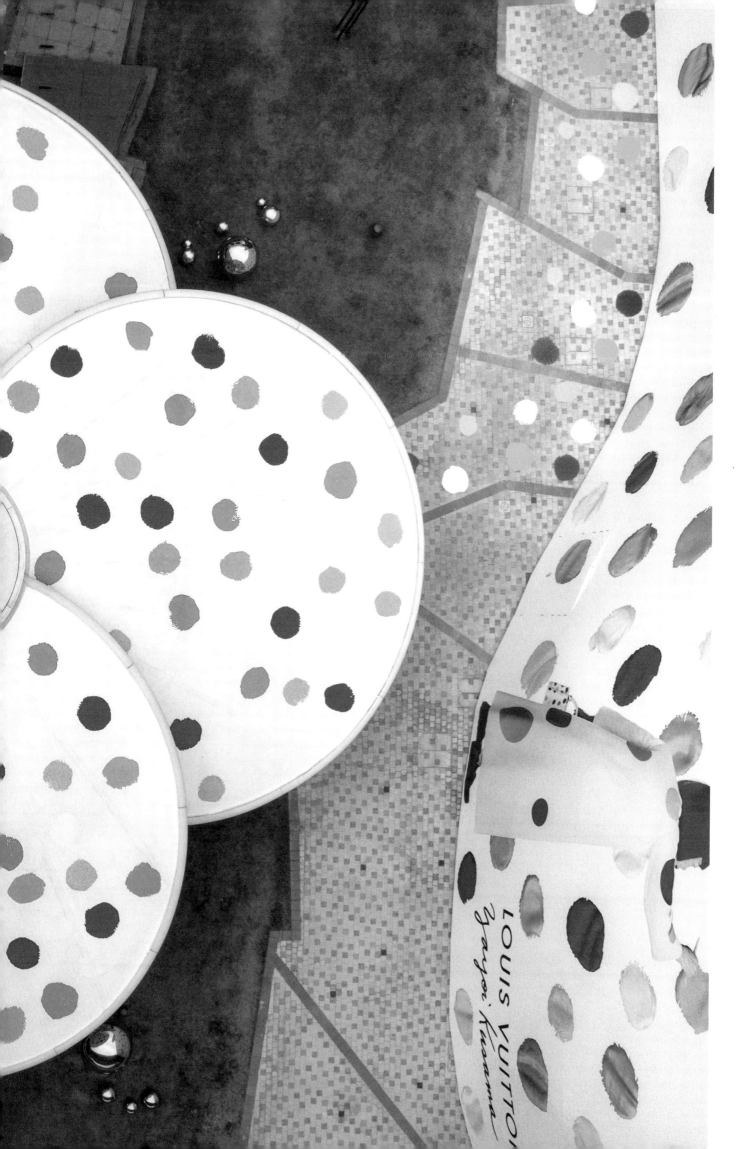

Louis Vuitton Qiantan Taikoo Li store, Shanghai, 2023

Photograph by Zhang Xin

Louis Vuitton, Painted Dots "takeover"

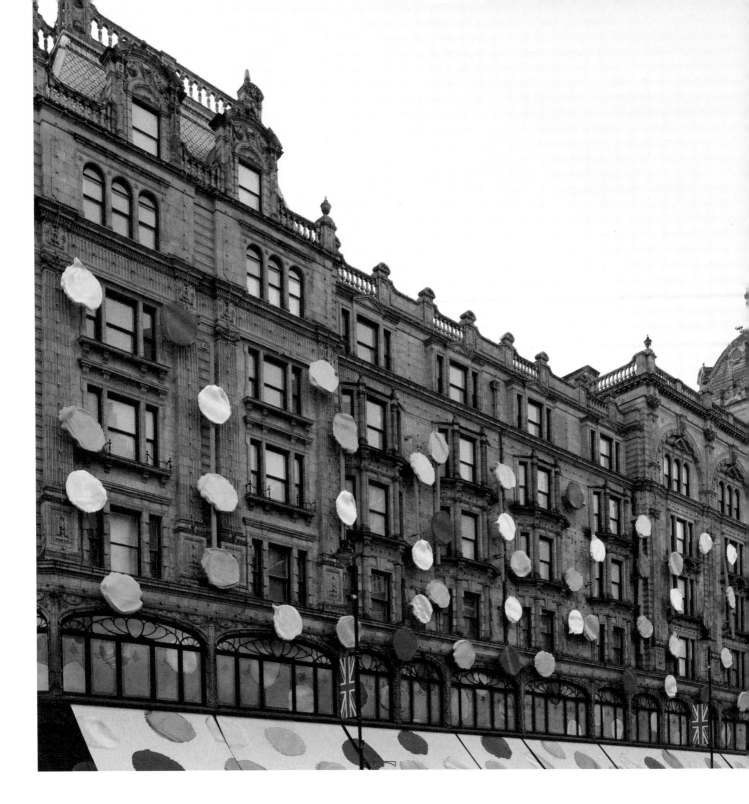

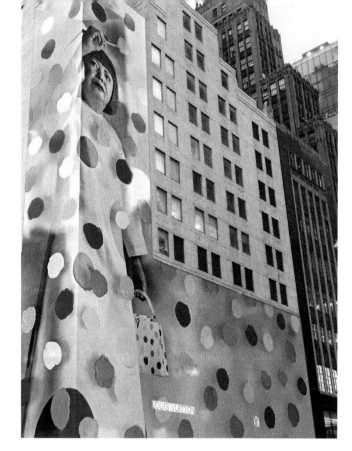

Louis Vuitton Fifth Avenue store, New York, 2023

Photograph by Harry Bowley

Louis Vuitton, Yayoi Kusama Painted Dots installation

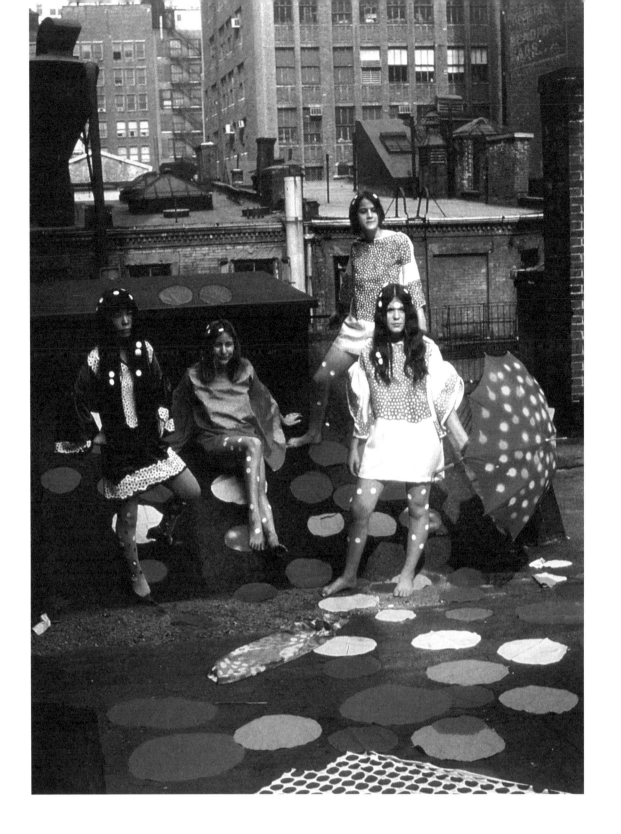

Happening on the artist's studio rooftop

New York, 1968

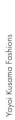

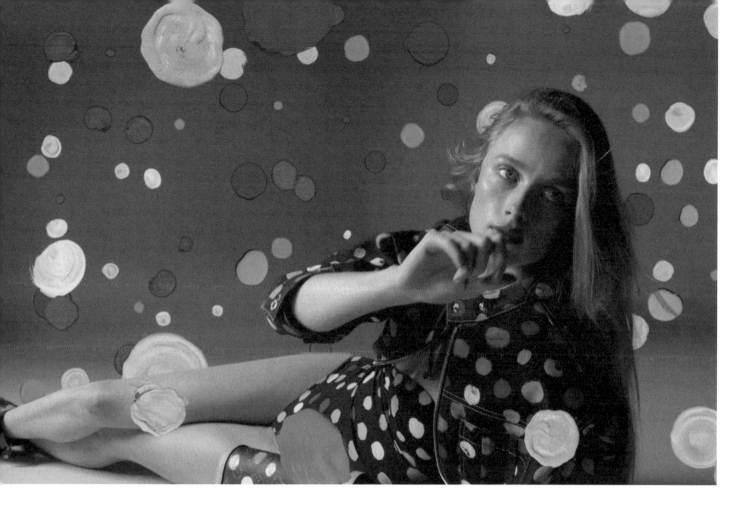

2023

Rianne Van Rompaey for Louis Vuitton

Video directed by Ferdinando Verderi

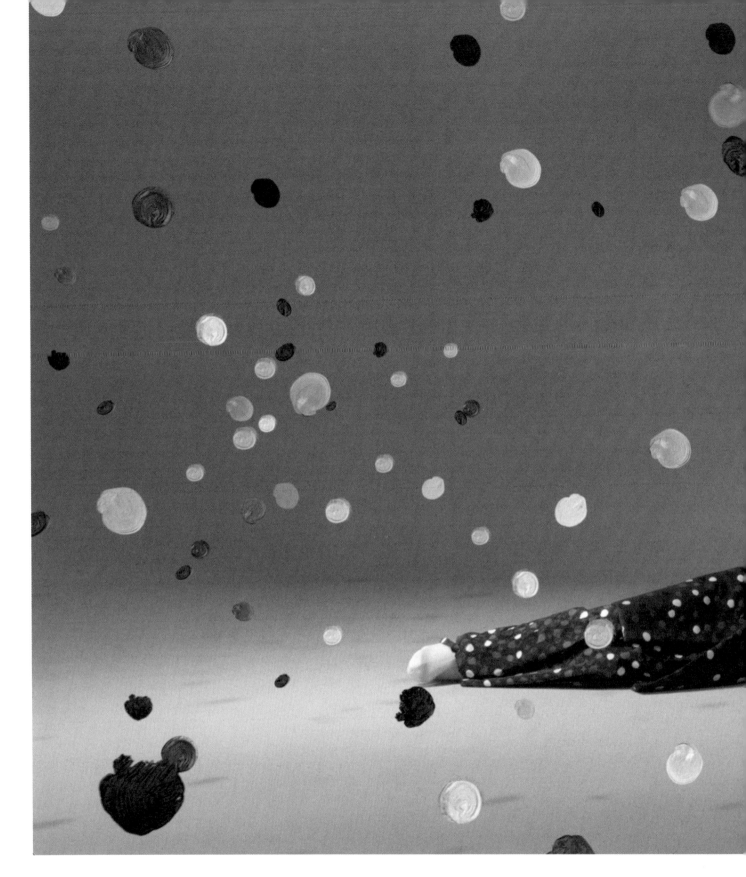

2023

Video directed by Ferdinando Verderi

Malik Bodian for Louis Vuitton

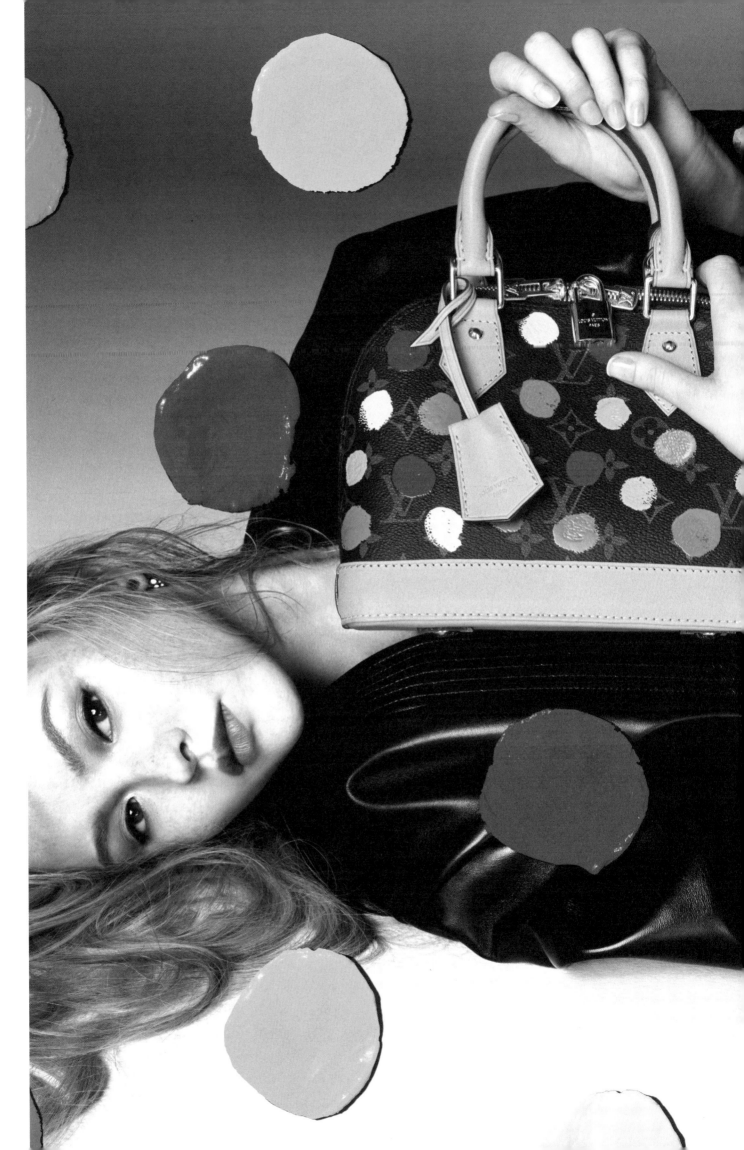

Photograph by Steven Meisel

2023

YAYOI KUSAMA IS AN IDOL—A LIVING ARTIST SUPERHERO. HER WORK IS ENDLESS. ENDLESS LIKE WE ARE. ENDLESS SOULS. ENDLESS FIBER, CELLS, WATER, AND MINDS. ENDLESS BEAUTY, ENDLESS WAYS OF BEING. THERE'S ENDLESS PAIN, IF YOU DON'T FIT IN. ENDLESS WAYS TO GIVE UP. ENDLESS WAYS TO EMBRACE IT. BUT TO KNOW THOSE WAYS, WE NEED ONE WHO HAS THE COURAGE TO SHOW US. SOMEONE LIKE YAYOI, WHO SEEMS TO HAVE AN ENDLESS WILL TO BE ALIVE AND MAKE THINGS.

WITH HER WORK, GAY MARRIAGE BECAME ART. SHE'S A RADICAL. A BEAUTIFUL, INFINITE, RADICAL IDOL.

ANNE IMHOFF

Self-Obliteration (Net Obsession series) Photo collage on paper c. 1966

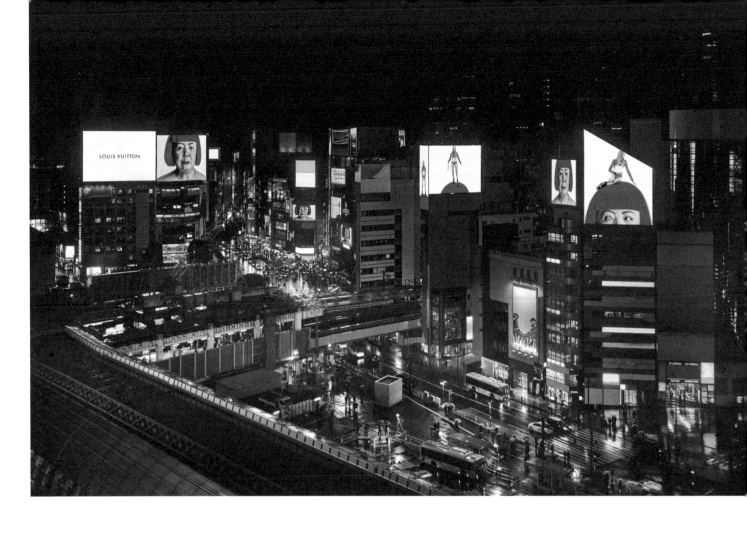

Photograph by Daici Ano

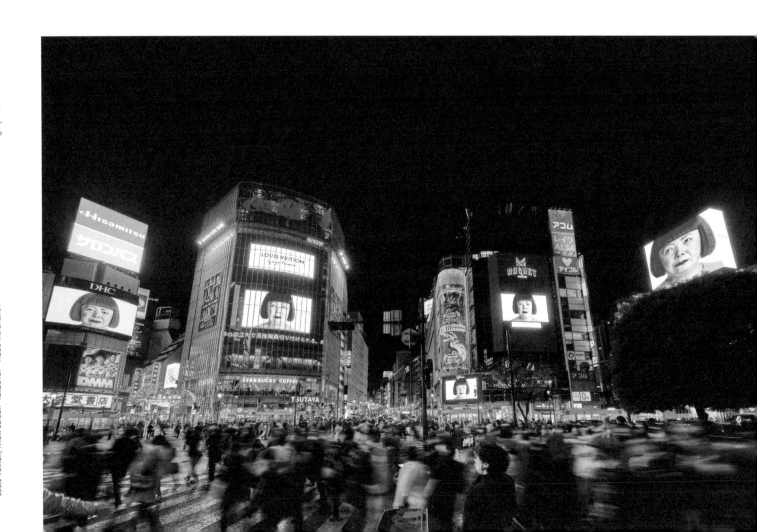

Louis Vuitton, Multi-screen "takeover" video installation

2023

Video directed by Ferdinando Verderi

Rianne Van Rompaey for Louis Vuitton

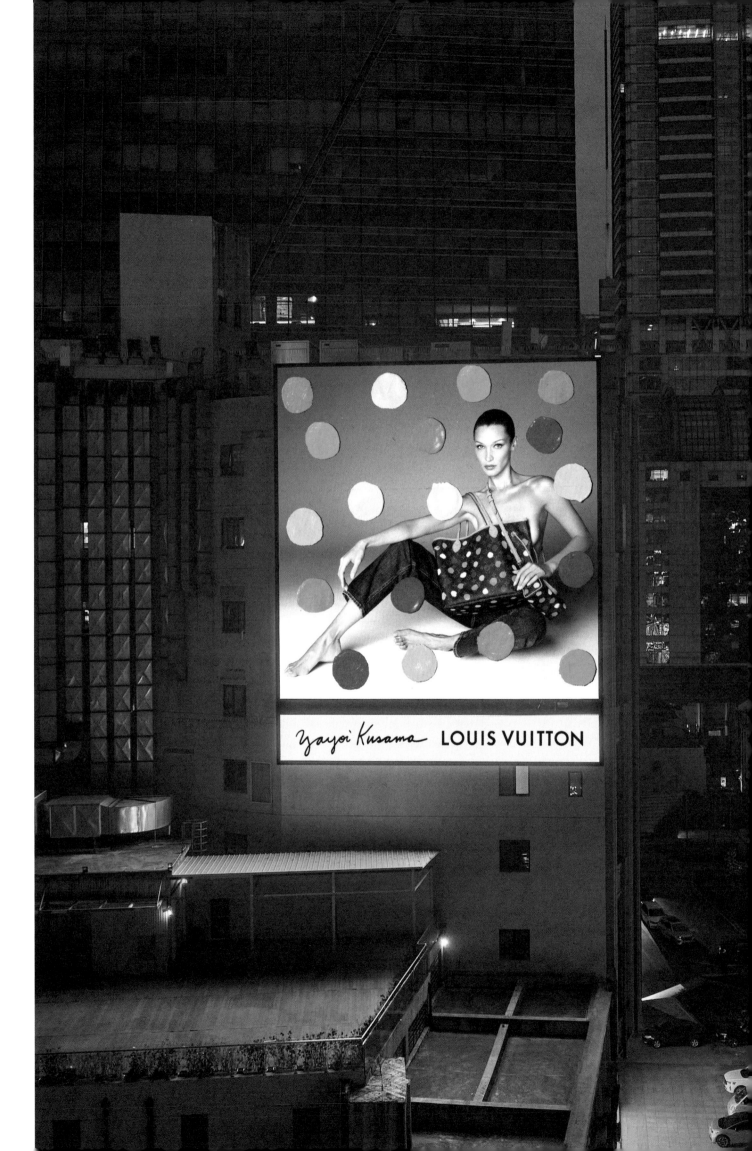

West Nanjing Road, Shanghai, 2023

Photograph by Zhang Enzhgou

Louis Vuitton × Yayoi Kusama campaign billboard

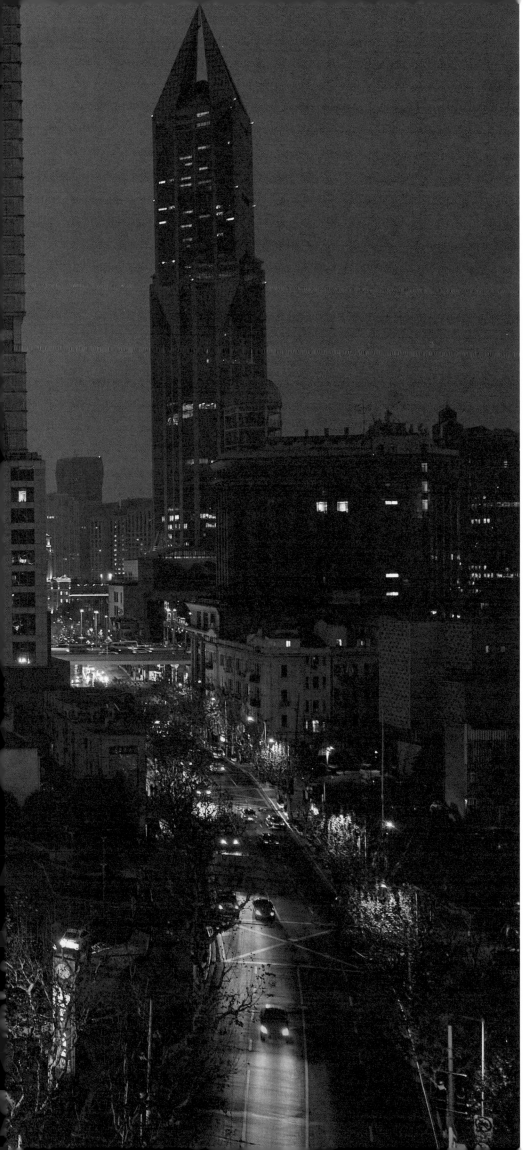

Creating Infinity

Yayoi Kusama

Louis Vuitton

CRAFTING INFINITY: THE COLLECTION OF LOUIS VUITTON WITH YAYOI KUSAMA BY JO-ANN FURNISS

Can a pumpkin be magical? Cinderella and the artist Yayoi Kusama might both answer "yes." "I was enchanted by their charming and winsome form," says Kusama in her autobiography *Infinity Net* of this major motif in her artwork that is equally transformational and beautiful. The pumpkin might become a coach, a work of art, or even a handbag. It could change somebody's life, even for a short time, or it could exist in its magical state for a lifetime, even going beyond one lifetime, hinting at the infinite. What is certain is that Kusama's talismanic objects, installations, and performances transform the world around them, including the artist herself.

Kusama could be seen as a fairy tale figure in real life, yet she is no mere Cinderella. Rather, she is a mixture of Cinders (from one of the retellings of the classic story), the Fairy Godmother, and the rescuing Prince Charming all in one—fighting against the ugly step-sisters of the humdrum and her own crippling anxieties through her art. Born in Matsumoto, Japan, in 1929, Kusama magically and deter-minedly transformed her life. Spinning enchantment from the pow-er of her art while on adventurous quests in the wider world in the 1950s and 1960s, from Tokyo to New York, she rescued herself in the process. After becoming a resident in a psychiatric facility when she returned to Japan in the 1970s in what appeared, to the outside world, to be a sort of slumber (in fact, she never slept but worked tireless-ly—she is not Sleeping Beauty, after all), she emerged as perhaps the preeminent global artist of the twenty-first century and certainly the most successful living female artist. Forever an outsider, Kusama has triumphed and become the ultimate insider—on her own terms.

The last time that Louis Vuitton met the magic of Yayoi Kusama in a collection was in 2012. Yet this relationship never ended—it also slumbered for a time and has awoken, evolved, and expanded with con-versations continued and extended. Louis Vuitton has a long history of working with artists, which can be traced back almost a century, when the eponymous founder's grandson and family aesthete, Gaston-Louis Vuitton, began commissioning artists to create store win-dows and works for the stores themselves. This impetus has traveled through time and has had even more resonance in the contemporary era; since 1988, Louis Vuitton has invited some of the biggest names in art and design to collaborate, including Sol LeWitt, Richard Prince, Takashi Murakami, and Jeff Koons, among others. Yet never before has Louis Vuitton committed so totally to the vision of an outside artistic talent as in this project. Here, Kusama's talismanic objects, motifs, and imaginings of infinity take over in a collection that infil-trates all product categories: handbags to menswear; womenswear to eyewear; fragrances to footwear to jewelry. In turn, there is a trans-mutation of some of the brand's own talismanic items, making them equally part of their own and Kusama's transformative world.

In 2012, Louis Vuitton played its part in introducing Kusama to a wider audience beyond the art world—according to a survey, by 2014, Kusama was the most popular artist in the world. The pop art power of the brand is much appreciated by the artist in terms of transmitting a vision to the wider world. Yet this long-lasting relationship goes far beyond an idea of the promotional to something ultimately emotional

for both Louis Vuitton and Kusama; it is why this current wide and exacting creative exchange has been able to take place, particularly as it started in the midst of the COVID-19 pandemic.

In fact, the fashion house has its own magical thinking and often embraces a daring state of mind. At first sight, it might appear that Louis Vuitton and Kusama make for odd fashion bedfellows. Yet, like many of the brand's other artistic ventures, here is a meeting grounded in sincerity rather than strategy, in iconoclasm over the conservative, and, above all, in a mutual appreciation of craft and excellence over the commonplace. At Louis Vuitton, when it comes to the magic of making objects, anything is possible.

In 2012, Kusama took one of the most timeless and magical of the fashion house's talismanic objects and made it her own—she hand-painted a Louis Vuitton trunk with her characteristic polka dots, which, for Kusama, represent infinity. She then gifted it back to Louis Vuitton, as a parting gift for Yves Carcelle.

An exact replica of these dots—an accurate representation of Kusama's hand—can be found throughout the latest collection and is one of the many things in this collaboration that has tested the limits of and advanced Louis Vuitton's savoir-faire. Each incarnation of the polka dots has been presided over by Kusama personally—as have all the many and varied objects in the collection—being moved with precision to the nearest millimeter, brushstrokes echoed in uncanny detail with their texture and weight intact. It is in this pursuit of the infinite through craft that both Louis Vuitton and Kusama are ultimately united. It is in the making of magical objects that transcend space and time in which both are engaged and recognize in each other. And both Louis Vuitton and Kusama want the person who possesses such objects to feel the care and emotional investment it took to make them, to become part of their story, which will become part of the story of future generations, stretching into infinity.

When does fashion go beyond fashion? Maybe when it's made with eternity and infinity in mind. An initial glimpse of Kusama and Louis Vuitton's infinity-made-fashion took place in San Diego in May 2022, at the Salk Institute, at the Louis Vuitton Cruise 2023 show. In the setting sun, embracing the vista of the natural world the Institute overlooks, there was the glinting of the infinite in Kusama's mirror balls, a motif familiar from her *Narcissus Garden*, shown (unofficially) at the 33rd Venice Biennale in 1966. Here the balls—smoother, smaller and in varying sizes—were placed with exacting precision, embedded in some of the leather goods, encircling a Cannes bag or starting to proliferate on a soft Side Trunk. It was an intervention and a hint, a shape of things to come.

In the collections that have arisen from this project, it is that idea of proliferation that has become paramount. The cascading motifs, their talismanic qualities, and the notion of infinity mirrored in the collection's expansiveness sweep up iconic pieces and transform them along the way. And it is perhaps in handcraft that the idea of the eternal exists for both Kusama and Louis Vuitton.

At the heart of Louis Vuitton is the idea of travel, both literal and metaphorical. Since its founding in 1854, with Louis Vuitton's

master trunk making, to today, with the desire of the house to transport those who buy its objects, whether in actuality or through the imagination. At Louis Vuitton, *la voyage* is all. Together with Kusama, that voyage is emphasized as one that moves through space and time, the traveling of objects through the ages.

Just as Kusama's motifs have traveled with her for most of her life—she began painting her dots as a child of around ten—and will exist after she has gone, so too will these objects, through the apotheosis of handcraft. At Louis Vuitton, nothing is disposable, all are built to last. At the same time, there is a notion of how the infinite can translate, of how it can reach people and be made to function in the everyday, of how it touches people and transforms them. These are clothes and accessories, after all, and it is a joyful participation through wearing them that is always sought—and this is something Kusama is no stranger to in her art.

In 1969, Kusama founded several fashion companies all of which are now defunct. The clothing was meant to embody interaction, communal connection, and sexual revolution for her audience, with the somewhat aggressive, avant-garde items taken from her polka dot–infused happenings and transferred to the department store. While this idea has been toned down somewhat today—none of the clothing in this collection has holes for orgiastic activity, for example—nevertheless, there is still an idea of interaction and an extension of the artwork that is found in the collection. Now the medium could be said to be more transformational in its playfulness and subversive in its elegance. While it still might be a vehicle for Kusama's obsessional self-obliteration through infinite patterns, there is also the romance of purpose for this collection—it's the space that takes on a life of its own through the wearer.

The thematics of the collection begin with symbols of the infinite: the transference of the 1,500 mirrored orbs of *Narcissus Garden* into the world of leather goods, shoes, and jewelry, all echoing an architecture of infinity. Alongside this is another Kusama motif of the infinite, the painted dot—a proliferation appearing across clothing, across genders, across accessories, from a colorful iteration to a gradation of black, silver, and gray. The painted dot itself morphs into Kusama's more familiar polka dot. Woven into jacquards and knits, and printed onto silks and leathers, the elegance of the everyday is utilized for women in short, sharp signature Vuitton silhouettes and into more utilitarian menswear. The dots are all-encompassing, proliferating over all product categories from enamel jewelry and denim, to perfume bottles and surfboards. In the meantime, hints of an exotic flower have begun to unfurl, encompassing intricate printing and jacquards in the menswear, with elegant debossing in leather goods, together with tour-de-force prints and leather techniques in womenswear and accessories.

The next wave further utilizes Kusama's psychedelic take on flora and fauna, mainly through flowers and faces, together with her eternal pumpkin. With a more insouciant air in clothing, savoir-faire is nonetheless at its height through delicate embroideries and precise marquetry, particularly in leather goods such as the Capucines and

Monogram Empreinte bags, where Kusama's elegant hyper-florals co-exist. Recent works, such as *Where I Want to Live* and *The Place for Life* are the site for Kusama's fauna, in the shape of faces. Her joyful characters cascade over clothing and accessories through a combination of hyper-printing and intense embroideries, from women's denim to men's varsity garments, happily disrupting supple canvas monogram bags and artful sneakers. Yet it is the pumpkin that perhaps takes joyful center stage, from exciting yet exacting jacquards and denim prints in casual menswear to a new Monogram Pumpkin Minaudiere in women's leather goods. The graphic playfulness knows no bounds; from hard-sided trunks and men's leather goods with pumpkin "portraits," to silk scarves and the very signature tag of the collection itself.

It is perhaps fitting to finish with Kusama's translation of her *Infinity Net* work into the world of Louis Vuitton. It was Kusama's mesmerizing *Infinity Net* paintings that first brought her to prominence as a young artist in New York in 1959 with their repetitive, obsessive, rhythmic forms. The delicacy and strength of these works are both utilized, whether in a familiar black and blue printed leather, in a surprising fuchsia on Capucines bags, or in the simple encompassing and enveloping softness of a refined wool stole— and there is an idea of the sublime and infinite engulfing all.

MARC JACOBS ON YAYOI KUSAMA AND LOUIS VUITTON

FIONA ALISON DUNCAN You've worked with many significant artists. What do these collaborations mean to you, and where does Yayoi Kusama fit into the roster of artists you've worked with?

MARC JACOBS When I was at Louis Vuitton, I had this idea that I was collaborating with Vuitton. It wasn't my name on the door, it was Vuitton. At some point early on, I thought about how, in Paris, romantically, once upon a time, people in different creative fields collaborated with one another. There was this kind of creative society. I was thinking of Elsa Schiaparelli, Coco Chanel, and the different people in their worlds. As a visiting person, as creative director, and as a collaborator with Vuitton myself, I thought it would be exciting to bring in other creative people to collaborate with—this, to me, seemed like a very European, French thing. I reached out to people whose work spoke to me: Richard Prince, Takashi Murakami, Stephen Sprouse, and then there was Yayoi Kusama.

FAD I love thinking about you as a collaborator with Vuitton.

MJ What I saw in fashion at that time was that young designers were creating ivory towers for themselves. "What an old way to think about things," I thought. Wasn't it the generation before us who built these unapproachable and unreachable things? Why not do the opposite? Let's bring in other creative voices. Outside of the art world, we brought in Pharrell Williams, Kanye West, and other people in music. Even in the ads, we were always bringing in different artists. It felt, to me, very natural and much more contemporary to reference this old time in Paris where, again, there was all this incredible creative collaboration happening.

FAD It's interesting because Kusama's work has also been so collaborative at different moments in her career.

MJ I remember first learning about her performance art pieces from the sixties. I found that to be a really exciting piece of her history. How amazing it would have been to be there then. Going from that moment to the personal exchange I had with her—the whole trajectory is quite extraordinary.

FAD How did you first meet Kusama?

MJ I first met Kusama in her Tokyo studio in 2006. I was excited; I knew I was meeting an incredible person. I didn't want to take up too much of her time or overstay my welcome. I was trying to be respectful, so I said, a couple of times, "You've been so generous and you've given me so much of your time, I should go now." Anytime I said that, she grabbed my hand and pulled me back in. She wouldn't let me leave. A lot of our conversation was repetitive; she is such a representation of the work she makes, with this idea of infinity. She kept repeating, "We have to create it." It felt very special that she was holding my hand and saying this. I felt like I was in the presence of a person who was clearly put on this Earth to be creative and make things.

FAD Kusama's sense of her own destiny from very early on is exceptional. That 2006 meeting was recorded. In it, you talk about not hav-

ing a separation between life and art. This is something Kusama related to and obviously embodies. Could you elaborate on that?

MJ I think that says it right there: there's no separation. I don't think we arrive in a place, do our job, and leave. When you feel like you were put here to do a certain thing, no matter where you go or what you do, that thing is always with you. You'll always be thinking about it and constantly redoing it, re-looking at it, and rethinking it. It's always that one thing. This is what she was born to do. It's what she's always done and continues to do and redo.

FAD In an interview, you speak about the interlocking Louis Vuitton Monogram as this infinitely reproducible and recognizable icon, and about how you were juxtaposing it with Kusama's own infinitely repeating shapes.

MJ I revered the people that we collaborated with at Vuitton. I didn't want it to just be a commercial exercise—that felt wrong and disrespectful. Of course, it's a commercial product. Of course, we want to sell things. But the art and the creative side had to come from a place of integrity. In fashion today, the word "collaboration" is used a lot. I don't want to sound bitchy, but I do see brands that collaborate with people and it doesn't feel like there is much heart or soul in it. I had so much respect and admiration for Kusama and her work, and what we did together had a commercial appeal, definitely, but whether it was with Yayoi, Richard, or Takashi, I always felt that there was a lot of heart and soul in what we did, and a lot of integrity as a result.

FAD What is it about Kusama's work that translates so well to fashion and design?

MJ You don't want to reduce a great artist to being decorative, but her work is extraordinary and she is such a representation of it. What she brings in terms of herself—what she looks like, how she dresses—is appealing from a visual sense. On a fashion level, she offers so much to take in: the colors and patterns are bold and playful. The world she has created has a face-value appeal. I was immediately drawn to her work, probably in a very predictable way, and by that what I mean is that I love polka dots.

FAD What is it about polka dots?

MJ I've always loved a spot or dot. I had a primal connection to Kusama's work because of that shape and the repetition of it—the infinity of it. It's hard to explain a primal connection, but if it were squares, I wouldn't have responded the same way. I have a natural affinity and love for this endless round shape; no corners, just endless.

HANS ULRICH OBRIST IN CONVERSATION WITH AKIRA TATEHATA

Creating Infinity

Yayoi Kusama

Louis Vuitton

HANS ULRICH OBRIST I want to ask you about how it all began: How did you and Yayoi Kusama meet?

AKIRA TATEHATA [in translation] When I went to Yayoi Kusama's first collage show in Tokyo in 1975, I was a little hesitant and scared. Kusama was considered a queen of scandal in Japan. I remember seeing her, a small woman sitting in a corner, and being afraid to talk to her because of her reputation. But that reputation was unjustified. The show was fantastic, poetic, and courageous. I was shocked by her genius. My mission as a curator became to establish her on the domestic and international stages, to get her the right kind of recognition. I was still in my twenties and I had no influence. I was not known. I was the youngest member of the curators' group at the National Museum of Modern Art in Osaka and I had no authority to make any decisions. I established two objectives: Kusama should have a retrospective at the Museum of Modern Art [MoMA] in New York and be exhibited in the Venice Biennale. Since I had never been to MoMA or the Biennale, I only fantasized about these dreams. As I gained more experience as a curator, the Japan Foundation contacted me to become a Japanese commissioner for the Venice Biennale. When I first brought up Kusama's name, we were told that it would be difficult because she had suffered from psychological problems.

Three years later, I brought up Kusama's name again and even though it was opposed by many parties, I finally convinced head of the Japan Foundation and other government figures to hold a solo show. At that time, people located Kusama within Pop art, Postmodernism, Post-Minimalism, and kitsch. I had seen the catalogue for her 1989 solo exhibition at the Center for International Contemporary Arts in New York—her first international retrospective—which showed the important role she had played in the transition between abstraction, Neo-Dadaism, Pop art, and Minimalist art in New York. The *Infinity Net* paintings and soft sculptures were featured in that show.

Kusama's works were easily loaned at that time, so I exhibited them, also focusing on the transitional role she had played in the New York School. I was criticized and told I should have emphasized kitsch and Pop more. But more curators started looking at Kusama's work because of this show. Soon after, the Los Angeles County Museum of Art's curator approached me to become the advisor and write the catalogue text for the exhibition *Love Forever: Yayoi Kusama, 1958–1968*. The exhibition traveled to different museums and galleries, including the Museum of Modern Art. I had accomplished my ambitions of placing Kusama in solo exhibitions at the Venice Biennale and MoMA and seeing her become an international figure. During this time, I had started fostering a relationship with Kusama. In 2001, at the first Yokohama Triennale. I was able to act as a curator to continue to introduce her work to the world. Little by little, I achieved a better understanding of our mutual intentions.

HUO I'm interested in the incredible depth of your relationship. I have always believed in working with artists again and again. Being one of her closest confidantes, I'm interested in the development of your relationship with Kusama over the years. How has your percep-

tion of Kusama's work changed and how has the perception of her work changed more generally?

AT It is true that some of the ways I've viewed Kusama have changed, but the basics haven't. Observing her in the midst of creation, Kusama has a special mentality. When she continues the same type of work for several weeks—the *Infinity Nets* are a good example—she doesn't get tired or bored. She continues working on her creations at a steady pace. Whether it be sculpture, installation, or literature—she has published fourteen books or novels—she practices systems of repetition and reproduction. Maybe fifteen or twenty years ago, she started the fifty-work *Love Forever Series*, which she made using a felt-tip pen. Up until then, her repetitions had been, generally speaking, more abstract. Suddenly she started to come up with more concrete, representational images, mainly centering around her self-portraits. These were made using monochrome colors.

In the following series, *My Eternal Soul*, the works contain some abstract images but continue to be more concrete. She also started using very strong colors. Of course, Kusama had used color before, but now she was demonstrating her power of drawing using color. I was really impressed and surprised by this; it was different from the image I had of her up until then. One thing that hasn't changed, and I think this may come from her special mentality, is that Kusama doesn't do any preliminary drawings or anything on a trial-and-error basis. She doesn't work on something repeatedly, gradually improving upon it until it becomes the final product. She immediately creates what to her is the final product, the final work. Kusama's mentality is the major motivation for her creative work; as such, she could be considered an outsider and yet, as Jan Hoet, director of SMAK in Ghent has remarked, Kusama is not an outsider, because she changes with the times. An outsider does not belong to a particular time or era. In Kusama's case, she really follows the zeitgeist. As the times change, her work changes. She will have a peace message for one era, another message for another era. A genius knows where she should be and when she should create something.

HUO This is a really key point. If you think about her 1968 *Anatomic Explosion* on Wall Street, where dancers performed in the nude accompanied by a musician in front of the New York Stock Exchange, it was really a reaction to the times. Kusama's work has always left the viewer a lot of space, aligning with Marcel Duchamp, who said that the viewer does half the work. How does Kusama connect with the viewer?

AT If it is about connecting and synchronizing with the audience, Kusama is somewhat of an outsider—she's very private and she creates images from her own world—but in her case, what is very private conversely leads to issues and feelings that many people in the public think about. For example, when she uses high heels, robes, or fabric, things that women may associate with, it leads to such big images on such a large scale that those things become cosmic. Even if she is an "outsider" and people see something that is rather unusual in her work, they also feel sympathy and in sync with her.

HUO That's a great answer. The other aspect of my question was about how Kusama brings different art forms together in her work: novels, poetry, installations, performances and happenings, all the while reinventing painting again and again. The fluidity of her practice is very relevant to younger artists now, who are also bringing all the art forms together.

AT Creating poetry is at my core and I have become very interested in Kusama's written work. She started writing novels and poetry after she came back from New York. She is highly intelligent, and she writes with deep insight. Her first prize-winning publication includes violent scenes such as castration and other elements that were close to the images in her visual art. The methodology of her literature connects with the methodology of her art, as in the image of suicide or infinitely repeating particles or dots. An image recurs in her writing of her repeating the dots, and while doing this, she keeps disappearing. Her motivation is obsession. She keeps repeating and she can't help repeating—that's obsession. Obsession is a human sensation, it can be similar to fear, something that you want to escape, deny, or overcome. It is a negative feeling, yet people are attracted to others who are suffering from obsession because everybody has obsessions. Kusama boldly shows other people's obsessions and her own, and this resonates, transcending differences of gender, culture, or generation. No matter where you go, whether it's South America, Asia, or Europe, many people are attracted to her work. Intrinsically horrifying things can become a common thread, connecting people and inspiring communication.

HUO You mention the dots—I want to discuss Kusama's dots and the new Louis Vuitton collaboration, which is the second time Kusama has collaborated with Louis Vuitton. It's the first time that every product category—women's wear, accessories, fragrance, bags, shoes, sunglasses—will be done by one artist. From the beginning, Kusama has wanted to share her philosophies with everyone and to bring art outside of the museum, to the people. She famously said, "Polka dots can't stay alone." With just one polka dot, nothing can be achieved. It is important that they appear together in great numbers. Early on, she also said, "I want to become more famous, even more famous...." This project contributes to that in an important way. In order to understand this project with Louis Vuitton, it's important to hear about her desire for these dots and for her work to be everywhere, reaching as many people as possible.

AT I agree with your view. A little over ten years ago, Kusama created her first Louis Vuitton collaboration, and now the second one is ongoing. In both iterations, the Louis Vuitton retail space was covered in dots. Now, that extends farther into the urban environment. The Tokyo Tower, a great landmark, has been embellished with polka dots. Mirror balls were laid out on the foothold of the tower. You might wonder why an artist accepted such a commercial endeavor. Some people might misunderstand that Kusama has commercial ambition, but her real message, the core message, is to save the world with love. This goes way back. An example of this is found in the letter she wrote to

President Richard Nixon during the Vietnam War. When you first read it, you might think her message is, "Why don't you stop warring and have sex with me?" That's an extreme position, a provocation, which risks being misunderstood. But the love that Kusama believes in, she really believes could save the world. Whenever there is a world crisis, whether it's pandemic or war, she sends her message of doing away with evil with love. The Louis Vuitton project holds this idea and image of polka dots—the basis of communication—spreading all over the world and among all the people of the world, and that through this, the common thread of our humanity will be recognized, leading to a peaceful time. Kusama has a self-love that can be seen as egoistic and narcissistic, but at the same time her self-love could, in turn, fill the world with her own image and love. She's not doing all this to be a sensationalist or simply to attract attention. She has a very stubborn and strong belief in wanting to change the world with love. This is her mission.

HUO This is very beautiful. I am reminded that Kusama is working on a new series at the moment titled *Every Day I Pray for Love*. The poet and artist Etel Adnan once told me, "The world needs togetherness not separation, love not suspicion, and a common future not isolation." That seems to connect so much with what you've just said.

It's noteworthy that at this moment in time, there's a big interest among younger artists in running their own companies, brands, and even their own economies. This is something Kusama anticipated. She ran a fashion company in the sixties and had even developed, in her teens, her own fashion line. For her, fashion and art have not been antagonistic—quite to the contrary, there is a bridge between the two.

AT Kusama, as you say, considered fashion not only as a personal interest, but she also created her own company. She signed contracts with department stores and tried to sell her fashion widely. She was interested in pairing enterprise with her art activities at an early stage, but she was also very radical. She created fashion for sex, which was rather scandalous and not something that could be sold widely. She was trying to save the world through art and this was part of that. Of course, this kind of business was not a mainstream business, it could not turn into a large-scale business; it was very eccentric and scandalous. Many younger artists are trying to start up their own brands now, and maybe what she and these artists have in common is that they are trying to save the world with the power of art, in a broad sense. It's very interesting to look at this from a social perspective. Maybe we need to look at the meaning of enterprise for Kusama from a new angle.

HUO I'm always interested in artists' unrealized projects. We know a lot about architects' unrealized projects, since they publish them as part of architecture competitions, for example. I've spoken with many artists about their unrealized projects, but we generally know very little about them because they're rarely published. Louise Bourgeois once told me about her dream to build an amphitheater. Can you talk more about Kusama's unrealized projects, dreams, and utopias? In a way, the idea of having the polka dots everywhere to create world peace is one of

these utopic projects.

AT I mentioned before that Kusama doesn't work in trial-and-error; something that seems impossible from an outsider's point of view actually will get realized as a work of art. I've seen many such examples from her. She's intuitive and, of course, ultimately, some engineer, technician, or expert will help create the final project, but she still gets to realize these things in front of your eyes. She has a lot of *Infinity Mirror Room* projects, for example, for which she never creates models or prototypes herself. She gives the simple and precise instructions—as there are many different ways you can position mirrors—just once and the technician will follow those instructions and then a fantastic space gets created. Every time it is realized, we are so surprised. Her intuitive judgment is best when not intervened with. When I was working with her, kind of assisting her, if she asked me for advice, I would try not to say anything because if I gave my opinion, I knew her work would be negatively affected. As for the future, what I can say is she is stepping into new fields and that she is always willing to embrace the challenge of new endeavors.

HUO Art has been connected to healing, and Kusama has spoken very publicly about her mental health. She says, "I fight pain, anxiety, and fear every day, and the only method I have found that relieves my illness is to keep creating art. Painting helps me keep away thoughts of death for myself, that's the power of art. The power of art is to keep away thoughts of death." This is so relevant to the current world. We live in a moment where, with the environmental crisis and the many different wars raging, the idea of healing the planet is more important than ever. It will be great to hear about the legacy of healing in her art and how the Yayoi Kusama Museum and Foundation, of which you are a part, plans to carry Kusama's art of healing into the future.

AT Maybe she was not aware of it herself at the time, but from a very young age she was engaging in some sort of art therapy. She has this image of being fearful as a small child, and in trying to move away from this mental burden, she got her start. She had an instinctive sense of therapy. Healing was a very important thing for her on an individual level. Even today, it continues in the creation of her work. Central to her work is obsession, and making work is how she gets away from obsession. I'm not an expert, but I think that's the way she uses it, as art therapy. Kusama established the foundation that I'm involved with. She is ninety-three, and still very active in creative work. The main purpose of the foundation is to maintain her legacy—her messages, thoughts, publications, and artworks—going forward. How Kusama's philosophy is to be inherited and disseminated by the foundation is something that we are still thinking through together.

Transcription and translation by Eriksen Translations

MIKA YOSHITAKE ON YAYOI KUSAMA

FIONA ALISON DUNCAN Yayoi Kusama, being in her nineties now, is holding almost a century of history, and a century in which a lot changed for women and artists of color. Could you help us understand just how exceptional her ambition is for a woman from Japan born in 1929?

MIKA YOSHITAKE I've never met someone as ambitious and singularly pioneering as Yayoi Kusama. Kusama comes from a matriarchal family, in which her mother and her mother's family were the owners of the large seed nursery where she was raised. Kusama battled with her mother, a strong and controlling woman who was a role model and foundational to Kusama's ambition. Kusama still calls herself an avant-garde artist; she always wants to be on the forefront of whatever is happening. There are stories of Kusama carrying a six-foot painting all the way up and down twenty-five streets in Manhattan only to find that the gallery owner wasn't interested. But she never gave up. Stuffing her kimono and her suitcase with money on her journey from Japan to New York and knocking on the doors of different galleries, doing as much as she could to get herself known in the early days, I think paid off. The ambitious expansion of her practice is also evident in the vision that she has of polka dots multiplying into infinity, as well as her technological progression from paintings to stuffed and sewn sculptures to the *Infinity Mirror Rooms*, which expanded her vision of infinity.

FAD There's an intense coexistence of polarities or binaries in Kusama's work, from self-obliteration, death, suicide, solitude, and individuality to excess, accumulation, fame, and connection. All of these, of course, can be a form of transcendence or reaching toward the infinite. Could you speak about the dynamic interplay of binaries in her work?

MY Deep dualities recur in Kusama's practice, such as the artist's engagement with infinity and ephemerality, organic and cosmic life, accumulation and obliteration, the scale shifts between the microcosmic and macrocosmic worlds and the positive and negative spaces of her nets and polka dots. Since the very beginning, growing up in the family seed nursery, Kusama has had a significant engagement with organic and cosmic life, or the "biocosmic." Her observations of plant anatomies and their cycles of life and decay became the basis for a mysterious vision that generated her most intimate collages, assemblages, and sculptures. These are not necessarily opposites, they are dissonant convergences, a mode in which Kusama's work exists as dynamic and not static. These dualities generate unique forms that are not representative of one thing. A pumpkin can have both a grotesque and cosmic aesthetic. Like a hole in a peach that reveals the indexical trace of an insect's life, Kusama's vivid world exists between mysticism and symbolism.

FAD Could you speak about Kusama's motifs of infinity nets and polka dots?

MY The *Infinity Net* paintings are inspired by the waves that she witnessed over the Pacific Ocean flying from Japan to the United States. The original image is actually ocean currents. The polka dots are the negative spaces of the infinity nets. That binary network is

very important. The polka dot is really about interconnection. One polka dot is an isolated cosmic form. It could be the moon. It could be the sun. And yet, for Kusama, two dots connote the symbolic realm of communal connectivity. I use the term "radical connectivity" to describe her philosophy of self-obliteration, which called for the emptying of one's ego in pursuit of seeing one another on equal terms. This idea became politicized in the late 1960s during the Vietnam War when Kusama staged her notorious happenings, in which she rapidly painted polka dots on nude bodies, before police arrest, to demonstrate the communal connection against the alienation that people felt amid the increasing futility of the anti-war protests. Self-obliteration was a means of communal healing, to radically connect those who experienced being on the margins of life.

FAD Around the same time as those performances, Kusama had her own fashion line.

MY She had a company called Kusama Enterprises. It's really remarkable that she was already thinking about this more entrepreneurial way in which she would promote herself beyond her art practice. I think this was because she wasn't as well-known enough then, and so used other means to promote herself through her provocative happenings via the press. She was very self-conscious of being photographed. In addition to designing the incredible infinity net pattern and tie-dyed tunics, many of her clothing designs had cut-out openings to reveal breasts and genitalia to promote sexual revolution and freedom. There was an amazing beach happening where the performers were all wearing tunics, the tide was rolling in, and together they held a Soviet Union flag. This was a political statement about war and the Cold War. Kusama had sewn parachutes during World War II in Japan, so she had the skills to sew. She was trying to do something that was very against societal conventions and make a statement as part of Kusama Enterprises. Later on, in the early 2000s, she collaborated with the design firm graf, and they reprised some of her sixties designs with current patterns. They also made DayGlo environments and furniture.

FAD Your engagement with her work has spanned both your doctoral work and the many exhibitions you've mounted of her art. How have curatorial approaches to Kusama's work changed throughout her life and career?

MY Kusama had this bout of success early on, in the late 1950s and early '60s in New York, but her first survey exhibition in a museum wasn't until 1987 at the Kitakyushu Municipal Museum of Art, Fukuoka, in Japan. After returning to Japan from New York in 1973, Kusama went through a period of poor health and retreated for a while. The 1987 survey focused a lot on her installations that are still under-recognized, in my opinion, because formally they're more challenging, with these large-scale, psycho-sexual, grotesque botanic forms and expansions of her accumulation sculptures, which look like thousands of phalluses stuffed and sewn around domestic objects. At the time, the reviews were really mixed. Two years later, when Alexandra Munroe curated her big survey in New York in 1989, Kusama's work

was revisited in the United States within the context of abstraction, Minimalism, and performance art. This was a critical survey with an incredible catalogue that included a deeply researched chronology. She went on to represent Japan in 1993 at the Venice Biennale. Since then, she's had retrospectives all over the world. Japan has been the place that has taken her early, pre–New York years seriously. Kusama is also a prolific novelist and her exhibitions in Japan have also tended to be more literary. She started publishing novels in Japan in the 1970s and '80s. Kusama's major breakthrough was when she had her major retrospective which was organized by Tate Modern, London. It opened at the Reina Sofía in Madrid in 2011 and then traveled to the Centre Pompidou, Paris; Tate Modern; and the Whitney Museum of American Art, New York. That was also the year of the first Louis Vuitton collaboration, and a time when Instagram started to become popular. My exhibition at the Hirshhorn Museum and Sculpture Garden in Washington, DC, further catapulted her because the show featured six *Infinity Mirror Rooms*, which are often the most Instagrammed installations. These convergences really helped to spearhead the recognition of Kusama in a popular and social media sphere as well as in the academic and art worlds.

FAD What are the roles and responsibilities of a curator with regards to an artist like Kusama?

MY The role of a curator is to understand how Kusama speaks to our current moment. Historically, you want to be able to understand the social and geopolitical dynamics that she was coming up against, living as an Asian woman and growing up through war and witnessing so much destruction. The cultural and racial divide between the United States and Japan when she moved to New York was both challenging and informative. She experienced a lot of racism and discrimination as a Japanese woman. But she also used her identity to her advantage, playing the stereotypical Japanese artist clad in a kimono in some of her films and happenings. I think that the role of a scholar or curator is to understand the impetus behind these events and her deep philosophy as an artist.

A curator's responsibility is also making historical corrections. There are stories about Andy Warhol and Kusama meeting, for example. He saw her *Aggregation: One Thousand Boats Show* installation at the Gertrude Stein Gallery in 1962, which featured a rowboat covered in thousands of stuffed and sewn white phallic tubers and surrounded by a wall of 999 photographic posters of the same boat. That was before Warhol had made his first silk screens. Of course, he became a household name for his silk screens. There are other examples like this. Her first *Infinity Mirror Room* was made in 1965, the year before Lucas Samaras's *Mirrored Room* from 1966, but people still think Samaras's work was first because of the bias given to white male artists in Euro-American history. You dig into these histories and try to reset them, so that the artist gets her due. You rewrite history so that people know she was a pioneer.

FAD Kusama is as well-known for signature motifs as she is for her own likeness—a diminutive figure, dressed in dots, with bright red hair in a severe crop. What is she like in person?

MY Kusama is intense. You can tell that her body has a memory when you watch her paint just from the powerful energy she gives off. The first time I met her, she was very focused on getting her story told and correcting false historical claims about her; for example, she and the artist Joseph Cornell had had a *platonic* relationship (there's been a lot of writings about them being lovers). She also loved gifting one of her design products and exhibition catalogues. After that, every time I would visit the studio and meet with her, she was always adamant about showing her latest works one by one. She wanted to know if I liked it or not, what was my favorite, what was working, what wasn't working, and how the public would react. She wanted immediate feedback. In the last few years, I've heard that she's become more at peace with herself in her place in the world. She has always wanted her work to be seen and experienced by as many people as possible, and this has been a driving source for her creativity and survival.

FAD Earlier on you mentioned that one of the curator's roles is to understand how the artist's work speaks to our current moment. How is Kusama speaking to today?

MY Kusama's practice offers a deeper awareness of life, mortality, and therapeutic healing in our age of the global pandemic. Kusama has always been honest and open about her lifelong struggle with mental illness, and the pandemic has helped us to confront mental health issues. Her philosophy of self-obliteration has been a means of communal healing, to radically connect humanity and nature, and thus her work has been an inspiration in terms of normalizing struggles with depression that many people have been going through. The last section of the exhibition I curated in Hong Kong is called Force of Life, which features Kusama's most recent and prolific body of work *My Eternal Soul*. Rendered in vibrant, often metallic palettes, these paintings demonstrate a fierce and primordial energy that generates enduring strength with recurring compositional motifs ranging from the familiar dots, nets, fish scales, primordial figures, mosaics, radial forms, shells, strips, stitched patterns, tentacular eyes, and delicate marks reminiscent of fingerprints. Her latest body of work is a source of peace and healing, but also confronts humanity's power struggles and the need for interconnection. Her strategies are received and disseminated so well on social media because her work is based on a shared economy of people's desires to connect with one another and feel they are not alone.

KUSAMA COVERS THE WORLD BY JEFFREY DEITCH

Yayoi Kusama caused a scandal at the opening of the 1966 Venice Biennale. Her *Narcissus Garden*, covering a section of the Giardini with 1,500 mirror balls, was the first artwork that visitors encountered as they approached the Italian Pavilion, the principal venue of the festival. The Biennale authorities should have been thrilled, but Kusama undermined the supposedly noncommercial status of the exhibition with Dadaistic provocation. A sign near the artwork advertised "YOUR NARCISSISM FOR SALE, $2" (and, conveniently, it also offered the price in lire as well). At the opening, the artist tossed mirror balls in the air, offering to sell them to visitors. The director of the Biennale was not pleased.

Sixty years ago, Kusama was already playfully blurring the boundaries between fine art, promotion, and commercial accessibility. Describing Kusama's artistic approach in the catalogue for her 1998 retrospective, Lynn Zelevansky wrote, "her work strives to be nothing less than all encompassing: no contradiction exists for her between aesthetic engagement and publicity." Kusama pushed the radical history of "Artist as Art" to a new level.

Visitors often wait in line for an hour or more to enter Kusama *Infinity Mirror Rooms* in galleries and museums. People crowd the sidewalks in front of Louis Vuitton boutiques, transfixed by Kusama window installations. Yayoi Kusama has transcended the contextual frame that traditionally separates the display of art from real life experience. Kusama's Louis Vuitton handbags, her storefront displays, and the buttons that she gives away are as much part of her art as her paintings in the collections of major museums. The remarkable Kusama story: her naked performances in New York in the 1960s, her residency in a Tokyo mental hospital since 1977, her radical novels, such as *Manhattan Suicide Addict*, are now inseparable from the experience of her art.

Museum curators were happy to offer calendars and coffee mugs with artists' images in the gift shops at the exit of their exhibitions, but traditionally frowned upon artists collaborating with commercial brands. Salvador Dalí had collaborated with Elsa Schiaparelli and Walt Disney, but the artists of the New York School had to fight to get the public to take their art seriously and tried to separate their art from the commercial sphere. The Pop artists began to venture into accessible products but—aside from Andy Warhol's embrace of "business art"—were wary of working with commercial brands. But even Warhol privately referred to his commercial collaborations as "the worst of Warhol." It was a younger generation, especially Keith Haring with his Pop Shop in SoHo, that opened a new artistic category—the art product.

Haring brought his Pop Shop to Tokyo in 1987, connecting with an enthusiastic audience. Japanese visual arts culture did not separate craft from fine art in the way it evolved in Europe and America. It was natural for Japanese artists to create works that merged fine art and craft traditions. Takashi Murakami expanded on Haring's innovations. His collaborations with Louis Vuitton and his own art products opened up the field for other artists. Yayoi Kusama's work was a perfect fit for this new artistic genre.

One of the most significant developments in visual culture over

the past two decades has been the increasingly active connection between the art world and the fashion world. As one of the world's most esteemed artists, Kusama has brought art and fashion collaboration to a new level of prominence. Kusama's work with Louis Vuitton encompasses both her imagery and her artistic persona. It extends to the uncanny spectacle of her robotic surrogate painting her signature dots in the display windows of Louis Vuitton boutiques. The Kusama robot reminds me of the famous Andy Warhol performance where he put himself on display, standing in a robotic pose in a specially constructed vitrine at the New York night club Area.

The conflation of an artist's signature imagery and "branding" has also been one of the most interesting recent developments in visual culture. Damien Hirst played with this convergence with his signature spot paintings, which have become as much a brand as an artistic statement. Kusama was ahead of her time in establishing her dots as her artistic brand. It is fascinating to experience the fusion of Kusama's and Louis Vuitton's brands. Each brand enhances the other.

Kusama's dots in every Louis Vuitton display window and on handbags carried all over the world extend her concept of artistic infinity. Every person who carries a Louis Vuitton Kusama bag is a participant in the work. Kusama's artistic vision has expanded beyond her *Infinity Mirror Rooms* and *Infinity Nets* to cover the world.

PHILIP LARRATT- SMITH ON YAYOI KUSAMA

FIONA ALISON DUNCAN Infinity and obsession: How do these two concepts come together in Yayoi Kusama's work?

PHILIP LARRATT-SMITH When I think about the idea of infinity, I think of Kusama talking about transcending herself. When she makes her *Infinity Net* paintings, she's repeating the same scallop-shaped brushstroke over and over. It's labor-intensive and almost like a form of meditation, and yet there's something about these vast visual fields that's mesmerizing and mysterious. I think the obsessive-compulsive dimension of Kusama's work is grounded in her need to assert her existence in the world, which in turn relates to her desire for fame. She has always had herself photographed extensively in the studio. From the time of her arrival in New York in 1958, she wanted to compete with the big boys. She wanted to take on a very macho art world that was celebrating the triumph of American painting. It's Mark Rothko, it's Clyfford Still, it's painting on a monumental scale. Kusama decided to take that on by making paintings—her early *Infinity Nets*—that are even larger than theirs. Her minimal, repetitive fields are in some ways an answer to Jackson Pollock's rhythmic drips and skeins.

Kusama is an artist who was always driven to become world-famous. She had a very exalted concept of her destiny from an early age. At the same time, she seems to have also had towering doubts and insecurities, which she needs to allay and work off through the making of her art. I think there's a side to Kusama's obsessions that is deeply pleasurable to her—compulsive mark making has its therapeutic aspect. Her art is a release but not a cure. One of the contradictions that fascinates me about Kusama is the coexistence of her need for psychological release through the work and the fact that she craves an audience. The forms she creates are coming from a psychic tendency that must be obeyed. At the same time, Kusama has always been aware of the publicity value of her psychological condition and is very good at using it to get attention. Fusing her biography and her art also allows her to circumvent the gatekeepers and power brokers of the art world, who by and large initially ignored or rejected her.

Paradoxically, Kusama wants to be everywhere and nowhere at once. "I'm here, but I'm nothing," as the title of a late work has it. It's like the idea of suicide, which exists in her practice as a stand-in for another idea, the idea of self-obliteration and disappearing completely, the fantasy of being liberated once and for all from the compulsions that she nonetheless finds intensely pleasurable. If Kusama wants to exist as an image or an idea in the minds of others, it is partly because she is always facing the threat of dissociation, the fear that she can't hold her personality together, that she can't make it cohere, that in the end she doesn't really exist.

FAD "I'm here, but I'm nothing." This is a very human condition.

PLS Through the fusion of her biography and her art, she seems to embody a particularly pure conception of the true artist. Kusama is like a contemporary archetype of the sick artist who, through her illness, reveals something about normal health—in the same way that Sigmund Freud thought that the neurotic's misery reveals something about ordinary psychology. Kusama has assumed the role of the mad

artist for the contemporary art world, and this is part of why the public responds to her so powerfully. Her extreme narcissism feels like a perfect fit for the selfie generation. The iPhone itself is like an *Infinity Mirror Room*. Her installations now seem like precursors to the world of virtual reality.

FAD Sometimes when an artist or public figure becomes very popular, there's a backlash and the bubble bursts, but with Kusama the interest seems to only build. Why?

PLS She has an extremely compelling story. Vincent van Gogh has a story, Edvard Munch has a story, Louise Bourgeois has a story, and Kusama also has created a narrative about herself that is accessible to people who otherwise may not be that interested in art. There's such a hunger for authenticity, and Kusama's mental disturbance and artistic achievement alike are unquestionably authentic.

FAD You've done extensive work with Louise Bourgeois, who's a fascinating historical counterpoint to Kusama. Their phalluses alone are a study of contrasts and convergences.

PLS When I first went to visit Kusama in her Shinjuku studio, I was instructed that Bourgeois was one of the very few artists Kusama liked and that it was okay to mention her. I think Kusama feels she recognizes something of herself in Bourgeois. Of course, Bourgeois doesn't have the Pop side that Kusama does, but there are other affinities. It was fascinating to me to discover that in the 1980s, after Kusama had more or less dropped out of the art world after several suicide attempts, she became famous in Japan as the author of these delirious, psychedelic novels that center around sexual perversion, prostitution, castration, death, necrophilia—you name it. The novels are fantastic and underrated. Obviously, another thing Kusama has in common with Bourgeois is that both have distinctive female voices that managed to survive long periods of neglect. There's a radicalization in Kusama's work from the 1960s that I think is partly a consequence of the fact that she didn't have gallery representation. Her politics were progressive for that moment, even for the art world. I also think that, because of the neglect, she felt she had to resort to elaborate strategies in order to hold the attention of the public. To some extent, the art world's powers that be failed, betrayed, and neglected her, so she's not overly concerned with them. She's determined to communicate directly with the mass public, the art world be damned. The current campaign with Louis Vuitton thus feels like an extension of her project of communicating creatively and directly with the masses. I sometimes think of Kusama as the preeminent Pop artist along with Andy Warhol (whose work she does *not* like). In the 1960s, she didn't have a factory, but she had her own gang, which was actually much more utopian and radical than Warhol's posse. Warhol also underwent a radicalization in his work in the sense that he went from making drawings and hand-drawn paintings to silk screens, photographs, films, and then further depersonalized himself, managing a band, editing a magazine, and so on. Similarly, Kusama goes from making paintings and sculptures to installations, performances, be-ins, and happenings.

FAD Have you had the opportunity to watch Kusama work?

PLS Yes. Kusama has a ferocious appetite for work, which is incredible to behold. The moment she finishes one painting, she begins the next. Just as the early *Infinity Nets* were often huge expanses of canvas that would later be cut down to size, her more recent painterly practice is also continuous and open-ended. The iconography changes and develops, but sometimes it seems to me as if she's making a single universal painting, of which each individual canvas is just one constituent part.

FAD Kusama is known for her polka dots, which can signify so many things, from connection, communication, and equality to the sun, the moon, and stars. These are all positive associations, but they can also call to mind cancer cells replicating or the atomic bombings of Hiroshima and Nagasaki during World War II. The twentieth century was marked by an awareness of how life can be taken over and torn apart by dot-like matter. Curator Mika Yoshitake has also mentioned that the polka dots in Kusama's 1965 *Infinity Mirror Room—Phalli's Field* reference, among other things, venereal disease.

PLS If Bourgeois has her spiders and Warhol has his soup cans, Kusama has her polka dot. She has claimed this motif as her own visual language. The dot is there from her artistic beginnings. If you look at Kusama's early works on paper, for example, they almost look like microscopic images of cells and very basic organisms. The components of the cell could be seen as prototypes of the polka dot. Later on, the dots get flattened out and turned into a Pop signifier.

Kusama has said that she repeated the image of the phallus because she wanted to abolish the threat of penetration. She was afraid, as she said, of something as disgusting as a penis entering her body, and so she covered objects with phalluses as a way of warding that off and projecting it out onto her immediate surroundings. The fear of contact with others can express itself through the fear of disease or contamination. That, to me, seems like an expression of the fear of intimacy with another person, which threatens to engulf her completely. Bourgeois's work is always addressed to the other, whereas in Kusama's work there seems to be no other. It is these tensions in the work that I am interested in: Kusama claims she doesn't have sex, and so everything becomes libidinized; there's a disruption in the realm of sexuality that is expressed throughout the work.

FAD *Infinite Obsession*, the exhibition you curated, included Kusama's polka dot–wrapped trees. Could you describe that work?

PLS To some extent, it's Kusama laying claim to the world around her. The polka dot is her symbol, and the whole world has become her canvas. In Buenos Aires we covered the museum's facade with a polka-dot decal, so it was as if everything was now seen through Kusama's eyes. The polka dot is a very flexible form, which Kusama is able to adapt to almost any context or support. Even now, as I walk around Manhattan, every time I look up, I see an image of Louis Vuitton bags covered with polka dots or models wearing Louis Vuitton clothing covered in polka dots. She seems to have succeeded in making the world over in her own image.

IMAGE CREDITS

A Message of Love, Directly from My Heart unto the
Universe, 2022
Glass mosaic
120 ⁵⁄₁₆ × 7 ¼ feet (36.7 × 2.2 m)
Fabricated by Miotto Mosaics Art Studios
Commissioned by MTA Arts & Design and New York City
Transit
© YAYOI KUSAMA, Courtesy of Ota Fine Arts, and Yayoi
Kusama Foundation
Photo by Kerry McFate
pp. 136-37

Flowers Speak, 2016
Acrylic on canvas
76 ⅜ × 76 ⅜ in.(194 × 194 cm)
pp. 138-39

Yayoi Kusama at approximately 10 years old
Japan, c. 1939
p. 143

Summer Flowers (detail), 1990
Acrylic on canvas
17 ⅞ × 20 ⅞ in. (45.5 × 53 cm)
p. 144

Flowers That Bloom at Midnight
Installation view
Fairchild Tropical Botanic Garden, Miami, 2009
pp. 146-47

Yayoi Kusama overlooking the water
Seattle, 1957
p.148

Yayoi Kusama in a field of flowers
Fukuoka, Japan, 1994
p. 149

Flower Obsession (Gerbera), 1999
Performance film still
Video; duration 1:21 minutes
pp. 150-51

Flower Obsession (Sunflower), 2000
Performance film still
Video; duration 2:40 minutes
pp. 152-53

My Soul Blooms Forever, 2019
Urethane paint on stainless steel
97 ⅝ × 62 ¼ × 49 ⅞ in. (277.5 × 158 × 126.7 cm)
p. 154

Untitled (Flower Sketches) (details), 1945
Pencil in notebook
8 ½ × 11 ⅞ in. (21.5 × 30 cm)
p. 155

Yayoi Kusama with her Flowers That Bloom
at Midnight, 2010
p. 157

High Heels for Going to Heaven, 2014
Fiberglass-reinforced plastic, stainless steel
51 × 21 × 31 ft. (1560 × 660 × 960 cm)
pp. 158-59

Butterfly, 1985
Screen print on paper
21 × 23 ⅞ in. (45.5 × 53 cm)
Edition of 100
pp. 160-61

Yayoi Kusama in her Flower Obsession
Noko Island, Fukuoka, Japan, 1994
pp. 162-63

Flower XL, 1993
Screen print on paper
Image: 23 ¾ × 28 ½ in. (60.6 × 72.7 cm)
Sheet: 28 × 33 in. (71 × 84 cm)
p. 165

Flower Obsession, 2017/2020
Installation view
Yayoi Kusama Museum, Tokyo, 2020
pp. 170-71

Yayoi Kusama at her Self-Obliteration Happening
New York, c. 1968
pp. 174-75

Yayoi Kusama Fashions Happening on her studio rooftop
New York, 1968
p. 194

Self-Obliteration (Net Obsession series), c. 1966
Photo collage on paper
8 × 10 in. (20.3 × 25.4 cm)
pp. 200-01

A special thanks to all the teams at Louis Vuitton
and their partners involved in the Louis Vuitton × Yayoi
Kusama project.

CAMPAIGN DOCUMENTATION IMAGE CREDITS

Campaign billboard, Photograph by Frédéric Berthet, Musée
d'Orsay, France, 2023
p. 189

Campaign billboard, Photograph by Zhang Enzhgou, Shanghai
p. 204

CONTRIBUTORS

Delphine Arnault
Delphine Arnault is former Executive Vice President of Louis Vuitton and current Chairman and CEO of Christian Dior Couture.

Jeffrey Deitch
Jeffrey Deitch is a longtime gallerist, curator, and art critic.

Fiona Alison Duncan
Fiona Alison Duncan is a Canadian-American author and curator. Her debut novel *Exquisite Mariposa* was awarded a 2020 Lambda Literary Award. Duncan's fiction and nonfiction have been published in international publications such as *Vogue*, *Spike Art Magazine*, S*ternberg's Solution Series*, and *The White Review*. She is the co-curator of the exhibition *Act Like You Know Me* about the radical American artist Pippa Garner, on whom she is also writing a literary biography.

Jo-Ann Furniss
Jo-Ann Furniss is an editor, creative director, consultant and writer. The editor-in-chief of *Arena Homme+* from 2004 to 2011, she has held editorial positions at *i-D*, *The Face*, *Sleazenation*, *style.com*, and *AnOther Magazine*. Among others, she has contributed to *The Wall Street Journal*, *The Telegraph*, *The New York Times*, *The Independent*, *Colors*, *Dazed and Confused*, *Vogue Hommes International*, *Love*, and *Self Service*. She is the author of a previous book about Louis Vuitton, *The Icon and the Iconoclasts: Celebrating Monogram*.

Marc Jacobs
World-renowned designer Marc Jacobs created his first collection with the Marc Jacobs label in 1984. The following year, Jacobs received the distinct honor of being the youngest designer ever to be awarded the fashion industry's highest tribute: The Council of Fashion Designers of America (CFDA) Perry Ellis Award for New Fashion Talent. From 1997 to 2013, he was the Director of Louis Vuitton. Currently, Marc Jacobs International includes ready-to-wear and accessories as well as multiple award-winning fragrances which are sold in his eponymous stores around the world. His company is committed to giving back to the communities where it has stores and beyond, and has been involved with over 100 charities worldwide.

Philip Larratt-Smith
Philip Larratt-Smith is a curator and writer based in New York. Since 2019, he has been Curator of The Easton Foundation in New York, which administers the legacy of Louise Bourgeois. In 2012, he presented Bourgeois's psychoanalytic writings in the exhibition and two-volume publication *Louise Bourgeois: The Return of the Repressed*. His recent exhibitions of Bourgeois's work include *Louise Bourgeois: Freud's Daughter* at the Jewish Museum, New York (2021). He was the co-curator, along with Frances Morris, of the successful exhibition *Yayoi Kusama, Infinite Obsession*, which traveled throughout Latin America with a staggering 2.6 million visitors for the entire tour.

Hans Ulrich Obrist
Hans Ulrich Obrist is Artistic Director of the Serpentine Gallery in London, and Senior Advisor at LUMA Arles. Prior to this, he was the curator of the Musée d'art moderne de la Ville de Paris. Since his first show *"World Soup" (The Kitchen Show)* in 1991, he has curated more than 350 exhibitions. Obrist's recent publications include *Ways of Curating* (2015), *The Age of Earthquakes* (2015), *Lives of the Artists, Lives of Architects* (2015), *Mondialité* (2017), *Somewhere Totally Else* (2018), *The Athens Dialogues* (2018), *Maria Lassnig: Letters* (2020), *Entrevistas Brasileiras: Volume 2* (2020), and *140 Ideas for Planet Earth* (2021).

Akira Tatehata
Akira Tatehata is an art critic and poet based in Japan who has written extensively about Yayoi Kusama's work. In 1993, he invited the artist to represent Japan at the 45th Venice Biennale. He now serves as Director of the, Yayoi Kusama Museum, Tokyo; Director of The Museum of Modern Art, Saitama; and Chairman of the Japanese Council of Museums.

Isabel Venero
Isabel Venero makes books with, for, and about artists. For two decades she has worked as an editor at large at Rizzoli, New York, where she has focused on contemporary artists' monographs.

Ferdinando Verderi
Ferdinando Verderi is a creative director whose work has shaped some of the most memorable fashion editorial and advertising moments of the past half decade. He recently served as Creative Director of *Vogue Italia*. He is responsible for the Louis Vuitton × Yayoi Kusama campaign ideation.

Mika Yoshitake
Mika Yoshitake is an independent curator who has had a deep engagement with Yayoi Kusama's work including organizing three major global exhibitions of the artist's work. *Yayoi Kusama: Infinity Mirrors* focused on the genealogy of her infinity mirror rooms from 1965 to the present. *KUSAMA: Cosmic Nature*, which was held at the New York Botanical Garden, followed the foundational inspiration and evolution of botanical forms in Kusama's work. And *YAYOI KUSAMA: 1945–NOW*, a major retrospective that opened in 2023 at M+ Hong Kong, considers her life practice through six recurring themes: Infinity, Accumulation, Radical Connectivity, Biocosmic, Death, and Force of Life.

First published in the United States of America in 2023
by Rizzoli International Publications, Inc.
300 Park Avenue South
New York, NY 10010
www.rizzoliusa.com

EDITED BY
Ferdinando Verderi
Isabel Venero

FOR LOUIS VUITTON
President: Pietro Beccari
Communication DIrector: Stefano Cantino
Editorial Manager: Axelle Thomas
Editor: Anthony Vessot

FOR FERDINANDO VERDERI STUDIO
Creative direction: Ferdinando Verderi
Art direction: Carlotta Gallo
Book design: Marco Minzoni
Project Manager: Nancy Doster

FOR RIZZOLI
Publisher: Charles Miers
Associate Publisher: Anthony Petrillose
Editor: Isabel Venero
Production Director: Maria Pia Gramaglia
Research and photo permissions for Yayoi Kusama
artwork and archival photos: Alex Jones

Printed in Italy

2023 2024 2025 2026 / 10 9 8 7 6 5 4 3 2 1

ISBN: 978-0-8478-7383-8
Library of Congress Control Number: on file

Visit us online:
Facebook.com/RizzoliNewYork
Twitter: @Rizzoli_Books
Instagram.com/RizzoliBooks
Pinterest.com/RizzoliBooks
Youtube.com/user/RizzoliNY